people
IN MY CAMERA

michael gnade

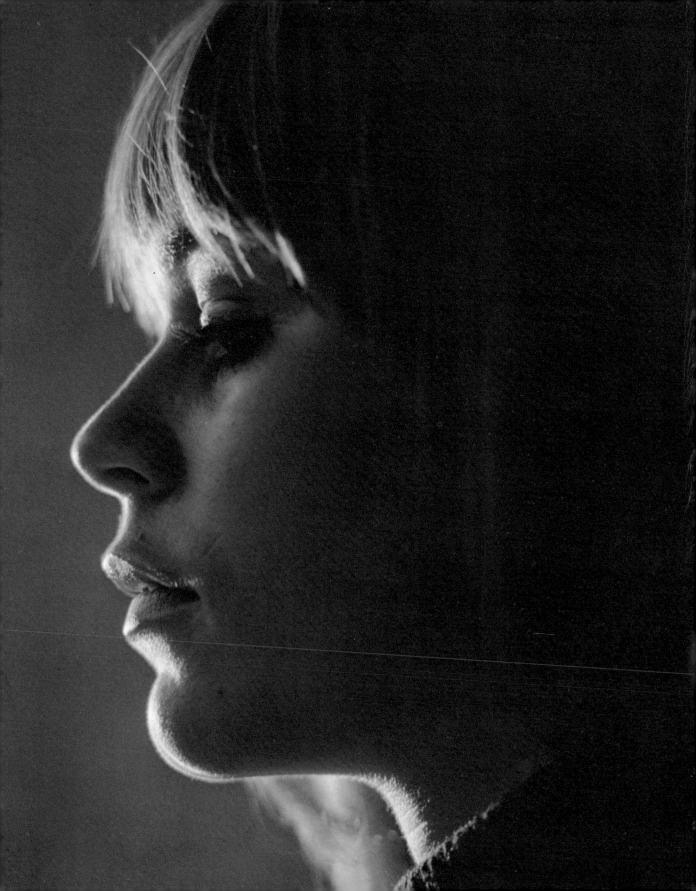

people
IN MY CAMERA

michael gnade

portraiture
figure studies
photographic
approach
composition
processing
experiments

FOUNTAIN PRESS

I wish to thank my former art teacher, Hans Pfannmüller, for his artistic support and, in particular, his friendly advice in looking at the photographs.

My thanks are also due to:

Rudolf Dick
Christian Friedrich
Anton Gühmann
Herbert Kämpfe
Wolfgang Köllges
Rainer Schilling

for their technical and editorial assistance.

Special thanks are also due to Helmut Schwanen, Production Manager of Droste Verlag.

All the photographs, diagrams and layout, including the jacket and cover, are by Michael Gnade.

© Michael Gnade 1974
© English edition Argus Books Ltd 1979
First English edition 1979
ISBN 0 85242 632 1
Printed by Litoclub S.A. Napols, 300 - Barcelona
Depósito legal: B. 30707 - 1979
Número Registro Editorial: 785

Contents

Preface

Photographic content is the main theme of my book. Photographic technique takes second place since every aspect of the subject has already been covered elsewhere. The modern fully-automatic and semi-automatic cameras now available also enable the amateur photographer who is not unduly concerned with technique to take perfectly satisfactory photographs and slides. Excellent technical results can be achieved simply by following the instructions provided with the camera, film or chemicals. Artistic quality, on the other hand, is not so easily achieved. The purpose of this book is therefore to point out the *photogenic* aspects of human life. People are still the subject of great interest to photographers, and through the camera we can give valid expression to our desire to create photographic images of other people.

Any technical knowledge required is explained through the illustrations. Every aspect of technique can of course be taught and learned, but this is only partially true of the artistic aspects of photography.

The purpose of my commentary is not to lay down generally valid aesthetic rules. Everyone has his own concept of beauty, his own philosophy of life, and anyone wishing to be a photographer must find his own style. I can only provide stimulus and arouse interest. I can also relate some of my experiences and perhaps through them indicate some short-cuts.

The subjects covered are shown in the list of contents on the preceding pages. Each photograph tells a story just as it happened. Some of the photographs were produced for photographic journals, but here —in partially altered form— they are related to the main subject category under which they appear. For instance, "Marianne in Arles" serves to illustrate figure and portrait studies. "Photographic report on an Art School" is to be viewed in relation to the rest of Section 6, and "My coloured friends" and "Poor light conditions" come under Section 2.

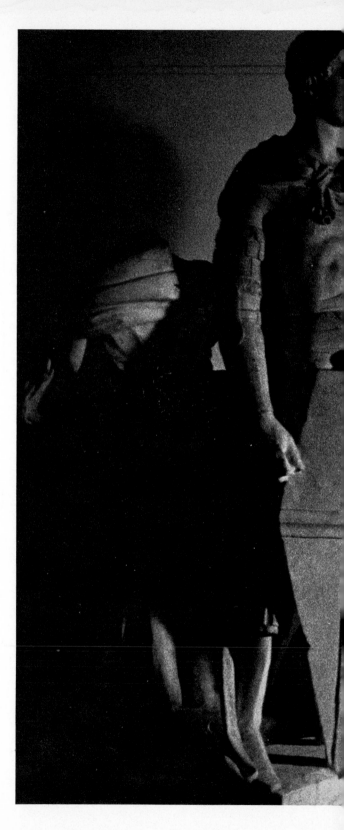

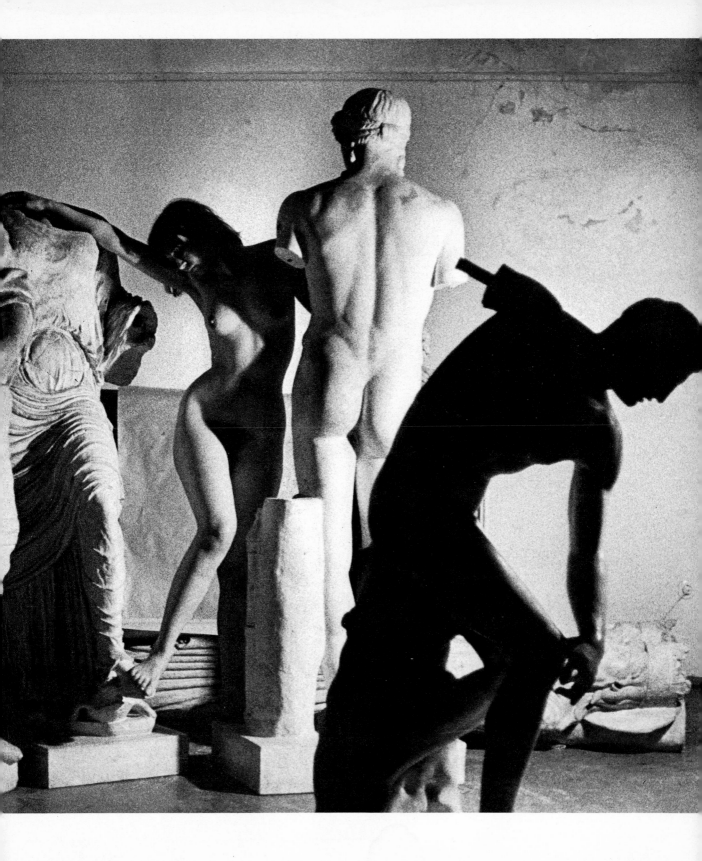

Most of the photographs illustrate various aspects of photography that are discussed separately. Since it is impossible to discuss aesthetic points beside each individual photograph, references are given, in brackets, to other parts of the book, which further explain the subject under discussion. Technical data — camera, lens, film, exposure and lighting — are given with each photograph.

Only practice will show what is important and unimportant in photography. My first piece of advice is therefore to take photographs quite recklessly and do not get discouraged, even when entire films are spoilt. In some cases, there is more to be learnt from bad results than from chance successes - but I nevertheless wish you every success!

Page 7: "Everyone has his own concept of beauty" but different periods in time also have different concepts of people; e.g. Classical, Renaissance, Modern.
50 mm lens: 1/125th at f/2: 400 ASA film
500 W spotlight as side lighting from the right.

Below: Knowledge of the history of art is not so important in practical photography as a sharp eye. Photograph taken in the Louvre, Paris.
50 mm lens: 1/60th at f/2: 400 ASA film
Diffuse daylight.

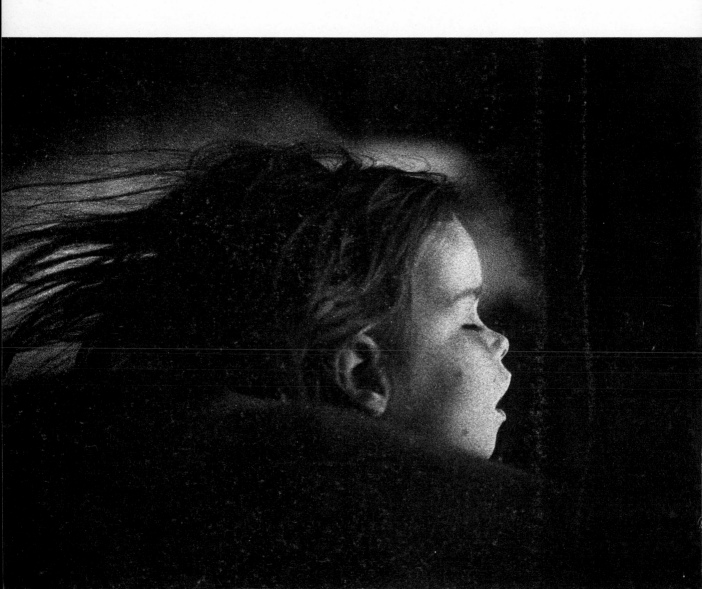

1

Camera
Lens
Subject and
Photographer

Practical human interest photography

From time to time people ask me where I find my models, especially the young girls. Yet whether my subjects are small children, beautiful young women or grandmothers, even the prettiest and most photogenic of them are not top professional models: they are people from every walk of life.

I am still mystified by the mutual rapport which comes between subject and photographer. Concentration on a specific subject — in our case a person — is a basic condition of photography and when I am not concentrating I cannot handle even a dog in front of the camera, let alone a person. In photography, the subject — whether an animal or a person — must be conscious of the interest aroused by its presence. If insufficient interest is shown, the necessary relationship is not established and there is no "magnetism".

Many actors are said to inspect the audience throught a gap in the curtain before their entrance in order to choose someone for whom they will act. If there is no-one suitable in the stalls there is no spark and the performance is flat and uninspired. If the right spectator is there he helps the actor to develop his role fully. True inspiration is always a two-way process.

The actor Jean-Louis Barrault (pp 11, 126-129) puts it as follows: "The atmosphere on the first night is beyond words. As soon as the curtain goes up we sense the mood of the audience. We can tell from the very first words whether it is warm or cold, friendly or distant, and whether it will be receptive or unreceptive."

The role of the performer who is establishing and trying to maintain contact with his audience is not unlike that of the photographer in relation to his model.

Right: Scene from Paul Claudel's "The Silken Shoe". Production: Jean-Louis Barrault (standing in the photograph on the left and above in a photograph taken from the portrait study on page 126). Photographs taken in poor light often require extremely sensitive film and maximum aperture. Film sensitivity can be increased by prolonged development at a higher temperature.
50 mmlens: 1/125 th at f/2: 800 ASA film exposed as 1600 ASA and developed approximately 5 minutes longer, and at 25°C. (22°F)
Stage lighting with various spotlights from some distance.

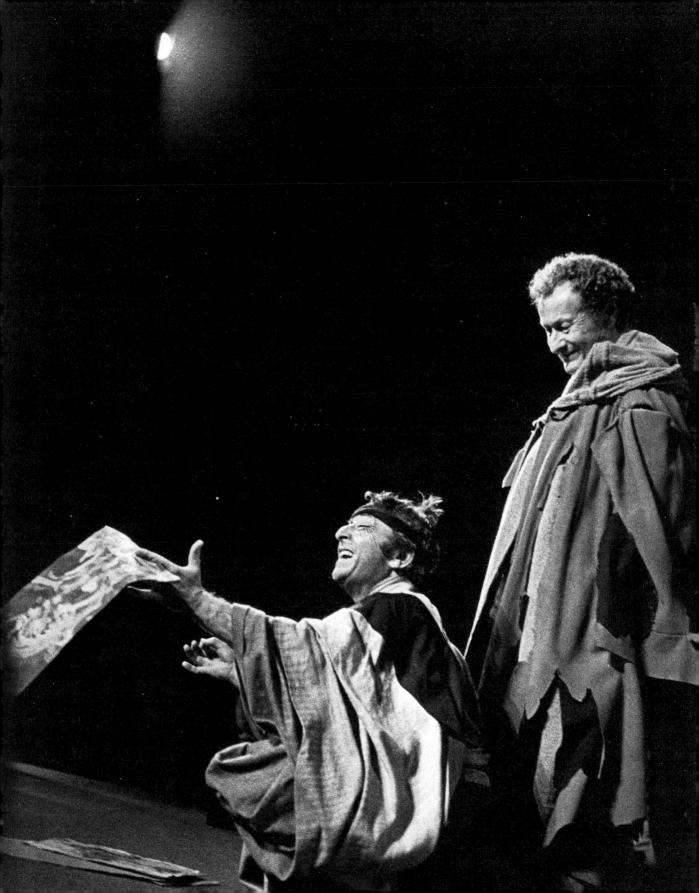

My repertoire
of subjects

Obviously my repertoire of subjects cannot begin to represent the inconceivably vast variety of mankind. For instance it lacks Nobel prize-winners, politicians of every kind, new-born babes, married couples old and young, weeding couples (couples in love are represented), soldiers, athletes. My subjects will not be to everybody's liking. Everyone has his own view of other people and everyone is entitled to his own type of model. No-one can tell another where to find his subjects.

In listing them below, I should like to thank my models who played such a decisive part in the production of this book. They inspired the photographer in me - whether they realized it or not. My warmest thanks are due to:

The children of Pentidatilo
Barbara Holmes, the dancer
The man of private means from Düsseldorf
Cornelia Köster, fashion student
The passer-by from Amsterdam
The woman walking by, from Paris
Mamou, the photographer
Christina Some
Doris for her legs
The tramp from Arles
Barbara Tapeser, the sculptress
The old man from Athens
The black man with the polar bear
The black man in the night club
The airline passenger who sat behind me
Claudia Köster, gymnastics teacher
The ladies from Cairo
The rowdies from Ibiza
Marianne Matheus, the pianist
Laura Fontana's hair

An old woman for her hand
Loko from Togo
Jean-Louis Barrault, the actor
The lovers by the Seine
Julia for her mouth
Hella Bantz
The teacher from Clermont-Ferrand
The oldest member of the Kunath family
Anatol, policeman and action artist
Ulli, student of sculpture
The little rascal from Rovigno
Brigitte Seidel, doctor's nurse
The unknown man in a cloak
The black Nubian
The hippy from the Joint Meeting
The horse-rider from Egypt
Inge, Christel, Biggi, Susi, Angelika, Monika, Michèle and Gisèle; nude models
Alexandra Zytra, record shop assistant
People walking along a boulevard
Marc Chareyre, male nurse
Pretty Astra and sweet Natalie
The master potter from Aswan
Professor Joseph Beuys
The girl wearing jewellery, whose name I have forgotten
Those people who did not tell me their name
The Klehmet family
Ulrike Jodeit, poster sales assistant
The oriental brass merchant
The old man from Antibes
Marléne Dousset, bar maid
The old man from Cologne
The rascals from Capri
The negro in the entertainments quarter
Klaus Becker, commercial artist, with Skye terrier "Domino of Hyde Park"

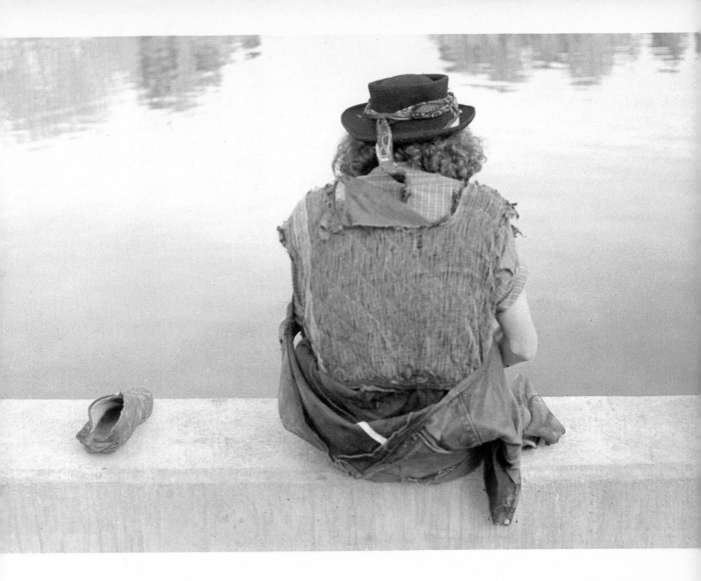

The employees of an Arab café
Inge Thorenz, secretary
A passer-by somewhere in Spain
A passer-by somewhere in France
Pièro, casual labourer
The girl from Venice
The face, full of character, of a souvenir-shop assistant
The little girl from Luxor
Daniela Flöhrsheim, artist
The sleeping cherub
The father with son at the artist's meeting
The rear view of Madame R
The rowdies of Barcelona
The couple of Toulouse station.

Not top models but people from other walks of life allowed me to photograph them - people like this hippie from the Joint Meeting in Düsseldorf, 1970/1971.
135 mm lens: 1/125th at f/5.6: 50 ASA colour transparency film (half-stop overexposed, hence the pastel-lile colours)
Diffuse daylight

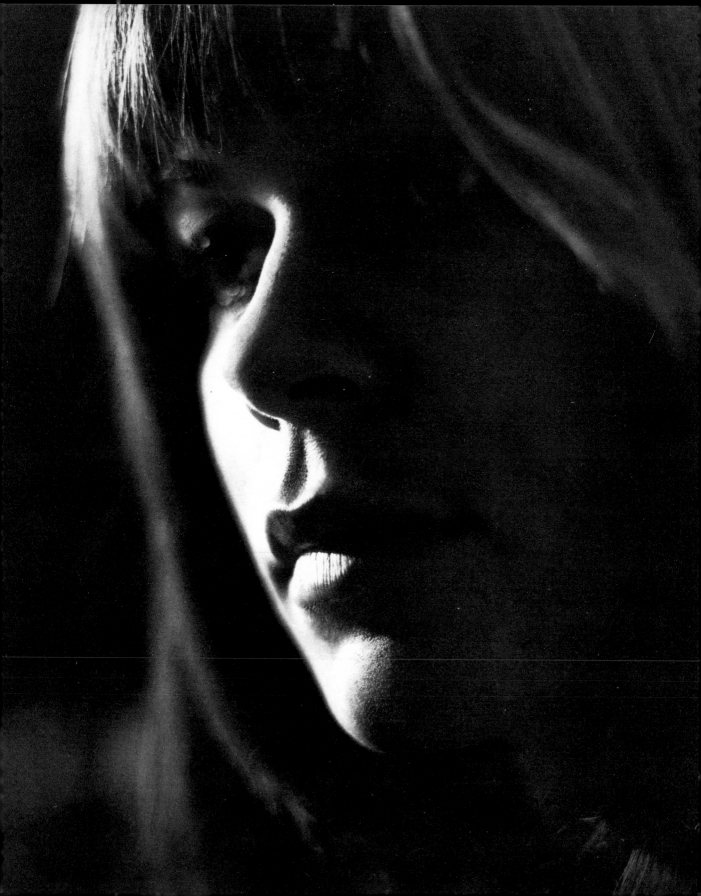

Maximum proximity

Actors feel that, in order to identify completely with a part, the must become immersed in it and experience it with heart and mind. Yet at the same time, to be master of their profession, they must be able to stand outside their rôle. It sounds paradoxical, but it is so.

Applied to photography this means that keeping away from, yet remaining close to, the subjet is just as necessary when taking photographs as when acting. However, if the photographer is too far removed from his subject, he will never produce a masterpiece.

The photographer must therefore get as close to his subject as is practicable. There can be no better advice than this in photography, and none which will lead more rapidly to success. Following this rule makes it far easier to separate the essential from the non-essential because the superfluous, which accounts for up to 90% of the picture in so many photographs, is simply omitted. "The last and greatest art is to limit (and isolate) oneself," said Goethe.

In photography, concentration on a subject is achieved simply by gradually reducing the distance between camera and subject. This gradual approach makes the photographer feel that his subject is drawing closer. If he finds he has moved *too close*, the camera is drawn back again. He then moves backwards and forwards in this way until the subject "looks right" in the viewfinder. The button should then be pressed quickly, before it is too late; before that fleeting moment passes and the photographer no longer feels convinced of the "rightness" of the camera's viewpoint. A technical aid to the close-up is the telephoto lens: the greater the focal length, the greater the telephoto effect (page 21). The photogenic impression obtained intensifies concentration on the subject. This effect is heightened in the reflex camera because the depth of field can be assessed in the viewfinder by using the pre-view button. Just experimenting with telephoto lenses will show how they train the photographer to see large associations of form and relate colours to each other.

The method of approaching the subject or bringing it closer sharpens the photographer's instinct. Application of this method to photographing a person, almost feeling the subject breathe, hearing the rustle of his or her hair, is the most direct route to gaining photographic experience.

Left: The closer the camera's viewpoint, the less in seen of the subject, but photographic quality is often increased accordingly.
150 mm lens with 21 mm extension ring: 1/125th at f/5.6: 100 ASA film
500 W bulb as side lighting

Below: Detail from the photograph on page 25.

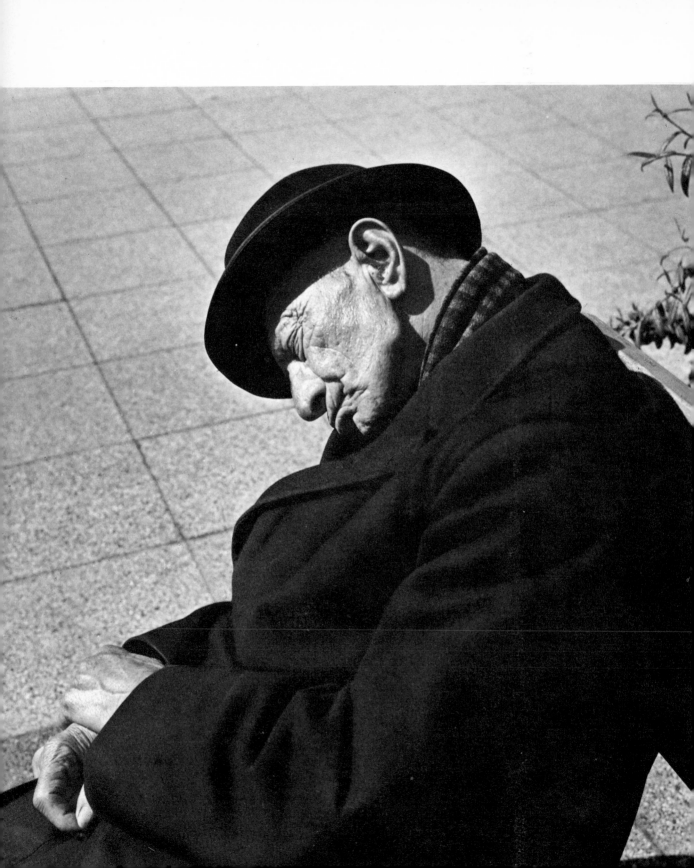

Angle of view

Deciding on the correct angle of view is just as important as finding the most significant part of the subject to photograph. The subject is not equally photogenic from every side! Seen from one direction, a person may be quite expressionless but from a *different* viewpoint that same person provide a superb photograph.

In portrait photography the subject sometimes tells you which is his "best side", by which he means the side he considers most attractive. Of course, his "best side" may in fact not be his most photogenic side because an element of subjectivity might have influenced his judgement. Nevertheless the subject knows that there is a difference between the two sides of his face, otherwise he would not be indicating one in preference to the other. It is obvious even to the novice that a profile is quite different from a full-view face. The photographer should view a person from every side; some people are seen at their most characteristic with their head averted, others in pure profile and many from the three-quarter or full-face view. Some are seen at their most beautiful and perhaps at their most characteristic, from behind.

It is not always easy to decide on the angle of view which best typifies a person. Occasionally time has to be spent on finding this angle. The photographs on pages 16-19 illustrate this point. They are not portraits but figure studies. This series shows that there are differences of composition between all photographs. Photograph 2 is more typical than photograph 1, since the face is scarcely visible in the first picture and it is the face which characterizes this type of person. The objective was to produce a photograph of a person, not a "post-card" of a town view. The third photograph was therefore taken at a shorter distance from the subject than the previous two. Although the camera viewpoint is still at the same height, moving closer changes the angle of view to give a more top view. Nevertheless, this composition is also unsatisfactory. The intention was to photograph the subject from the head down to the hands in order to exclude as much of his surroundings as possible; however, the surroundings still did not fit in properly with the main subject. This becomes obvious on comparison with the photograph on page 16, where the paving stones in the background make a *graphic*

This angle of view allowed subject and surroundings to be photographed as a whole; see also page 18. 80 mm lens on 6×6 cm: 1/125 th at f/8: 40 ASA film.
Direct sunlight

Left: The sketch for the photograph on page 103 shows that the angle of view has a decisive effect on composition. If the photograph had been taken a step higher or lower, the illusion of depth would have been reduced.

Below: The composition drawing for the photograph on page 16 should demonstrate the unity of the contrast between mass (person) and line (paving stone lines), achieved by means of the photographic viewpoint.

1. The first exposure is not always the best. This photograph shows too little of the subject's face which is so characteristic of him.

2. Seen from the opposite direction, too much unimportant background detracts from the main figure.

3. By moving closer to the subject, he appears larger and nearer in the field of view. However, here again subject and background still do not coalesce as they do in the subsequent photograph shown on page 16.

4. The final exposure has lost the main point of the situation.

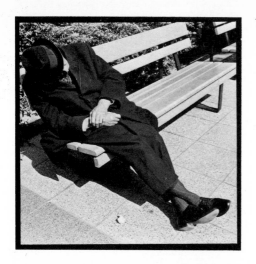

1

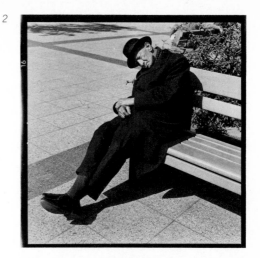

2

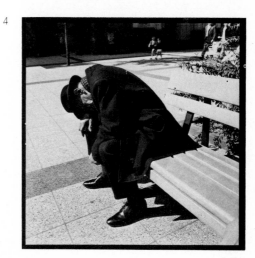

3

4

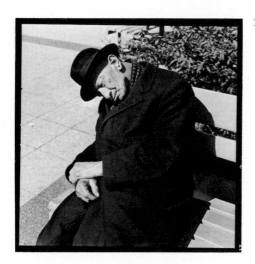

contribution, partly as a contrast of tone with the black material in the foreground but especially as an indication of space and perspective. The radiating lines of the paving stones, which lead towards a common vanishing point, are complemented and extended by the back of the bench. In this way it looks as if the square shape is divided diagonally — from top left to bottom right — especially since the old man's head is tilted in the same direction (see sketch). Photograph 4 was taken after the half-reclining, sleeping figure had slumped forward but the new position was not more photogenic. There was also no further point in taking close-ups to obtain details of the head, since the interesting features were now immersed in deep shadow.

Experiments with the angle of view can be supplemented and expanded by the extreme differences of height and depth which can be achieved by means of worm's-eye view and the bird's-eye view (page 103 and the composition drawing on page 18, top left). The view from above and below will now be discussed separately.

All photographs in this series:
6×6 cm
80 mm lens on 6×6 cm: 1/125th at f/8: 40 ASA film.
Direct sunlight.

High-angle and low-angle shots

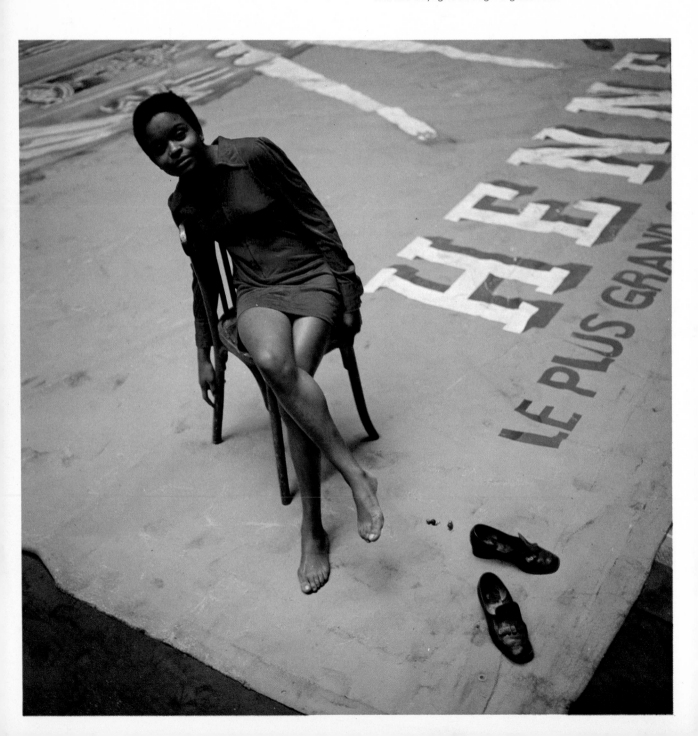

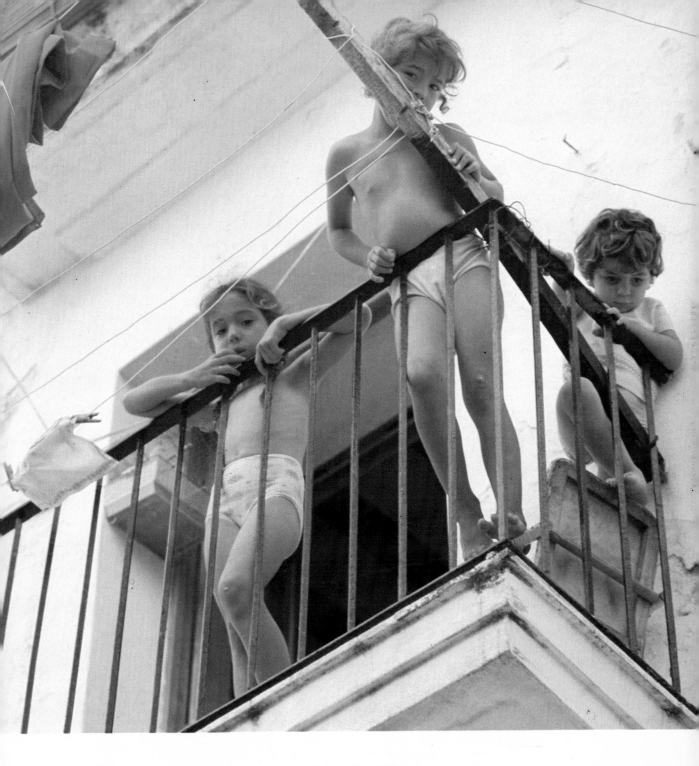

*Above: The low-angle shot (worm's-eye view) is obtained by holding the camera up.
250 mm lens on 6×6 cm: 1/125th at f/8: 160 ASA Colour reversal film.
Indirect but bright daylight*

Taller people frequently have to look downwards in order to locate themselves in the world. Smaller mortals prefer to look upwards for their points of reference, especially when they want to make contact with taller companions (page 132). Regardless of whether a person is short or tall, for every individual who is not used to looking in a certain direction there is another who is not used to looking in the opposite direction. This is a pity, especially in photography, because the worm's-eye view and its opposite, the bird's-eye view, provide interesting views from above and below.

If these expressions were to be taken literally, of course, we should have to fly like a bird (page 38) or lie flat on the ground (pages 113, 130); but even this does not ensure extreme *views* from above and below. In every case it is the angle of view in relation to the subject which determines whether the perspective will be extreme or moderate. Many photographers achieve *more* top view by holding their cameras above their heads than someone from the top of the Eiffel Tower when photographs are taken vertically by the former and horizontally by the latter. A slightly raised base - stairs (page 20) or one's own body height (pages 63, 87) — is likely to give plenty of top view when the subject is at a lower level.

If you saunter along by the Seine in Paris, you will find a pavement running immediately beside the river — a favourite place for tramps and lovers — and another footpath some ten metres higher running parallel to the main road. If you bend over the wide wall by the top path or if you sit on the parapet to let your legs dangle down and enjoy the view of the city, the possibility of also looking down towards the cobble-stones almost suggests itself. There is always some living thing to be seen here — dogs, cats, fishermen, Bohemians or walkers stretching their legs or making themselves comfortable on the wooden benches. Variety is provided by a couple kissing, like the two in the photograph opposite; in this instance the most suitable moment photographically was very brief. It lasted only a fraction of a second during which the tips of their noses were still sufficiently far apart to show enough contrast of light and shade between the hair and skin of the two faces. If the two noses had disappeared past

each other into a less well-defined area it might have been some time before they were again visible to the camera. Nevertheless it is owing to the bird's-eye view that the incident was at all photogenic; seen from the front it would have been comparatively dull.

The scene with the policeman and action artist Anatol (page 172) was also photographed from above downwards. It was taken from the top floor of an art school when the artist had spread his work and himself out on the front lawn. I photographed him straight ahead as usual and the view from above just happened. I was able to take my time, since the subject kept still — such "action pictures", as Anatol calls his productions, sometimes last hours or even days and nights. I therefore studied the situation at my leisure from various floors with shorter and longer focal lengths. The best viewpoint to fit the square subject into the square photograph was from the attic floor, using the 150 mm lens of a 35 mm camera. As already mentioned, a quite different photographic awareness results from the worm's-eye view which is obtained not only from the ground position but also, for example, by standing firmly on both feet with bent legs spread slightly apart. The body is bent only slightly backwards so that the chest expands forward considerably and the head is pushed into the neck to where the shoulders start; the camera is pointed towards the sky — or any other point — at roughly 45°. Amusing views can be obtained from this position with some luck, for example in the photograph on page 21. The angle of the image is due to the good fortune of having a 250 mm telephoto lens in a 35 mm camera at the right time. A second later the group of three was in fact not suitable for a photograph — one child was hidden, and the foreshortening of proportions was tricky.

A bird's-eye view is gained from the raised footpath by the Seine in Paris.
50 mm lens: 1/250th at f×8: 100 ASA film.
Overcast sky.

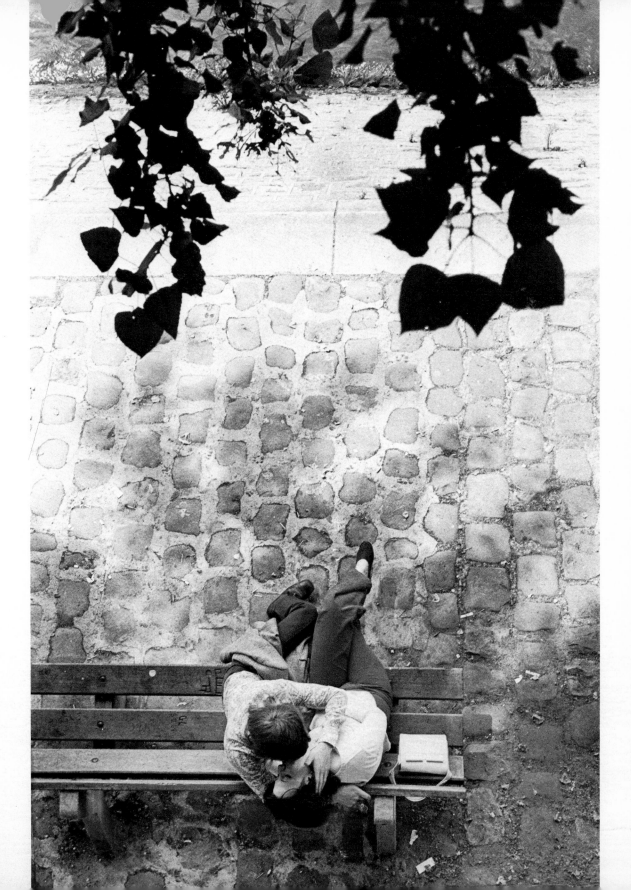

Even in extreme views from above and below the foreshortening of limbs should be kept within reasonable limits. If there is any puzzle as to what is the matter, the wrong angle of view has been chosen.

During another walk, the cheeky young rascal on page 132 pushed herself right under my camera. While busy photographing street scenes in Yugoslavia I felt something touch the bottom of my trousers and I found the cause of the disturbance immediately in front of the lens. The "bird's-eye view" effect is extremely clear in this case because foreshortening below the waist-line emphasizes the small Yugoslav's head and trunk so much. The whole figure gives a strong impression of being seen from above, however, because the pavement dominates the entire background — from the bottom to the top edge of the picture.

The possibility of photographing heads and other close-ups from extreme angles of view should also be noted. The depth dimensions of the subject are then found to present spatial problems which cannot be readily overcome with equal success from any direction (pages 25, 32, 119). Sometimes in this type of photographic situation there is only a single camera viewpoint from which a typical or original view from above or below is possible.

Sketches of the photographs on pages 32 and 132 should show clearly that high-angle and low-angle shots make the spatial-cubic properties of the subject far more conspicuous than the "normal" angle of view. The structural drawing of the detail photograph shows, in addition, that the centre axis (the dotted line) is often important in photographic composition.

Right: In this experiment the camera was considerably lower than the usual eye level: approximately 60 cm (2 ft) above the ground on a tripod.
150 mm lens with additional 21 mm extension ring on 6×6 cm, 100 ASA film: 1/125th at f/11.

500 W bulb as overhead lighting (side fill-in with white cardboard, which reflected part of the main light. Distance between board and subject - approximately 1 m (3.3 ft)

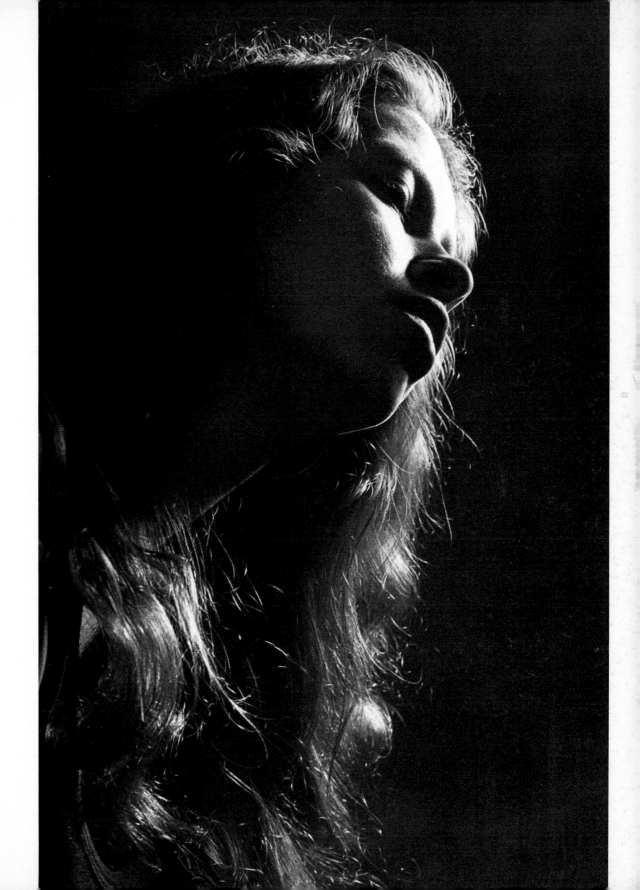

A gift grom the gods

There are photographic encounters that are affairs of the moment. They occur in fractions of a second, slip by even more quickly and are not remembered again until the film is developed. Others, however, are not forgotten so quickly; the photographic image sticks in the memory and the positive result is recognized even before the negative is fully developed.

The tramp on these two pages (and on pages 70 and 71)) who was sitting at the side of a street in France, had attracted my attention from a distance. I had probably already aroused his curiosity too, since he seemed to want to share his meal with me. Hand signals of protestation from me eventually showed him that I was not hungry but that I did very much want to "capture" everything about him — stick and stone, bag and baggage — with my camera. Showing no surprise, and without stopping what he was doing at all, he nodded his thanks when I cheerily wished him enjoyment of his meal and he proffered me his bottle of red wine. But I was not thirsty either and he was left to down his wine alone while I changed a lens. The moment was timed precisely for when his long, satisfying swig was at an end and the bottle came to rest upright — in the perfect position for the picture. My viewfinder was already aligned. It was a fleeting moment — and the fact that the photograph tends to be static rather than dynamic in character is due to the composure of the live performer. His pleasant expression never changed and the sight of the bottle of red wine only made it more intense.

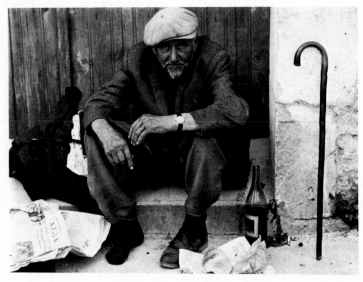

Left: Black-and-white variant of the full-figure colour photograph on page 70, for direct comparison with the close-up opposite.

Right: Colours can be shown to advantage in indirect light; both the brightest highlights and the darkest parts show their shades of colour.

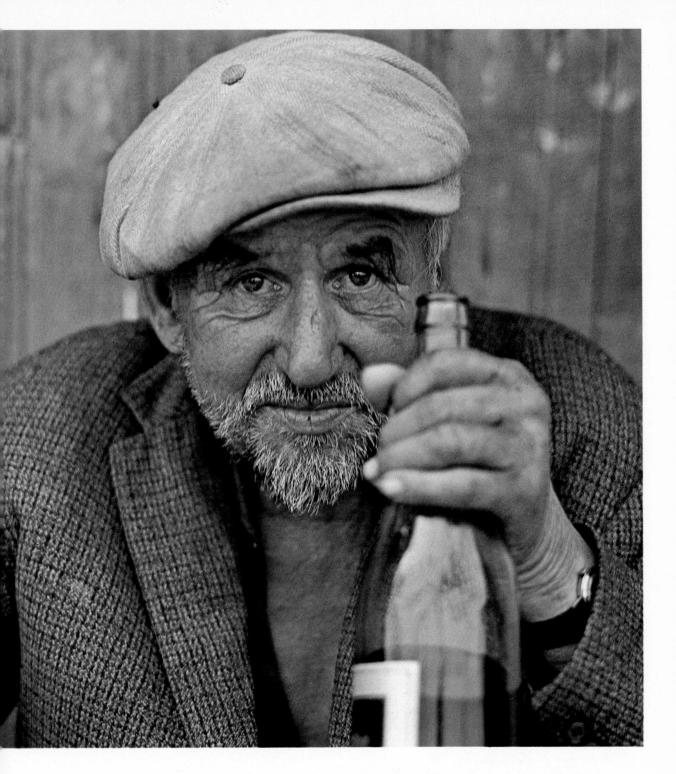

150 mm lens on 6×6 cm: 50 ASA colour transparency film: 1/125th at f/4.

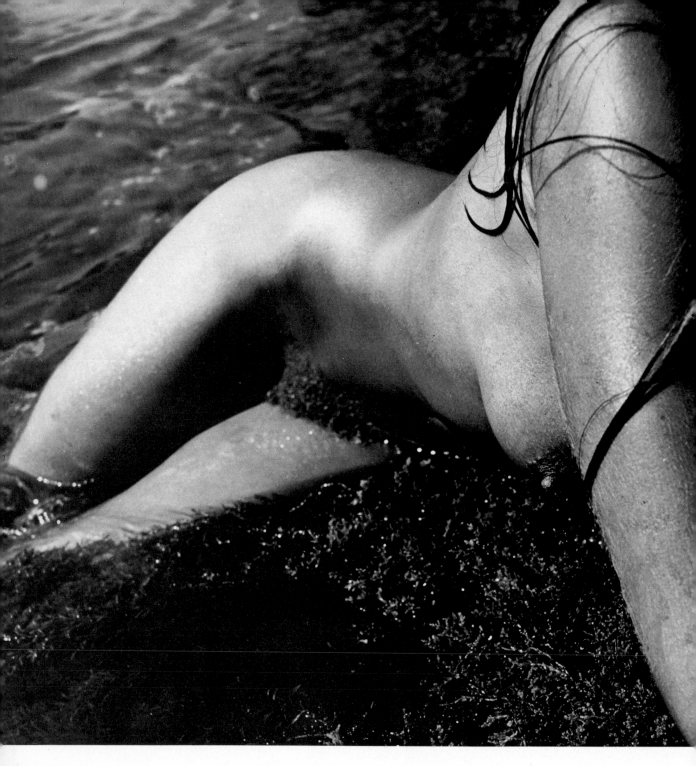

Wide-angle lenses intensify spatial effect: in the foreground the proportions are enlarged while in the background they are reduced.
50 mm lens on 6×6 cm: 100 ASA film: 1/250th at f/8.
Apertura: f/8 at 1/250. Film speed: 21 DIN.

28

Interchangeable lenses

Lenses are changed to facilitate composition. The purpose is to obtain a larger or smaller-image scale without having to alter the camera viewpoint. Different focal lengths also intensify or attenuate the effect of perspective, enlarge or reduce the image and provide the desired depth of field; they produce converging or parallel vertical lines or effects which are not obtained with normal vision and with normal or standard lenses. If the same subject is photographed using different focal lengths from one and the same viewpoint, it is not the perspective of the photograph which is changed, but the extent of image included. It is at its largest with wide-angle lenses, and far more of the subject is reproduced with a wide-angle lens than with a telephoto lens from the same viewpoint.

The most *wide-angle lens* — the "Fisheye" lens — has an angle of view of 180° and therefore has maximum image capacity. However, the inevitable distortions produced with the fisheye are not suitable for objective representations of people. Super wide-angle lenses also have a large angle of view and a very distorting effect. They alter the proportions when used to photograph people; limbs in the foreground are greatly enlarged while those in the background are unnaturally small. Such peculiarities may at best be considered rather amusing jokes. Even when moderately wide-angle lenses are used, human proportions are distorted and perspectives intensified. This can be desirable for some compositional ideas (pages 28, 47). The shorter the distance between camera and subject, the greater the wide-angle effect and perspective distortion.

Standard lenses fall within the next focal length category. The image which they reproduce is said to correspond roughly with the viewing angle of our eyes in respect of both depth of focus and the projection of perspectives. (pages 23, 44, 125). In this instance *"standard"* is relative — as in all things. The effect of a moderate wide-angle lens seems normal to

some (pages 38, 78) whilst that of a telephoto lens seems normal to others (page 82). The technical requirement of a standard lens is that the focal length must approximately equal to the diagonal of the negative format. The fact that the standard lens is the one used most frequently is explained by the compromise that this lens provides — "the golden mean" is often the best. With this lens both wide-angle and telephoto effects can be achieved by varying the camera viewpoint and enlarging only a part of the negative. (page 55: moderate wide-angle effect; page 153: telephoto effect).

The advantage of the *telephoto lens* — the third lens category — is that the subject can be made to fill the negative without reducing the subject-camera distance. This is sometimes necessary if the subject is at a height but a large image scale is required (page 21) or if important time would be lost in reducing the distance, resulting in the loss of the ideal moment for a photograph (page 93). A typical telephoto effect results from the reduction of perspective whereby the image planes at a distance from the subject — in both directions — appear to be brought together or bunched up. Extreme telephoto lenses thus give the impression that the distance between the subject and his surroundings — foreground and background — is negligible, whereas in reality it may be considerable. The subject looks flat (pages 96, 108). In addition, depth of focus is very limited. Image planes which lie only a little behind or in front of the main subject are noticeably blurred. However, this loss can be counted as a gain when material of no importance to the subject is pushed into the blurred areas while matter important to the subject is made to stand out all the more sharply and brightly (page 89). Image planes which merge in this way are a special advantage in colour photography and, sometimes, in graphically important black-and-white photographs. Since colours and graphic effects are all the more intense, they flatter the composition (pages 31, 105, 109).

In photography the telephoto lens gives the illusion of closeness to the subject. In *direct* close-ups and detail photographs, the distance between lens and subject is reduced in effect to a few centimetres. This will be discussed in the next section.

Telephoto lenses are not only ideal for distant subjects; they are useful for close-ups. Even when extension rings or ancillary lenses are used, the distance between camera and subject is still sufficient to allow adequate space for lighting. 6×6 cm.

150 mm lens with 21 mm extension ring on 6×6 cm: 50 ASA daylight type colour transparency: 1/30th at f/4.

500 W bulb as overhead lighting, side brightened with a white reflector board. The red effect is explained in the section entitled "Foreground".

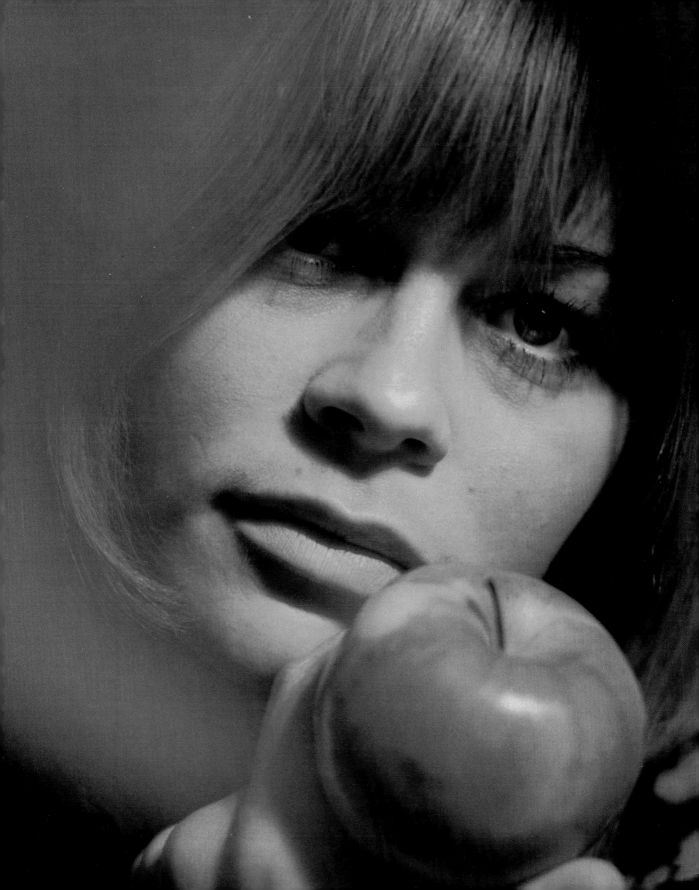

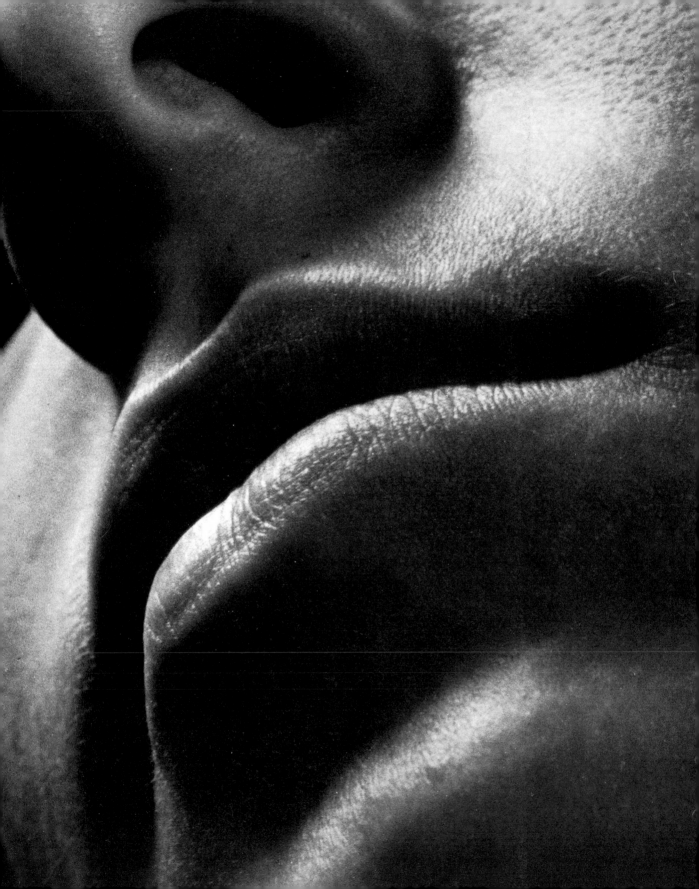

Close-ups and detail photographs (cropping and trimming)

Ever since people were first depicted in the fine arts — and particularly in portraiture — it has been customary to trim the image or subject when painting or drawing head, head and shoulders or three-quarter length portraits. Anything superfluous in the subject and his surroundings or anything which diverts attention from the essential area is simply omitted. Consequently, the reproduced part is all the more forceful. As Max Liebermann says, "omissions have to be made in drawing". In photography, also, less can mean more (see drawing on page 36).

Impressionist paintings, whether portraits or landscapes, are good material for the study of close cropping and strongly accentuated detail; the same is true of Asiatic interpretations of composition, their influence is evident in the work of the Impressionists. In both cases, the intention was to make the subject have as much impact as possible on the observer.

Photography has obviously long since adopted the same methods of composition because they are convincing. However, it has carried the emphasis on subject trimming and the consequent concentration on the chosen detail even further — to the extreme. The advantage lies in the possibility of opening up new image territory in close-ups and detail photographs. Large pictures of the eyes, pores (pages 32, 88) or even the smallest cell particles, cannot be shown so convincingly and suggestively with oil paints or a drawing pencil as with the camera. In the close-up range, significant detail effects are obtained automatically and are characterized by drastic subject trimming, sometimes on all four sides.

For this reason it is interesting to open the discussion of cropped or trimmed compositions by considering close-ups and detail photographs. For instance, either the camera is so equipped that the close-up range can be made accessible with a standard lens or it has to be fitted with extension rings, supplementary lenses, converters or bellows. (To prevent the subject-camera distance from becoming *too* small, a longer focal length is advisable. In this way shadows which might possibly be cast by the camera on to the subject are also avoided.) A single-lens-reflex camera is ideal for close-ups and detail photography since the subject

In the close-up range significant effects are obtained quite automatically, and result from substantial trimming — sometimes on all four sides. 150 mm lens plus 55 mm extension ring on 6×6 cm. 100 ASA film: 1/8th at f/5.6.
500 W halogen lamp as indirect brightening light.

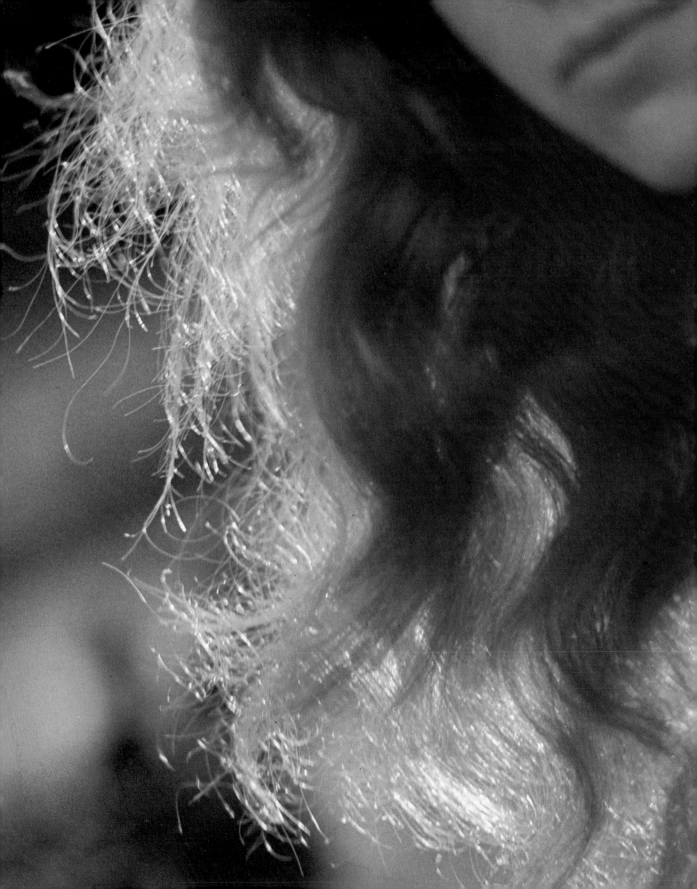

can be seen *directly* in the viewfinder, together with all its sharply-defined and out of focus areas.

Focus control is more difficult with the short subject-camera distance used for close-ups since the depth of field *de*creases as the image scale *in*creases. The subject or camera has only to move a few millimetres out of the focusing plane for definite blurring to become noticeable. It is therefore advisable to fix the camera to a tripod and to photograph the subject in static poses. Even a slight change of position alters the subject area covered (page 32). There must also be no movement of subject or camera since small apertures (depth of focus) and correspondingly longer exposure times are employed.

A portrait taken as a full-length photograph and then cropped to show only the head, has the appearance of a close-up photograph (page 119). Photographically speaking, however, this term is correct only when part of the head, not the whole head is shown. In close-up photography, at least one side of the head is omitted and even two, three or all four sides of it may be omitted (pages 14, 31, 34, 97).

Parts of the head could, of course, be enlarged from the negative of a full.figure photograph but technically better results are obtained by choosing the detail of interest when taking the photograph. The entire negative is then available for enlargement, instead of only a fraction of it. The advantage or utilizing the full negative format is even greater in the case of colour transparencies (page 120).

Even without having seen the negative, it is possible to tell from a photograph whether it was composed at the time it was taken or whether it was edited in the darkroom in an attempt to retrieve something of the lost composition by the enlargement of detail.

It is always better to arrange the picture as nearly as possible in its final form on the negative (page 122).

This ideal cannot always be fully realized. For instance, if the camera takes square photographs and a horizontal or vertical oblong photograph is required, allowance must be made for trimming from the outset (pages 28, 109, 126). The same applies equally to cameras taking oblong photographs (miniature cameras, for instance) when square photographs are required.

Photocaption — see page 36.

35

Also, with snapshots there will sometimes be insufficient time to reduce the subject-camera distance to a minimum. In situations requiring speed, it is often necessary to tolerate superfluous surroundings which can be eliminated later by (detail) enlargement.

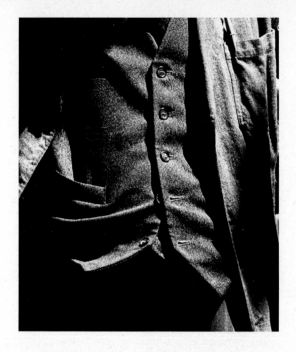

Above: A detail from the photograph on page 121 does not show the best solution. If the subject detail is considered important, it should be photographed using the whole negative.

Drawing: If desired, a subject can also be fitted closely in the viewfinder (see also the photograph on page 97).

Photograph on page 35: Lighting is used to give rich contrasts in close-ups and detail photographs. This study of hair was taken against the light in the late afternoon sun.
150 mm lens plus 21 mm extension ring on 6×6 cm. 50 ASA colour transparency film: 1/125th at f/4.

2

Light

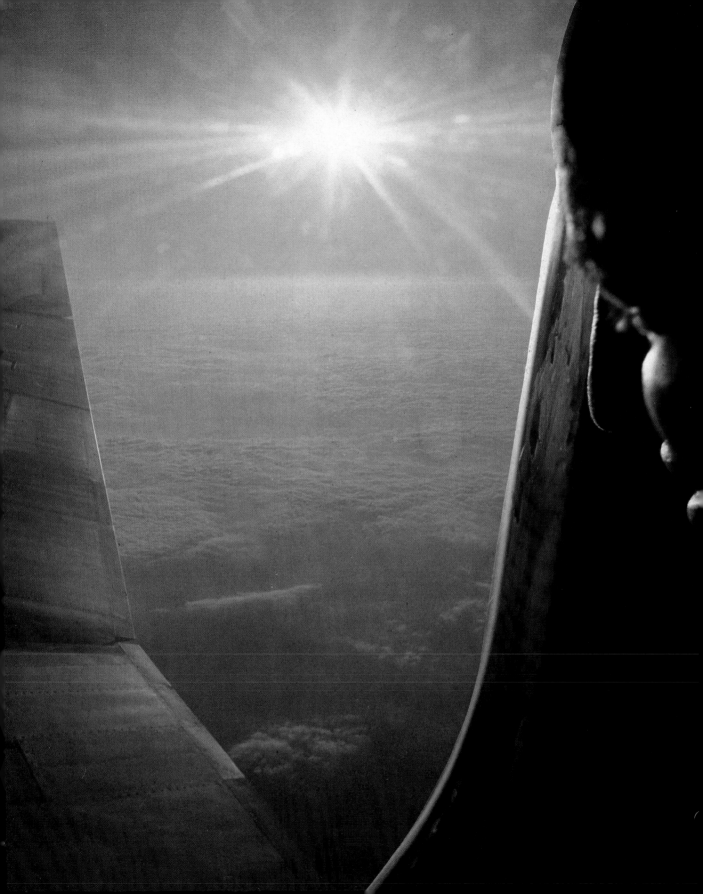

Light impressions

Light is even more important in photography than in painting. For the photographer, light is the final but also the most splendid, creative medium (pp 83, 87, 142).

The force of natural light is seen at its most impressive from an aeroplane above the clouds (page 38). A view over the sea remains in the memory not just because of the immense vastness of water but also because of the flood of light it brings. The unforgettable picture of wide, distant country — whether desert or mountains — is always fixed in the mind because of its lighting.

Sometimes it is scant light which arouses our attention: light falling through dense foliage (page 42) or through a doorway (page 53); the reflections in a street wet with rain (pages 51, 55), or the early dawn in a room when the curtains are still closed but outside the morning sun is already shining and the darkened room is still lit dimly as in a dream (page 130); or the thundery darkness over the countryside when it is suddenly split by lightning; the impressive spectacle of light when the storm passes over and every shade of light from grey to blue is seen in the sky in quick succession; and then finally the fascinating blends of warm and cold light when, in the twilight of the evening, natural and artificial light struggle for ascendancy (page 139).

Artificial light alone, with no contribution from natural light, looks quite different: the pale circle of light from a street lamp; the blue glow of a kerosene lamp, the cone of light from a spotlight (pages 11, 127), the stray light from an electric bulb (page 59), the neon advertisement lights of a city street (page 50); also the blue, red, green, violet and other coloured illuminations (page 31) used to floodlight stalactite caverns, pyramids, the Yellowstone National Park, the Eiffel Tower and other spectacles whenever natural light is inadequate and ordinary artificial light is too drab; and not least the artificial light in the photographer's studio: halogen lamps, photographic lamps, flashbulbs and filament bulbs (pages 41, 47, 56).

In Egypt's Valley of the Kings, opposite Luxor to the west, an extreme change from natural to artificial light is experienced on descending out of the glaring midday sun into the cool, dim tombs. The change is even more striking on returning from the kingdom of the dead into the dazzling light of day. This experience of the sun's boundless profusion contrasting with the limited usefulness of artificial light leaves a strong impression (page 108).

'Before sunset'. Photographed from the aircraft cabin.
50 mm lens on 6×6 cm. 50 ASA colour transparency film: 1/500th at f/16.

Direction
of light falling
on the subject

A distinction must first be made between *direct* and *indirect* light. The latter is uniformly scattered light, apparently directionless and which produces little or barely noticeable shadow, such as when the sky is overcast or light is reflected from the subject's surroundings (pages 13, 125). *Direct* light, on the other hand, falls straight on the subject and the direction from which it comes is obvious (pages 34, 83, 141). *Frontal lighting* shines onto the subject from the direction of the camera. When there is no clear indication that the lighting comes from the side, top, below or behind, frontal lighting can be assumed (pages 67, 145, 147). The source of light can be higher or lower than the camera, in front or behind or slightly to the side of it (page 97). Frontal lighting produces photographs with little or no shadow since it is chiefly the illuminated side which is photographed. This is why flash mounted on the camera produces pictures which look flat and without relief.

Side lighting, like frontal lighting, is variable. Only a very few photographs have the light falling exactly from the side — at an angle of 90° — onto the subject. The effect of side lighting is always such that both the illuminated side and the dark side are visible from the camera viewpoint (pages 7, 14, 56, 148). If the lighting unit is more than 100° away from the camera viewpoint it provides lighting obliquely towards the camera and creates a rim of light round the subject (pages 44, 47, 141).

Lighting from behind (backlighting) occurs when the camera is opposite the source of light and the subject is between the two (pages 34, 48, 134). The shaded side is facing the camera and the back of the subject is illuminated. Standing out darkly against the illuminated background as it does, the subject is sometimes seen as a silhouette (pages 99, 155, 186).

Top lighting illuminates the subject from above (pages 87, 140, 164). When a person stands under a roof-light or under the midday sun, the top of his head, the bridge of his nose and his shoulders are lit. The term "top lighting" is also used when light falls on the forehead and cheekbones, but the shadow cast by the protrusion of the forehead covers the eye area, the shadow of the nose reaches down to the top lip and the chin and neck are dark (page 77).

Lighting from below is seldom natural. It may happen when a person stands on a high mountain at sunset or stands on his head when the sun is at its zenith. The light would then shine on the bottom jaw-bone and into the nostrils, illuminate the eye sockets and shade the bottom lip, cheeks, forehead and top of the head. This effect is achieved more easily with artificial light with the lighting unit on the ground or vertically below the subject. The effect is theatrical and makes people look strange. We are certainly not used to seeing it in nature. Lighting from below is sometimes used as a fill-in. In such cases it is not the main source of light (pages 142, 148).

The direction of the 1000 w halogen lamp lighting can be clearly seen as lighting from behind (circle of light top left). A 500 w light bulb provides additional side lighting from the right. The shaded areas were lit by reflected light alone.
80 mm lens on 6×6 cm: 50 ASA Colour transparency film daylight type: 1/60th at f/2.8

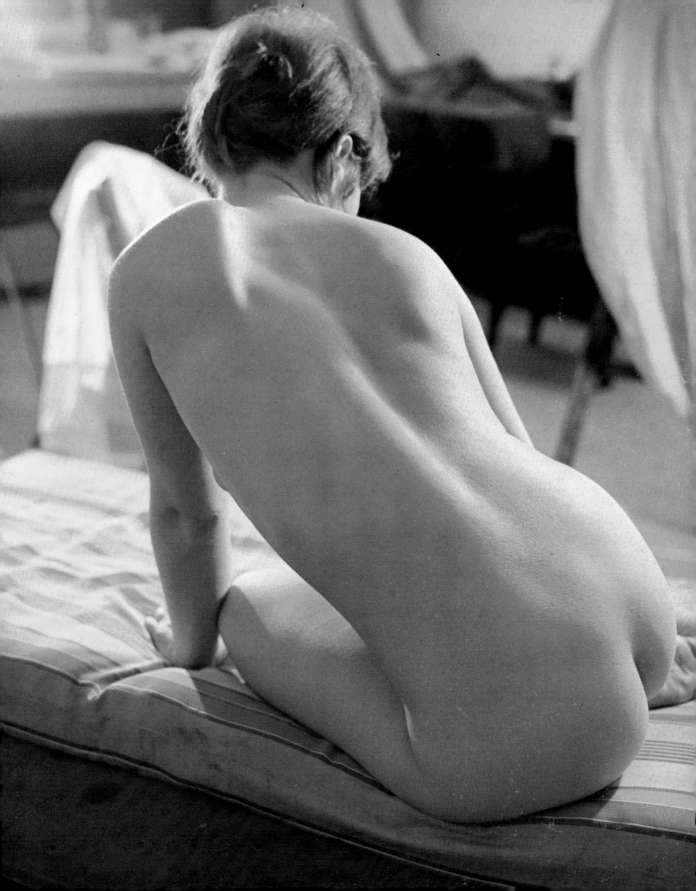

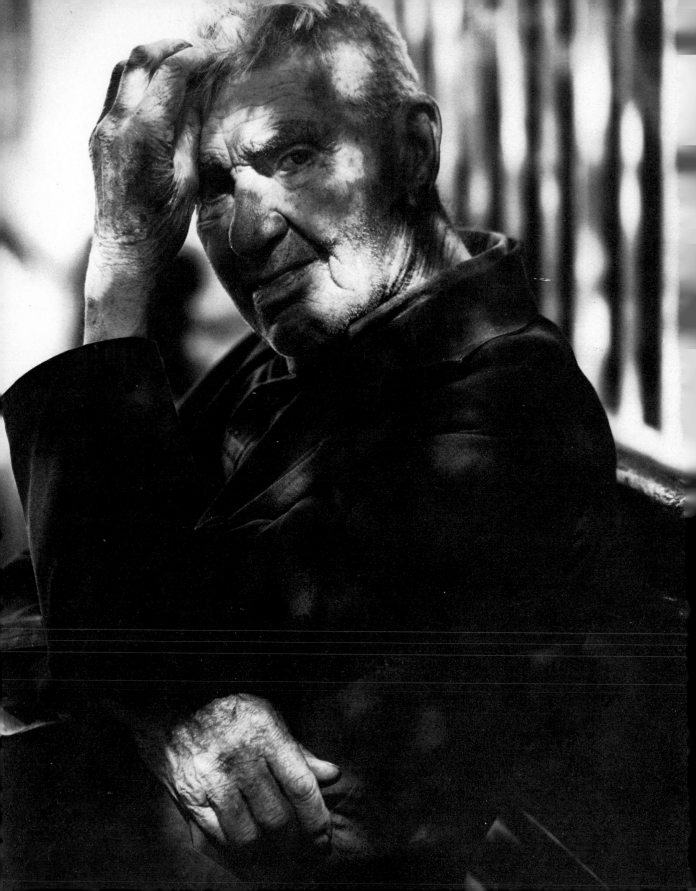

Daylight, artificial and mixed lighting

Light is reflected or absorbed by the objects which it illuminates, and shines through them or is broken up by them. Without objects, light would make little or no impression and it would appear merely as varying degrees of brightness. The atmosphere — air and clouds — also offer resistance to light; sunlight is reflected or absorbed by it. Depending on how clear or hazy the atmosphere, the light reaching the subject to be photographed is either hard or soft, direct or indirect, bright or difusse. The cold and warm-coloured properties of light are also influenced by various forms of resistance. The colour *temperature* of light is important only in colour photography, of course and it does no show in black and white photographs. What does it mean?

We sense the difference between *warm* light and *cold* light. In the case of natural light, it can be explained by the position of the sun. Red light — in other words, warm light — is predominant early and late in the day (pages 34, 153); in the morning and in the afternoon the light is cooler (pages 93, 125) and it is colder still at noon because blue is then predominant (page 82). In the case of artificial light, light bulbs, candles and fire light count as warm sources of light because they contain a large proportion of red (pages 96, 97, 138); photographic lamps, halogen and neon lights are colder (page 56). Electronic flash and blue flash bulbs are equivalent to cold daylight. The colour temperature of light is measured in degrees Kelvin (K). The higher the colour temperature, the richer the light is in blue or violet rays; the lower the colour temperature, the richer it is in yellow and red rays.

Light *intensity* influences light contrast. The weaker the light, the softer the modelling of the subject (pages 13, 154, 171); the more intense and direct the light, the harder the grading of tones (pages 7, 16, 110, 164).

In *daylight* the various effects of light can be observed more directly than in artificial or mixed light. In any event, artificial lighting practice can draw many lessons from nature. A few photographs will illustrate this point. The bright, impressionistic flecks of light in the study illuminated by natural light on page 42 were produced by the direct sunlight being screened off to a large extent by the leaves of a tree. The

Light takes shape on objects which it illuminates, through which it shines and by which it is reflected. The play of light on the face and hands of this peasant from the south of France is explained by the fact that the direct sunlight was screened off in parts by the branches of a tree.
150 mm lens on 6×6 cm. 100 ASA fil: 1/125th at f/4.

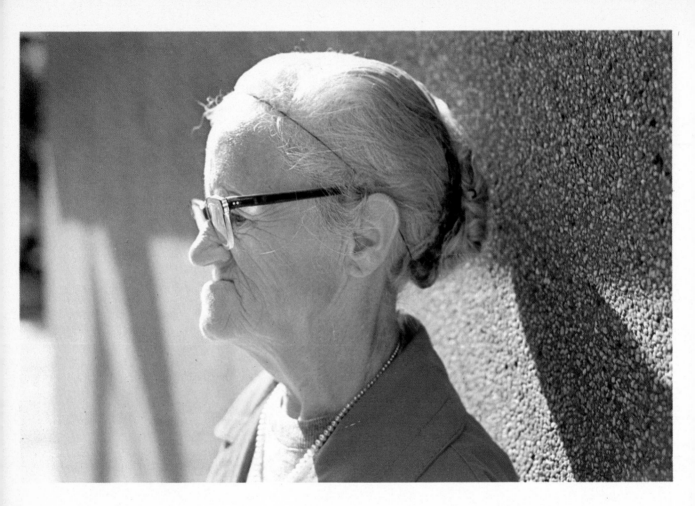

sunlight reached only the head and hands —
quite small areas in relation to the whole. Yet it is
this scant play of light which made this photo-
graph attractive.

The photograph on page 45 was taken in soft
light against the sun one autumn afternoon. The
areas in shadow were brightened slightly by my
white shirt from which light was reflected back
to the face.

The oblique lighting in the photograph on page
44 produced a strong contrast of light and
shade. The side of the old woman's face turned
towards the camera was really much darker. It
was made lighter, not by using reflected light or
flash, but by overexposing roughly one stop. A
transparent and ethereal effect was thus
imparted to the whole character of the colours,
including the lightest areas.

*Nature is a great teacher where lighting is
concerned. Many lessons can be drawn from her for
artificial lighting.*

*Above: Oblique lighting, general brightening by
overexposing by one stop.*
*50 mm lens on 35 mm: 50 ASA colour transparency
film: 1/125th at f/4.*

*Right: Backlighting from the late afternoon sun. The
atmosphere is brought to life by the contrast
between soft light and deep shadow.*
*150 mm lens on 6×6 cm. 64 ASA colour
transparency film: 1/125th at f/4.*

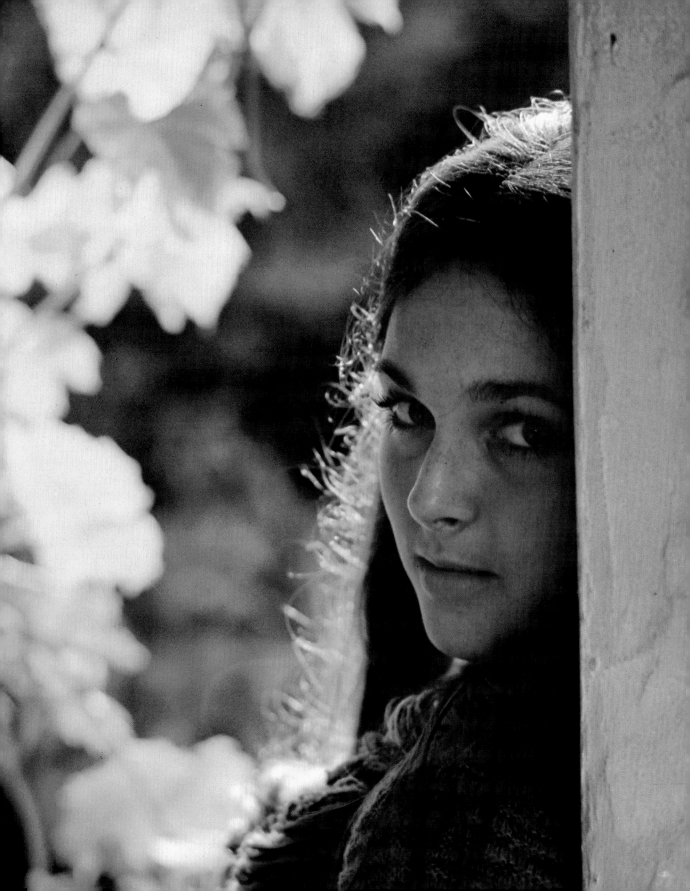

The photograph on page 87 shows even stronger contrast of light and shade. It is important that shadows show differences of shading. The fact that the brightest part — the girl's cheek — is almost colourless may be considered justifiable in this instance. This patch of light could not be bright enough since its purpose was to form a suggestive contrast with its surroundings.

The "Girl with Horse" (page 125) shows natural light of a completely different sort. In the previous photograph the light shone directly on to the subject like the beam from a spotlight but here indirect backlighting brightens the scene with a diffuse light. The fact that the subject's face turned towards the camera is so clear, despite the backlighting, is due to the subdued and hazy atmosphere.

Photographs can be taken just as freely from any angle with *artificial light* as with natural light. Inspiration is often drawn from an unintended lighting effect. For example, the photographic lamps or other sources of lighting are arranged in relation to the subject to produce an effect which corresponds to some mental picture. The photograph is taken and it is not until afterwards that the photographer realizes that the light is far more photogenic from quite a different angle of view, although nothing is changed as far as the lighting equipment and the model are concerned. A side light may have produced backlighting or a frontal light, top lighting.

In the photograph of the seated nude model on the opposite page (page 47), the illumination provided by the lighting arrangement was not interesting from all sides. The face was very faintly lit because a 1000 W halogen spotlight was pointing directly on to the model as side top lighting. From the angle photographed, however, the isolated light contours the averted head, the shoulders, the breast and the legs and this has produced striking contrast with the extensive grey tones of the subject; in fact they emplasize primarily the three-dimensional position of the body in space.

Three lamps — two 500 W and one 250 W — were needed for the photograph on page 97. The two 500 *W* lamps were placed in front, with each lamp at an angle of roughly 30° from the camera viewpoint. The shadow on one side is darker than on the other because red transparent paper was hung in front of the lamp on the left to reduce the light intensity. (The red effect can be seen on the model's cheek and neck.) The weaker 250 W lamp merely lit up the out of focus foreground of creased transparent paper which, with side floodlighting, produced attractive highlights.

Flash is a form of artificial light having the character of daylight. The light can be trained on the subject only in an uncontrolled way, of course, unless an adjustable lamp is used as a pilot.

The lighting can then be pre-arranged to give the subject illumination desired in the photograph. Here again a distinction is made between direct and indirect lighting and the second method is preferred to the first because better three-dimensional results can then be achieved. Flash can be used very satisfactorily to brighten up the dark areas of a subject without necessarily losing the overall impression of a photograph taken in daylight or artificial light. It is appropriate to point out here that all the photographs shown in this book were taken without flash, including those which were taken in very bad light conditions.

Artificial light colour transparency (type A) film is used when lighting with halogen, photographic or filament lamps (pages 56, 59). The exception confirms the rule, however, when photographs are taken in artificial light but on *daylight* film. In such photographs the colours tend towards warm yellow and red (pages 31, 41).

Mixed light is the combination of daylight and artificial light. Its use for black and white photographs presents no problems but in colour photography colour shifts must be expected. They can sometimes be attractive, however, so it is worthwhile mentioning them here.

A single light source can suffice to illuminate even a complex subject; in this photograph a 1000 W halogen lamp used as side top lighting.
50 mm lens on 6×6 cm: 400 ASA film: 1/125th at f/4.

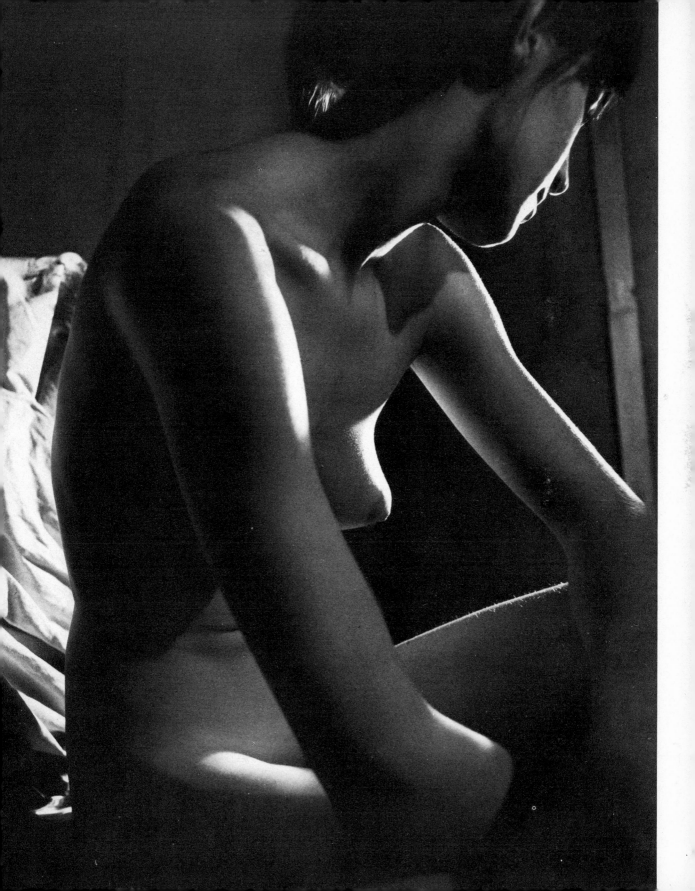

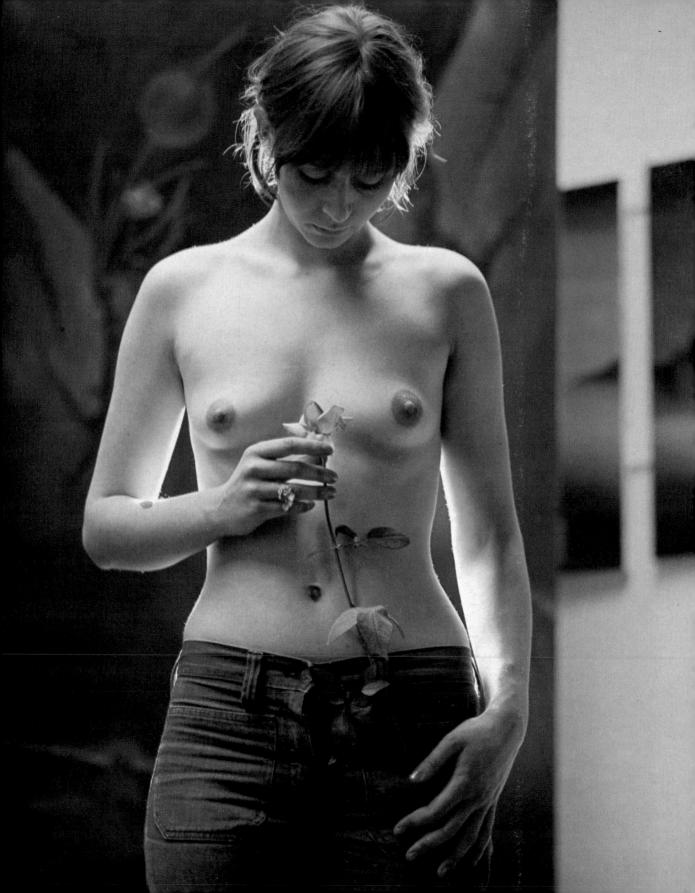

a. A lot of daylight and little artificial light: normal to warm colour character, depending on how much red or blue is in the daylight (page 63).
b. A little daylight and a lot of artificial light: very warm colour character, even with very cold daylight (pages 31, 96, 138 and cover).

Mixed light on artificial light colour reversal film (Type A)
a. A lot of daylight and little artificial light: very bluish tinge and therefore extremely cold-coloured.
b. A little daylight and a lot of artificial light: rather cool colour character, tending to blue-violet (page 48).

Red ochre, reddish orange, amber brown, sepia and sienna are dominating colours produced by mixed light using daylight colour reversal films, when the proportion of artificial light is very high and that of daylight low, as in the photograph on page 2, which was taken with light from a 500 w filament lamp and poor daylight. Side lighting was tried first but, after looking at the model from every side, the photograph was finally taken from the side giving most contrast. The simplest is sometimes the most obvious. On artificial light film, the same lighting would produce a bluish violet colour atmosphere as can be seen in the photograph on the opposite page (page 48).
The use of mixed light is a matter of taste. I am occasionally tempted to use mixed light for both practical and psychological reasons.
Sometimes, when artificial light is necessary, it is impossible to get rid of the daylight. The studio cannot be darkened and the photographer has to make do with a curtain which lets the light through. It is not always possible to shut out the daylight by placing tables, cupboards and other furniture in front of the window. It is simpler to put up with it and to accept it. If we are to get to like a thing, we must give it a try. There is also the possibility that the vague, indeterminate character of mixed light, its twilight atmosphere, may lead to lazy light

When an artificial light film is used, mixed light produces a cold-warm colour contrast. A 500 w filament lamp was placed behind the girl (backlighting) and additional daylight shone from the studio roof (top lighting)
80 mm lens on 6×6 cm: 50 ASA Colour transparency film: 1/30th at f/4.

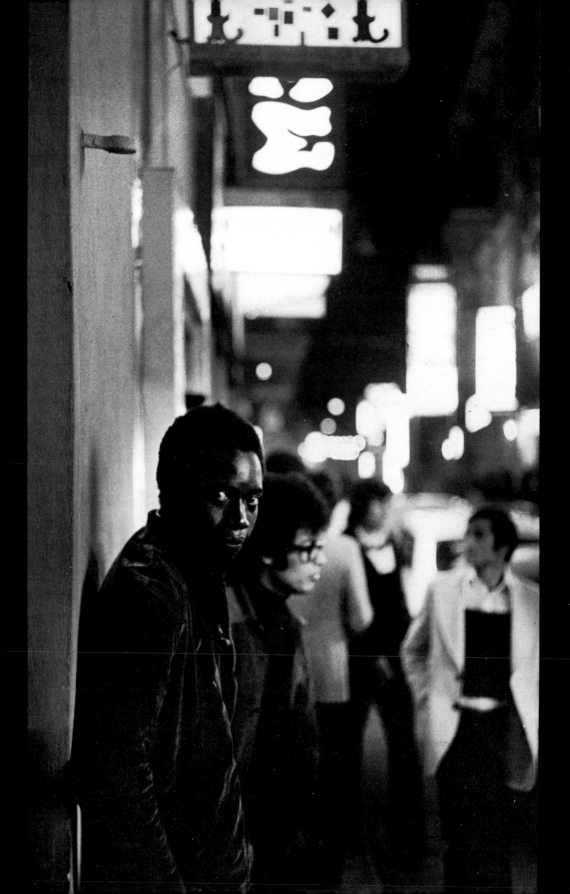

Poor light conditions

It is late in the evening, night time or the early hours of the morning is some large city and the photographer saunters along. The streets through which he passes, walking in a straight line along the gutter, are full of life. He sees only the kerb-stone on which he is walking; his tripod drags along the gutter behind him, its metal tips scraping noisily against the rough cobbles. The heavy metal has been a nuisance for some considerable time but it is too good to throw away. After all, it has been needed once so far, in front of the window of a junk shop in which dusty old rubbish — rusty skates, ragged furs full of holes, broken clocks, dented trumpets and a rotting crucifix beside a stuffed fox — tempted him to take a photograph. Now illuminated advertisements — red, blue, green, yellow — gaudy in every colour, dazzle the eyes. A negro with melancholy eyes looks into the camera and then pretends he has not seen it (page 50). Night-life pours out of the taverns in Athens, the pubs in Amsterdam, the bistros in Paris. The streets are full of laughter and shouts, music and car horns, an acoustic medley of very shrill and very muffled sounds. Men stand in front of the bar entrances, touting hot strip-tease and cold meat and, if you stop to listen, you are deliberately jostled, sometimes roughly and sometimes delicately, You look in the display cases where the recommended delicacies are proffered in words and pictures and you have a closer look at the naked and half-naked girls. Beside the case a hall leads to stairways going up and down; the open wooden door is rattled backwards and forwards by a member of the fair sex: the girl bends backwards and forwards as she looks first inside and then outside. The colour of her blonde hair looks even more artificial in the sinfully red light of the neon signs.

Above: Evening — or early hours of the morning — in some large city. Kerb-stones are more or less the same everywhere.
50 mm lens on 35 mm (moderate wide-angle effect because of the "worm's-eye view"): 800 ASA film: 1/60th at f/5.6.

Left: Plaka, the entertainments quarter of Athens. At midnight high-speed films — about 800 ASA — are used. With film exposure of up to 1000 ASA and development for a correspondingly longer period than that specified, even very dark subjects turn out satisfactorily.
50 mm lens on 35 mm hand-held: 1/30th at f/2.

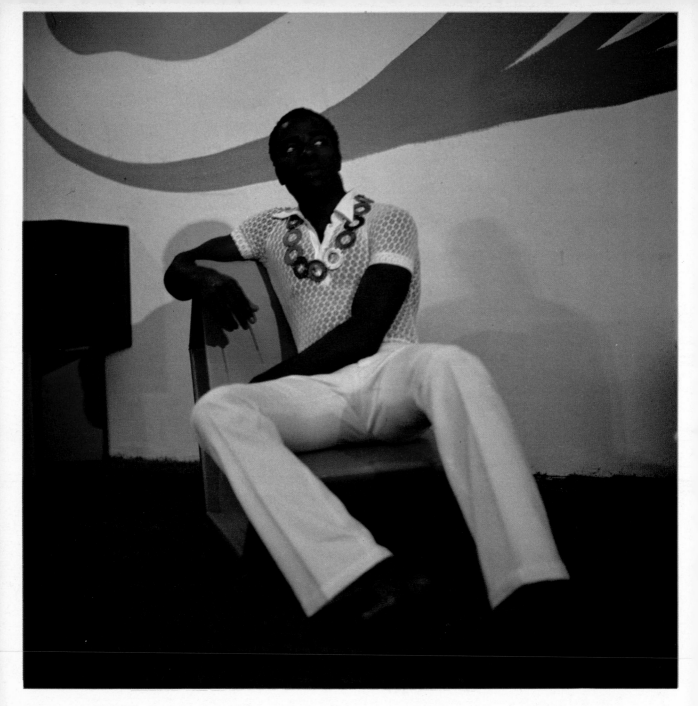

The light in discotheques is dim. If you decide to take a photograph without a tripod high-speed films must be used. Even so, long exposure times with the apertura wide open are necessary. To prevent camera shake, the camera was placed on the ground for the negro's photograph (right), I leaned firmly against a door-frame for support.

80 mm lens on 6×6 cm: 1/th at f/2.8.

Lens: 50 mm lens on 35 mm film: 1/8th at f/2

Both photographs were taken with 160 ASA colour transparency film uprated to as for 400 ASA and given prolonged development.

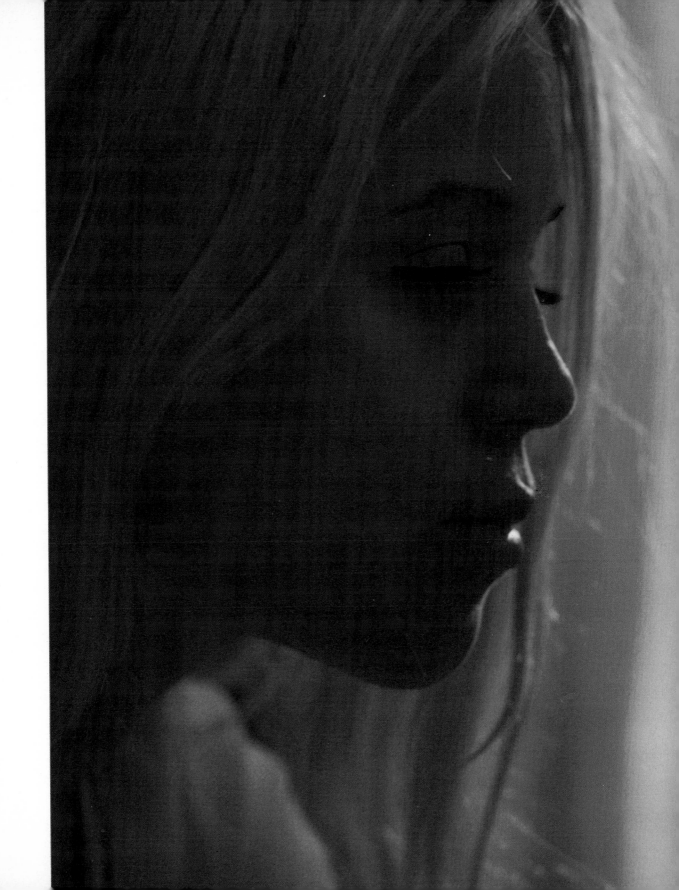

She is worth a colour film exposure (page 53). You wonder if it will turn out satisfactorily in these poor light conditions. Well, probably, and then somehow you are unwittingly drawn into the witch's kitchen. What you find inside are not so much moving subjects for photographs, as extremely still subjects squatting at the bar, leaning against a pillar or crouching on the ground; a negro in really dim twilight sits on a box as if nailed to it. Photographs with a *hand-held camera* are obviously out; it is far too dark. So you put your camera down on the ground and stretch yourself out behind it; now there should be no camera shake. The negro keeps as still as a statue; he looks as if he is painted on the wall, like the red pop-art in the background (page 52). Later you find yourself back in front of the door; everywhere is quiet, there is no noise to be heard and it is as hushed as in a church — quiet as the grave. You can hear yourself breathing and you look back and see the frantic activity of which you were just a part, as if from the outside looking in or vice versa. A municipal watering-cart drives along the gutter, wetting the asphalt and then the noise starts up again. Laughter from two figures approaching from the opposite direction sounds nearer, rises above the throb of the watering-cart, and is gone. The photographer raises his camera once again (page 55) and shortly afterwards he reaches his hotel, bed and sleep.

The technique of taking photographs in poor light conditions is as simple as a dream. Little can go wrong. Large apertures — the largest possible — are necessary. There is also little latitude with the shutter speeds, which are at the very limit to avoid camera shake, ie between 1/30 and 1/125 second. High-speed black and white films and colour films are just as easy to insert into the camera as slow or medium-speed films and high-speed colour transparency films can be exposed at twice or three times the rated ASA speed if given *special development*.

The above detail should show that the photograph opposite derives its effects largely from the vast area of foreground; the two figures alone are not very original.

Right: No fear of poor light! The light was adequate even during a night stroll through the streets of Amsterdam.
50 mm lens on 35 mm: 400 ASA film: 1/60th at f×2.

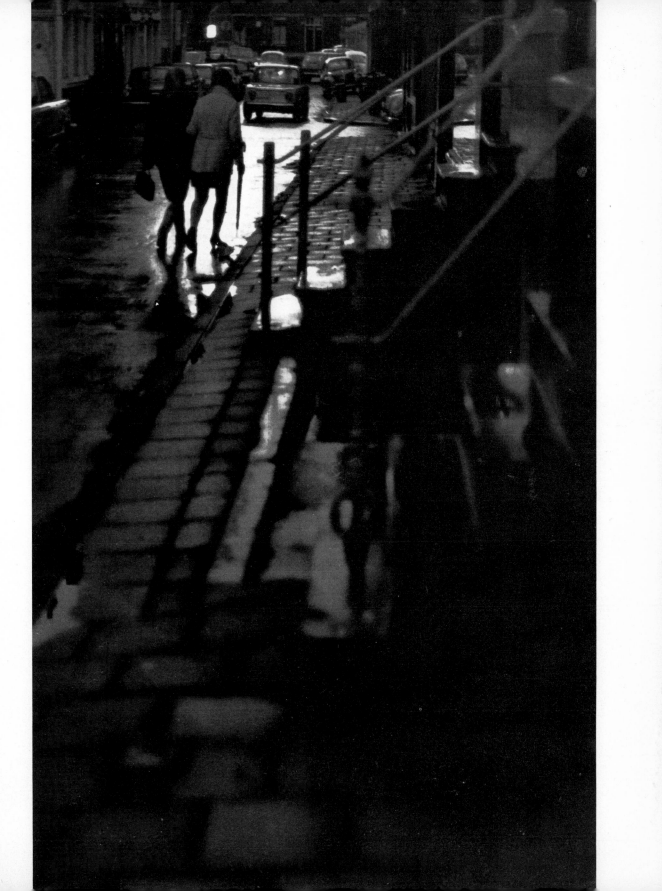

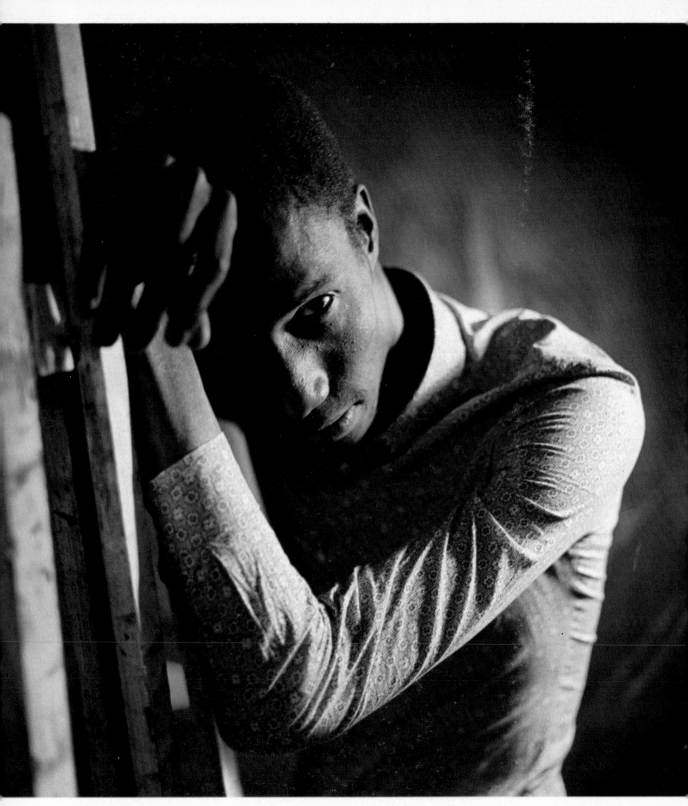

My coloured friends

When I remember our joint photographic adventures, at one time in Paris behind the scenes of a theatre (pages 20, 117) or, towards evening in the narrow streets of Arles (pages 146-148) and another time in Düsseldorf or Munich (page 60), I find myself wondering how we communicated. Was it almost entirely without words? We must surely have renounced the spoken word since I did not speak your language and you did not understand mine. Yet we missed out on nothing because of it; the sun was ours, the spring, the summer, and all the places where we lived for a while and enjoyed ourselves so much. Today you are far away, perhaps in Mombasa or Haiti, Cambodia, Togo, Martinique — Heaven knows where — and I am lying in a hotel room, stretched across two chairs pushed together with my feet on the bed and ready to tell of the pleasures we shared.

This is, after all, a good time to indulge in inspiring thoughts, remembering, for instance, Barbara Holmes, the black pearl from Central Africa (pages, 59, 99, 194, 195) who danced topless at the "Teenage Fair" in Düsseldorf to the rhythm of splendid, primaveral tom-toms. After the performance, seeking some respite from all the hustle and bustle round about, she and I — as if by mutual arrangement but, word of honour, quite by chance — had both made ourselves comfortable on a huge couch in the exhibition stand room of a sofa company, leaving the noise of the exhibition hall outside. There, inside, soft music dripped from the walls; the African girl, still quite hot from her last perfomance, refreshed her inner self with Coca-Cola and her outer self with perfume; meanwhile, I put a new film in the camera. In this atmosphere of pleasant idleness — in a greenish or violet light — we made friends and I thoroughly enjoyed myself taking photographs. The spotlights — roughly 500 *W* — were adjustable and movable so they could be used to give direct or indirect back, side and top lighting. After a while I asked my companion whether the light was too hot because it was reflecting quite fiercely from the wall in front of which she was patiently waiting. She then shook her large head sadly and whispered: "No, its much hotter in Africa".

Even so, after a good spell of Coca-Cola and small talk on the couch it was difficult to

Extreme lighting divides this subject into areas of contrast between brightness and darkness; its charm lies precisely in the highlighting of some areas. 80 mm lens on 6×6 cm. 50 ASA colour transparency film: 1/125th at f/2.8. Artificial light.

persuade the artiste to let me take more photographs.

She and I were both feeling tired. Catching her in front of a wall of aluminium foil which suited her glittering pink dress quite well was due solely to the fact that the prima donna had to pass by there on the way to her next performance.

But I will not dwell on my personal experiences, our sun-filled afternoons in the heat of French cities, artistic evenings of music and exotic rhythms; instead, I shall enlarge upon the cold, sober techniques of the art of photography. I have to explain which types of film I used to accentuate the characteristic, velvety blackness of your skin, especially how you should be shown as a subject of contrast, against the background which shows you to perfection. In short, I have to use your photographs as objects of technical experiments; yet I could have filled my time with them almost aimlessly and most pleasurably.

And now, to business. The lighting used for the colour photograph on page 59 was quite simple: a single filament lamp of approximately 250 W shone from roofing approximately 2.5 (9.8 ft) high. Its reflected light is quite clearly visible above the head and the arm on which the subject is leaning. There was also incident light from the front and the sides and the total brightness was thus sufficient for a photograph taken at 1/60 second with the aperture fully open and using 160 ASA reversal film. The lack of contrast from the light produced a photograph with good colour saturation and this is why I generally prefer to take colour photographs in light conditions which are too poor rather than too bright.

But there is no need to be dogmatic about it. The lighting conditions for the photograph of Mamou (page 56) were just the opposite of the above. Only one light source was used — a 1000 W halogen lamp — it produced strong contrasts of light because it shone directly on to the subject from a distance of four metres (13 ft aprox). The parts in shadow still show up quite well because the surrounding walls of the room partially reflected back the light from the spot lamp. The photograph was taken from a tripod at 1/125th with an aperture of f/2.8 on 50 ASA reversal film for artificial light. This exposure time does not really justify use of the tripod but in many respects — let us say of a psychological nature — working from a tripod helps me to concentrate better than using a hand-held camera.

Truth to tell, when taking the photographs, I was not in a mood to worry unduly over such matters. My entire concern or, rather, my entire pleasure was to be allowed to forget all technical problems completely in order to give myself up, utterly, to the person standing in front of my camera. And because the people who served as models for the photographs shown here were coloured people and not white, the need to understand them intuitively and not to analyse them intellectualy was far more important than when photographing representatives of my own race.

It is a unique pleasure to spend a day or an hour, or even only half-an-hour, in close proximity with a coloured person in whose presence many of our customary and valued ideas are called into question. Sometimes they are invalidated completely and, with luck, are exchanged for a world of new ideas free from bias and self-consciousness. This new land is not reached with technical knowledge alone — the weapon of risk-free certainty; the experience is a gift of nature.

☐

Dance artiste during an interval between performances. Indirect spot lighting from the surroundings provided sufficient illumination; in addition a light bulb above the model's head gave direct, warm-coloured light (its reflection can be seen in the aluminium foil wall).
80 mm lens on 6×6 cm: 160 ASA colour transparency film: 1/60th at f/2.8. Artificial light.

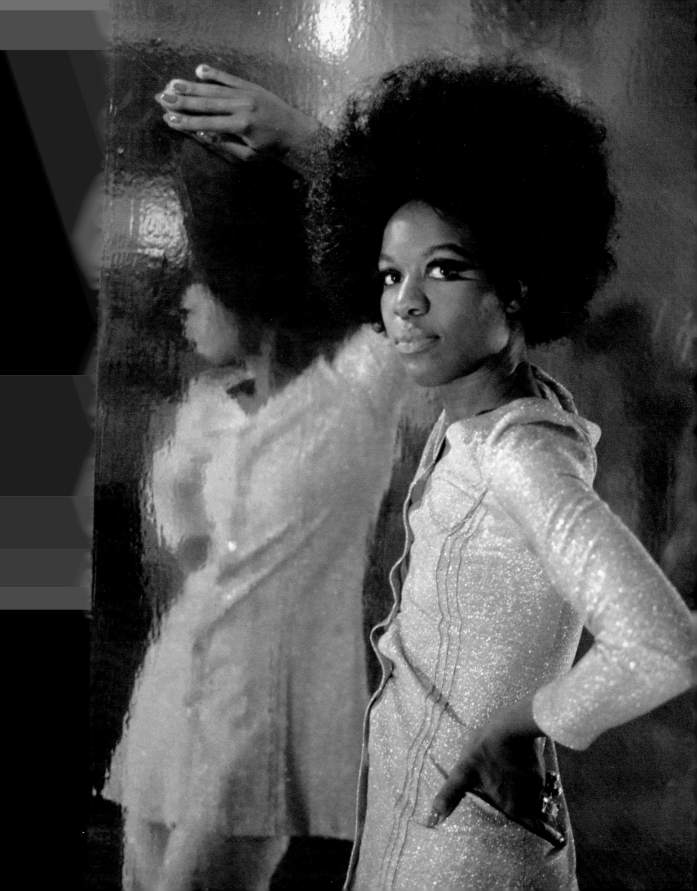

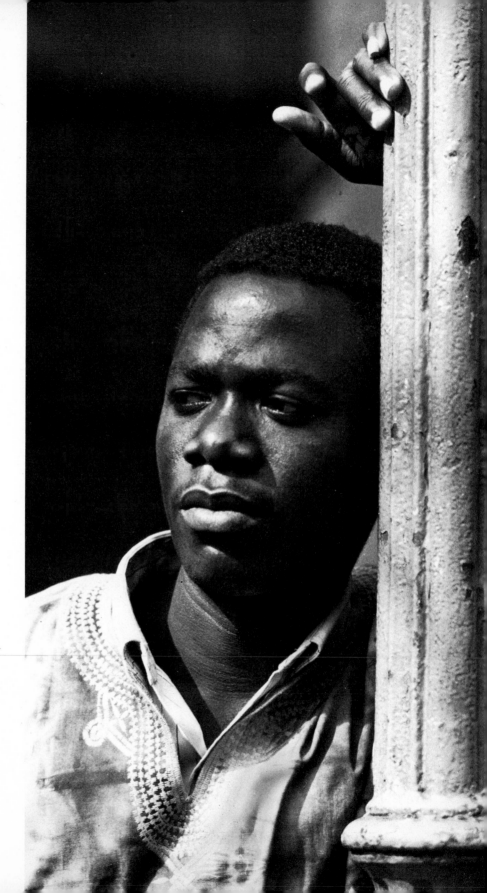

Moderate subject
contrasts give good
modelling. Within the
extreme tonal values of
white and black there is a
richly graduated scale of
grey tones.
150 mm lens on 6×6 cm:
40 ASA film: 1/500th at
f/4.

60

3

The subject's
surroundings

General surroundings

When photographing people the first requirement is the model, the second the light, and the third the surroundings. The last is not necessarily less important than the first, however. One frequent question is whether it is the model or a specifically photographic scene which incites the photographer to take a photograph. Quite often the answer is that it is the two together. It is important to photograph a subject as a whole, to see everything round about in relation to the model, since to compose means to put together. Landscapes, animals and plants are *natural* things which, when shown with people, can help to bring out their character (pages 85, 87, 125, 134, 141, 159).

Everything made by man is *artificial* - buildings, streets, furniture, every item of equipment from an egg-spoon to a jet aircraft. Here again, if they are considered as surroundings for the subject, then they must typify the person (pages 52, 59, 70, 82, 103). And of course natural and artificial objects can also be photographed together (pages 23, 38, 89, 133).

Surrounding objects can be regarded in various ways, being sometimes clearly recognizable as a table, chair, tree, water, flower, etc (pages 78, 117, 153) and at other times shown only as abstract colour tones or shades of black and white (pages 59, 96, 127, 186). In addition, countless variants can be used between the two extremes of recognizability and unrecognizability (pages 93, 154).

A different result is obtained by using decor materials in the following way. The entire contents of a room are *disarranged*, even turned topsyturvy to some extent, until ultimately no single item is left where it should be and everything looks completely out of place - yet for photographic purposes it provides a stimulating background. Alternatively, simulated chaos is created from paper and materials which can be crumpled, torn and crushed, then thrown about the room to produce, together with the model, *a new photographic arrangement* (page 63), On other occasions a surface painted to one's own liking serves as a background (pages 52, 67).

The result is a synthetic product like any other made by man's hand, but it is made with your *own* hands and not *another's*. Because of this small but important difference, a freely improvised decor is included in the list of natural and artificial items suggested for taking photographs.

A self-arranged decor — in this case packing paper, fabrics, the floor — stimulates not only the photographer's imagination but also the model's. 80 mm lens on 6×6 cm: 50 ASA colors transparency film: 1/60th at f/28. Daylight and a 500 W filament lamp as side-lighting

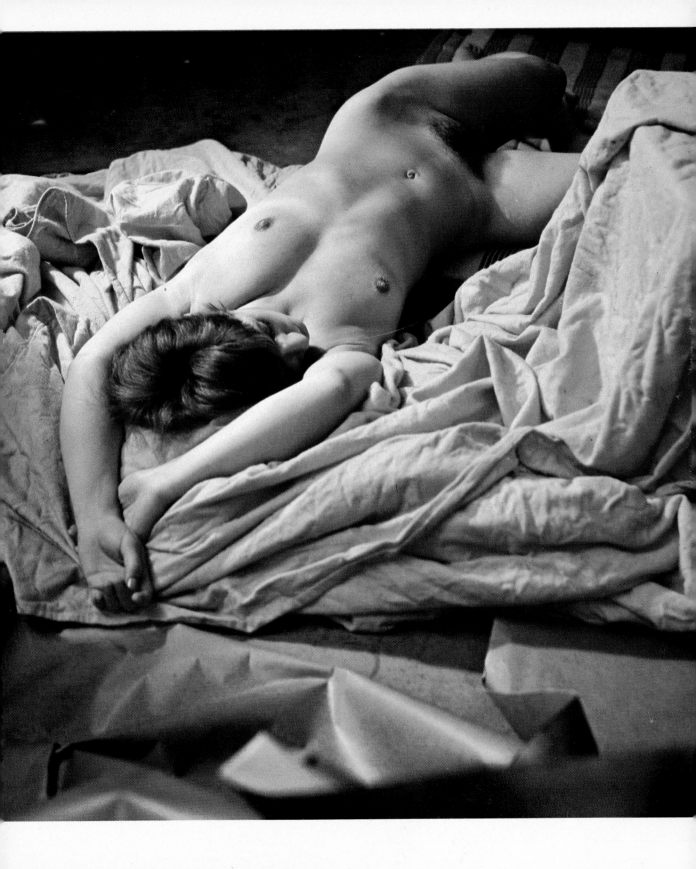

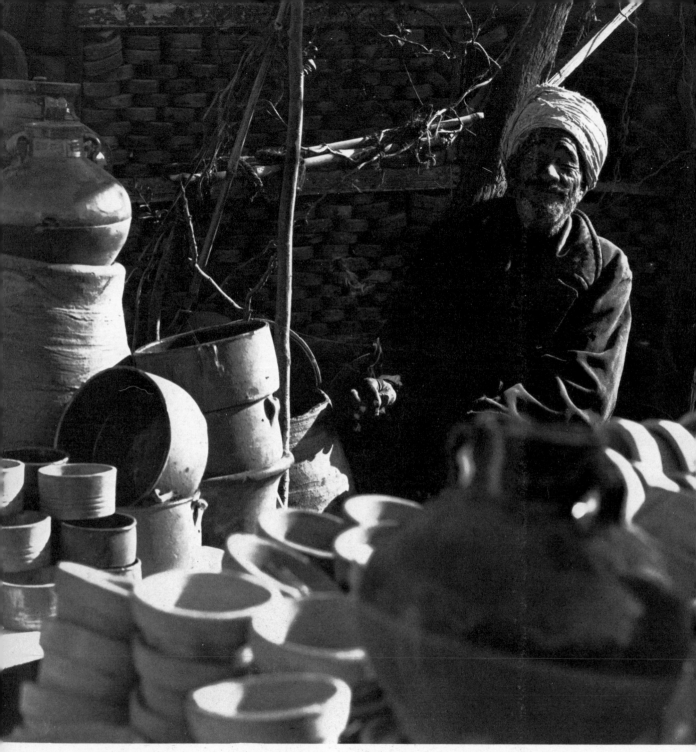

If the viewer is aware of the foreground, it can give a photograph an added impression of depth.

150 mm lens on 6×6 cm: 100 ASA film: 1/500th at f/5.6:
Direct sun as side-lighting.

Foreground

Most photographs have a visible background; it is absent only in detail photographs and close-ups (page 32). The foreground is shown less often even though it is frequently suitable for inclusion.

Many people will claim that a foreground is automatically present when the camera is pointed towards a subject - at a person in front of a boulevard café, for instance (page 198). But it is this person who is in the foreground and café chairs and the like are visible in the background. This is the usual situation but it can be different. So this time let us take a garden café (page 89). Here the main subject, the man, is moved into the middle ground and the furniture and other surroundings are banished into the foreground and background. The main subject is kept in sharp focus and the foreground is out of focus. Yet this very feature has its attraction because it produces a gradation of depth in space or colour - and sometimes both.

In the photograph opposite (page 64) it is the pots, basins and jars which provide a foreground and enrich the formal composition. They are also of importance to the subject since they show that the oriental gentleman is a potter.

In each of the photographs on pages 174 and 175 the foreground has a different significance. In the former it helps largely to create atmosphere rather than to characterize the subjects; it serves far more to set the background mood of a midnight discussion. In the second photograph, on the other hand, the plaster figure is not only a self-portrait of the artist; it is also photographically attractive as a graphic contrast of brightness against the darker background.

The foreground shapes in the photographs on pages 96 and 97 are to be regarded as abstract colour elements. The light reflections and lens shapes were produced by hanging transparent coloured paper and crumpled or smooth cloths on a string in front of the lens, and not in front of the light source as in the photograph on page 31. Some time was then spent in trying to find the best view and the most photogenic reflection, to ensure that the additional colour en-hanced the rest of the coloured scenery and did not look like unnecessary filling.

The foreground in the photograph on page 55 gives spatial perspective. This street scene is brought to life by extensive foreground haziness. But for the foreground, the two hurrying figures alone would scarcely have produced an effective picture in this situation (for comparison, see the detail of the figures on page 54). In this respect, reference may also be made to some later photographs in which the foreground is of importance to the composition because, through colour or shape, it imparts character to the main subject (pages 84, 93, 96, 103, 136, 153).

Detail from the photograph on page 174.

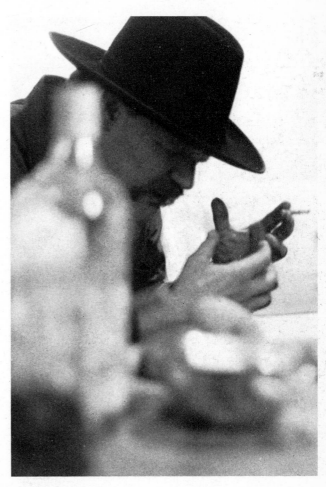

Background

A roll of white, black, grey or coloured paper, two to three metres wide (7-9 ft) and usually ten metres (33 ft approx) long, which is fastened to a wall below the ceiling and which can be rolled down to the floor, provides a simple abstract background (pages 25, 68, 185, 188). This gives a tone and colour which, for all its simplicity, can be of great value in photography - more so than an assorted, random mixture of light and shade or of colours made up of various surrounding objects. Of course, a roll-up paper background is not the only means of providing clarity of surface and space distribution. More complex and imaginative backgrounds made by the photographer as scenery or found in the street, the home or in nature can also be photographed as abstracts (pages 44, 92, 138, 193). The simplest natural example known to all is the sky which is infinitely variable as a colour scale or a scale of grey tones and which makes an excellent background (pages 38, 140, 186). If the horizon and land which go with it are also taken into consideration it is found that the surface area of the upper background element in relation to the lower has quite a decisive influence on the effect made by the foreground subject - a person standing, for instance. The drawings (on page 66) should clarify this point; one has no horizon, the second has the horizon in the middle and the third and fourth have the horizon in the upper and lower halves of the picture respectively.

Houses and streets provide artificial backgrounds which often give striking perspective lines (pages 16, 21, 50, 82, 121). Any interior space, from a telephone box to a sports arena, serves as background material for the photographer who wants to photograph his subjects in their own surroundings (pages 11, 139, 169).

The photograph on page 67 shows a decorative background I made myself. It is a canvas stretched on a frame and washed with water colours. Its colour and surface texture were designed to form a contrast with the reclining girl. It looks artistic in style (paint structure, brushwork), whereas the bold pattern of the subject's dress is graphic. Lettering would look very well on the yellowish red area - for a record sleeve, for instance. Other backgrounds are also possible, such as plain black or white, although representational by nature (pages 126-129);

Right: The artistic style of the strong-coloured background forms a contrast with the graphic pattern of the subject's dress.
80 mm lens on 6×6 cm. 160 ASA colour transparency film: 1/30th at f/5.6.
Daylight indoors

Below: The four drawings show the positions of the horizon:
a) no horizon; b) horizon in the middle; c) horizon in the top third; d) horizon in the bottom third.

a

b

c

d

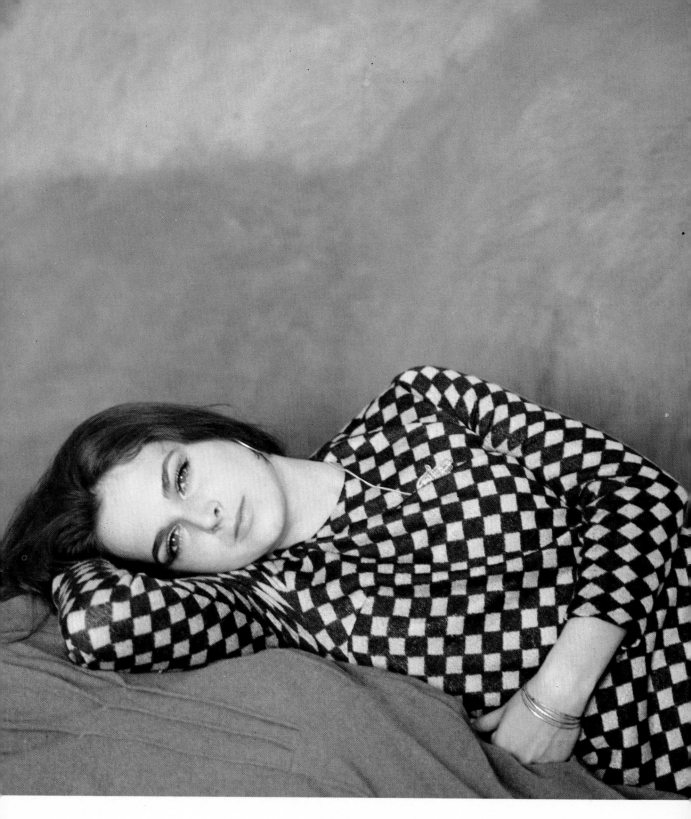

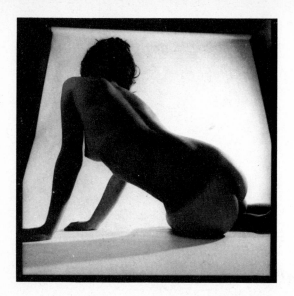

camera — also contributed to the angle of view. Fortunately, the lens was already on the camera, as there would have been no time to change it and the train pulled out seconds later.

☐

colour surfaces (pages 20, 105); colours which give atmosphere (pages 142, 153); random colours - shapeless blobs of colour (page 161); rhythmic arrangements (page 141) and rectilinear arrangements (page 146).

In the black and white photograph on page 69, opposite, the background is obviously important to the main subject. (The French painter Cézanne said: "The background is the most difficult.") What would the couple be without the railway station atmosphere and the train standing in the background? An ordinary everyday occurrence hardly worth photographing? Such fond farewells are seen at every railway station, of course, but it is not always possible to photograph them well. This photograph was taken at Toulouse station. Admittedly, there is an element of luck in having the camera in the right position at the right time. Taking the photograph from a height - from the window of a compartment - was also an advantage, since that made it possible to include the train waiting alongside. The horizontal line of the coaches would have cut across the vertical line of the couple if the photograph had been taken from a lower viewpoint or on a level with the main subject. Also, the platform edges which converge so beautifully towards a common vanishing point and which really relate the main subject to the background, would not have lain at such a favourable angle. The lens — of focal length 150 mm for a medium-size

Top left: a roll of background paper hung from a rod is the commonest background in photographic studios.
50 mm lens on 6×6 cm. 100 ASA film: 1/60th at f/4.
1000 w halogen lamp as indirect back lighting.

Right: Including the background in the photograph explains the farewell scene. The diagonal platform lines, the difference in the size of the figures and the contrast between areas in and out of focus give spatial depth.

150 mm lens on 6×6 cm. 125 ASA film: 1/500th at f/5.6.
Strong sun in the south of France.

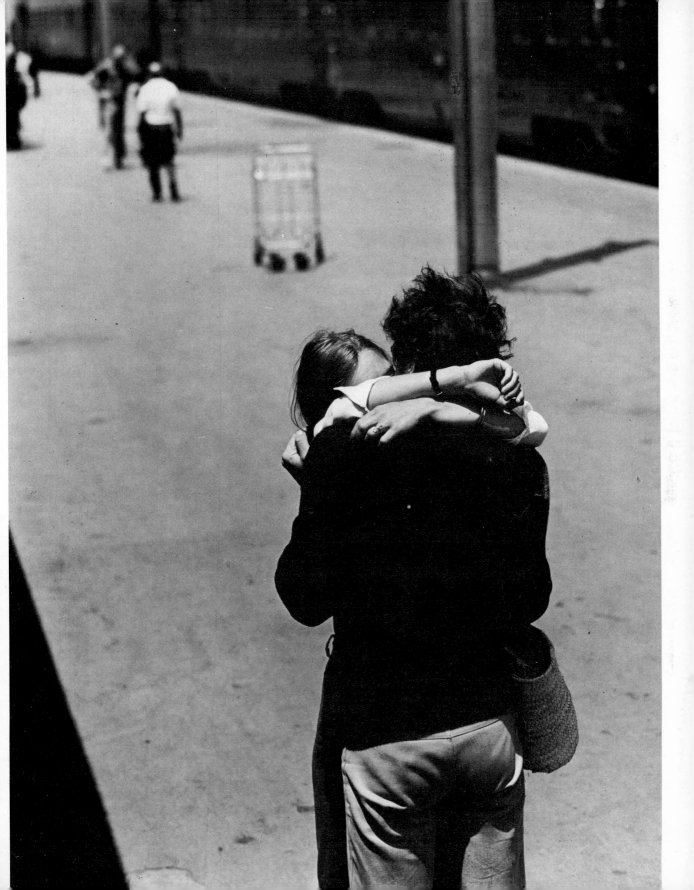

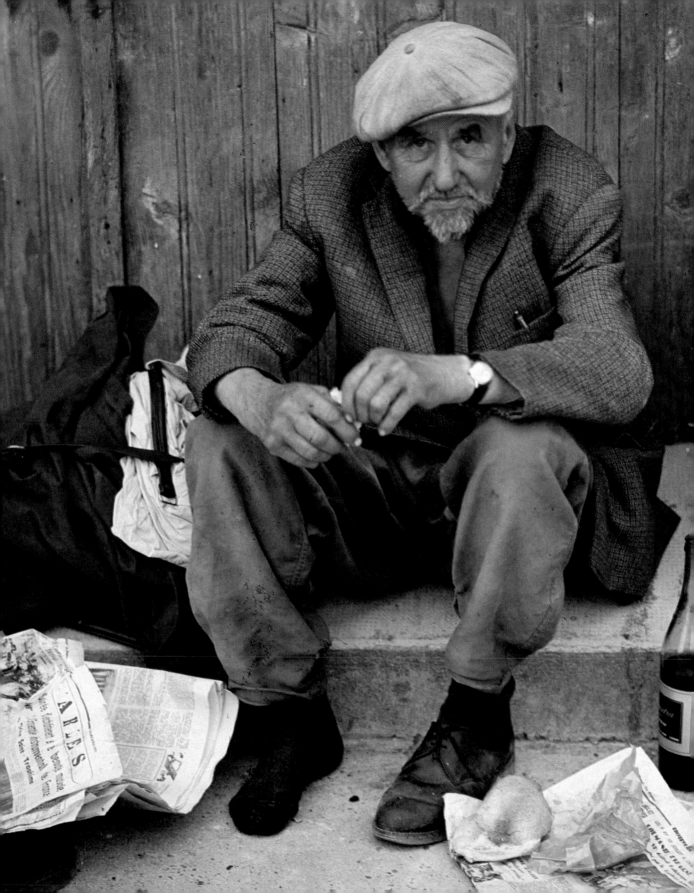

Middle ground

If we analyse the subject's surroundings further, it is impossible not to consider things which are neither in the foreground nor wholly in the background but which are primarily on the same plane as the subject (page 70). The objects surrounding the still life subject opposite consist largely of a rucksack, a newspaper, a bread roll, a bottle of red wine and a walking stick. The photograph has little depth but if it is divided up in space the tramp's protruding hands are in the foreground, the objects listed above and the tramp's body are in the middle plane and the wooden planks form the background. The three spatial planes do not give a three-dimensional effect in the photograph, however, and all the surroundings look as if they are in the same plane as the subject.

Photographic composition of this type is not to be confused with that in which the main event takes place in the middle plane but the surroundings quite definitely lie in front of or behind the subject and are accordingly photographed consciously as foreground and background (pages 89, 93, 108).

Photographs in which the surroundings are in roughly the same plane as the subject can be seen on pages 78, 105, 109 and 159.

When the surroundings typify the subject, they should be photographed with him. They turn this tramp into an individual. The stick is in exactly the right place and the pink wrapping paper is exactly the right colour.

80 mm lens on 6×6 cm. 50 ASA colour transparency film: 1/125th at f/4: Diffuse daylight.

This nude subject shows that not only the surroundings but the subject itself can constitute the foreground, middle distance and background.
150 mm lens on 6×6 cm: 100 ASA film: 1/15th at f/4: Daylight in the studio.

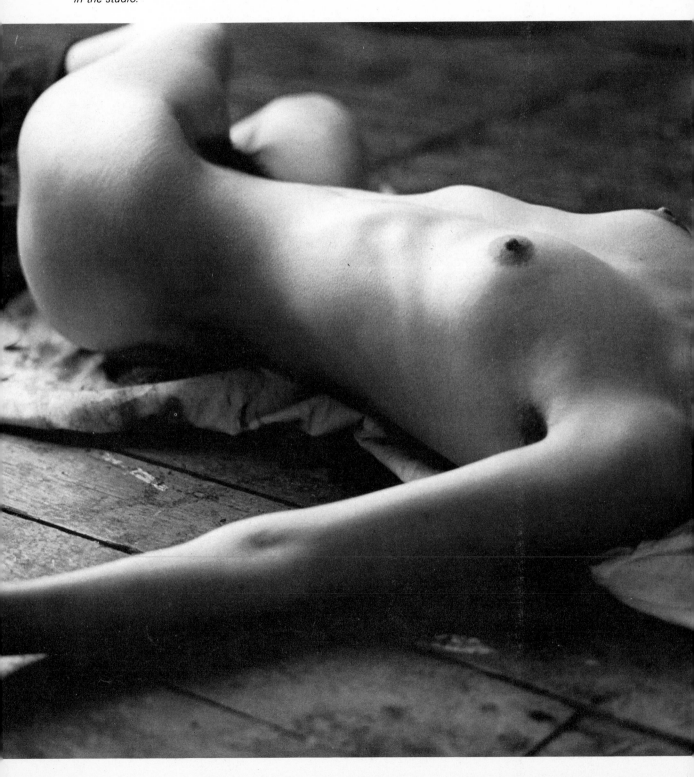

Excluding unimportant material

The extreme perspective makes the foreground parts larger and the background areas smaller. The composition "building blocks" - arm, chest, pelvis, legs - can be clearly distinguished as cubic units - tubes, cylinders, box. In addition the lines of the floorboards emphasize the three-dimensional effect.

If the body or head of a person is photographed to fill the negative, so that the spatial dimension from the foreground to the background is determined by the subject, then his or her surroundings are no longer of any great importance (pages 14, 77, 110). Yet even very small subjects have their surrounding details. An eye has its lids and lashes (page 88), a mouth its nose and chin (page 32). The photographer has to decide which detail is to be of primary importance and which of secondary importance. If shapes are photographed to show their typical properties clearly — round or square, smooth or creased, harmonious or discordant, shiny or matt, etc — then the shapes themselves generally indicate which part must be relegated to the surroundings as being of secondary importance (pages 34, 167). A photograph can be arranged according to the rules of perspective by enlarging the foreground or reducing it and having areas in and out of focus (page 122).

In the photograph on page 72 the arm is in the foreground, the upper part of the trunk is in the middle plane and the pelvis and legs are in the background. This arrangement was the result of perspective foreshortening of the limbs which form a 'zigzag' in space. The arm is disproportionately large in comparison with the proportions of a nude model standing upright and the pelvis is disproportionately small while the legs are foreshortened considerably.

By concentrating on the model and disregarding the surroundings as much as possible, the photographer's attention is focused on the essential. He notices if an arm is holding or supporting something, hanging or lying, relaxed or tense (pages 28, 155, 188); if the eyes are clear of bleary, appealing or piercing (pages 97, 119, 128); if the skin looks smooth or wrinkled, etc (pages 120, 164).

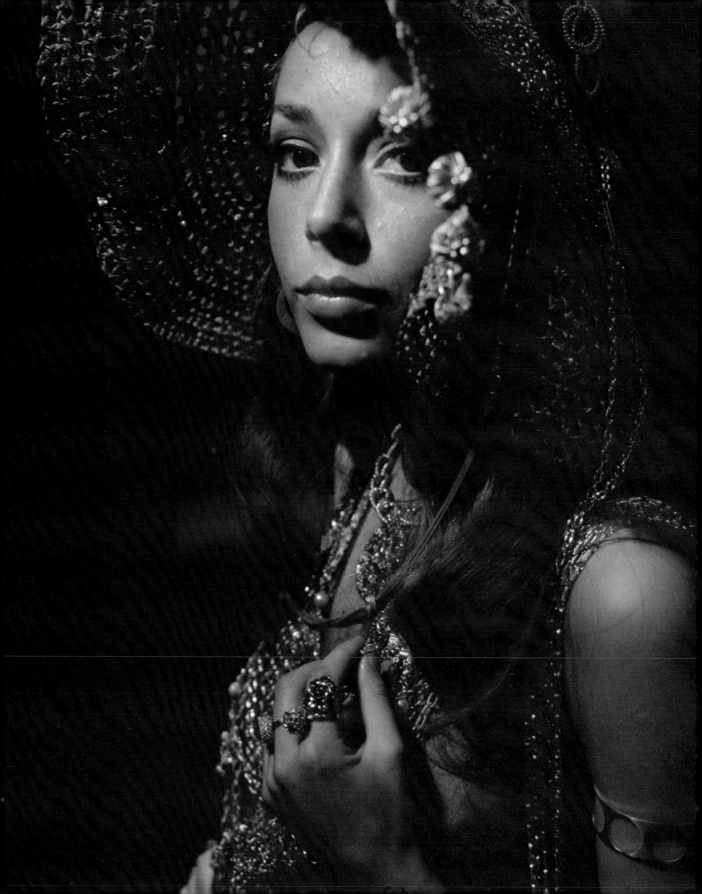

Materials

The photographer is grateful for any opportunity to concentrate on his favourite occupation - taking photographs. At major events it is all he can do to get the camera to his eyes among the pushing, jostling crowd of visitors. Happiness for the photographer must be finding a place where he can pursue his creative urge without interruption. Just such an opportunity was provided for me by some girls who were making jewellery at a trade fair. Their site was set a little apart against the side wall of the exhibition hall and it was less noisy than in other parts of the fair.

A girl from a fashion school — not a photographic model — was exhibiting at the fair, wearing her own creations and bedecked from head to foot in gold jewellery. She was photographed frequently on account of her dresses and the pieces of jewellery. Even the television cameras came to see her.

I was lucky enough to notice this photogenic young lady in the early days of the exhibition. There would have been too much commotion for me to take my photographs at a later stage when word of her attractions had spread. *Materials* need to be photographed in peace and quiet; with undivided attention if the photographs are to turn out well. The undertaking is difficult enough in itself without distractions from third parties.

As usual the beautiful prima donna assumed that she had to smile sweetly for the camera. I told her that I did not want to take a photograph of her looking "posed" and that the best thing was to take no notice of me. It is doubtful whether she followed my wishes or not. So much I can say in all conscience: the photographs which I took of her would have been far more stilted if I had not first asked her to forget all distractions and act as if we were alone together with no onlookers standing round or to act as if only she were present with no photographer.

To help her achieve this object, the first photographs of her were taken via a mirror. When a woman is looking at herself in a mirror, something outrageous would have to happen to make her look away. I then stood behind her and she was not able to see me directly as I took the photographs. It was easy and subsequent photographs which were not taken via a mirror were more a success because there was the feeling that we could act naturally when taking photographs and being photographed.

The lighting always has to be controlled in a specific way if the characteristics of materials —whether metal, stone, glass, wood, fabrics or skin — are to be apparent in a photograph. Whereas light-absorbing materials — matt, dull, absorbent surfaces — tolerate *direct* light (pages 63, 67), smooth, shining, reflecting surfaces are best photographed in *indirect* light or with back lighting on account of their reflective properties (pages 59, 78).

Adjustable filament lamps provided *indirect* subject lighting for the coloured photograph of the jewellery girl (page 74) and they were directed towards the bright roof of the exhibition

The subject's attire forms her immediate surroundings and it is sometimes most attractive in a photograph. The "materials" worn by this lady of fashion glistened and sparkled so much that precautions had to be taken against halation. They took the form of indirect lighting and photographing the subject indirectly through an aluminium mirror.

80 mm lens on 6×6 cm. 160 ASA colour transparency film: 1/60th at f/2.8.
Five 250 w overhead lights above an exhibition stand.

stand. The light was thus diffused but produced sufficient contrast, as can be seen from the shadow formation. There was no unpleasant halation from the jewellery.

By way of contrast, the head of the old man from the Orient (page 77), was exposed to *direct* sunlight. The turban material and his skin, which were features of importance to the photograph, tolerated the light well. Neither tended to produce halation. The tremendous light given off by the midday sun in Africa intensified the sheen on the skin and the pores can be seen clearly in a way not noticed with the naked eye. On the subject of technique it should be added that the photograph was taken on a medium fast film (100 ASA) and was developed according to the instructions. The light intensity would also have been sufficient for a 40 ASA film. The reason for using the 100 ASA film is that, even in countries where the sun shines constantly, the same degree of light is not always available in every situation for all twelve or thirty-six negatives on a roll of film. There may be completely shaded subjects worth photographing. A medium fast film is best if the photographer wishes to do justice to both extremes. It has a wide range of exposure and is fine-grained.

Materials are represented to varying degrees in all subjects. Row on the left: Grass from the photograph on page 141; Fabric from page 77; Cloth pattern from page 103. Row on the right: Skin from the photograph on page 122; Hair from page 88; Cobblestones from page 51.

Right: Surface textures are emphasized the more the contrast between light and shade. Lighting from the side, above or below is more effective than frontal lighting which casts hardly any shadows visible from the camera position. Strong sun provided top lighting for this African from the Nubian desert, throwing his wrinkles into sharp relief.
150 mm lens on 6×6 cm, 100 ASA film: 1/500th at f/8.

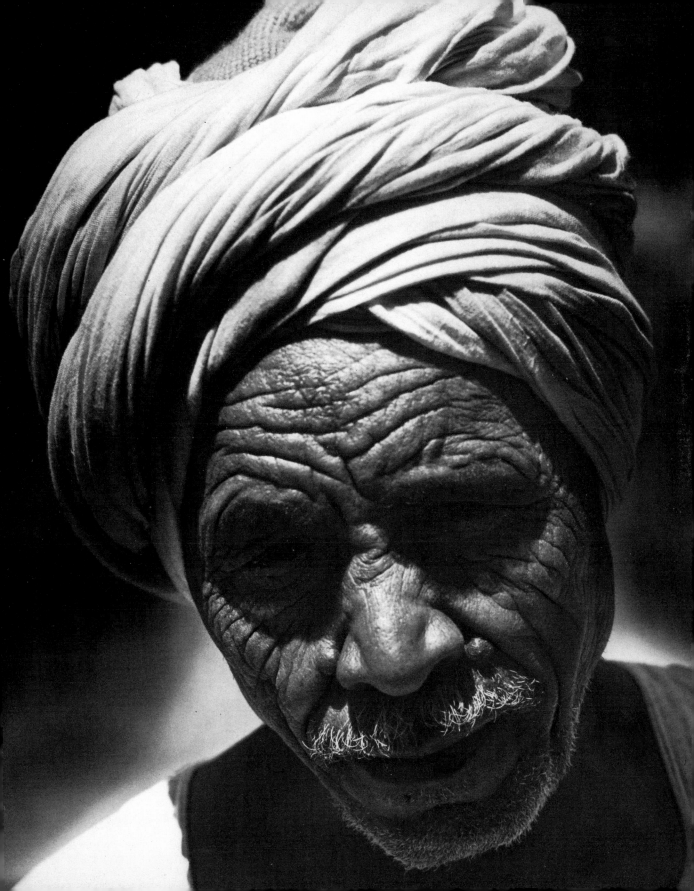

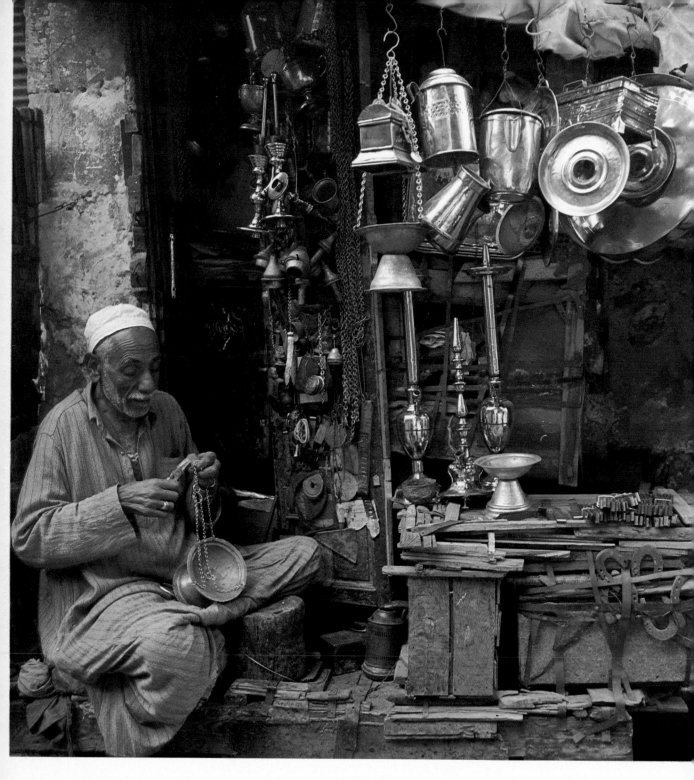

A person in typical surroundings. Living and dead materials are on a par in such "still life" photographs 50 mm lens on 6×6 cm, 50 ASA Colour transparency film: 1/125th at f/5.6: Diffused daylight.

Still life photographs with figures

Why not seek to characterize a person by placing him side by side with still life subjects? "Seek" is perhaps not the right word, since people are found in typical surroundings everywhere. Wherever there are objects made of wood, stone or metal and wherever there are houses, tools, furniture, jars, flowers, etc, there are probably people as well (pages 16, 64, 70, 173).

Quiet characters, particularly the elderly, are the most suitable for this type of shot. They have come to be more at one with their environment than young people (page 78). Good composition is desirable, both in form and colour. The bric-a-brac which is often present in such subjects must not dominate the photograph. It should be recognizable more as part of the whole. A "still life" must show *still life,* and that takes space.

In practice, however, still life subjects are not usually photographed at all easily or even quietly. Appearances can be deceptive, as will be realized by considering the case of the photograph on the opposite page (page 78) of the man in the Aswan bazaar.

The subject with his metalware caught my eye from a distance. Past experience having made me rather prudent, however, I showed no enthusiasm at all but tried to look as disinterested as possible as I attempted to get close. In the Orient, once you have your eye on a particular human subject, then, in order to photograph him, you have to divert the attention of his nearest and dearest from your purpose until you have found the best viewpoint. Once you have attracted attention, either from the subject or the people round about, any attempt to take a photograph is doomed to failure. Everyone will try to stop you. I have never found out for sure if this is primarily for national or religious reasons but it is probably for both.

I therefore became preoccupied with rafters, and the cloths stretched across the narrow streets in the opposite direction. As luck would have it, a mosque towering above the old town was visible in the distance, too remote to be of interest for a photograph. I was able to point my raised camera at all these things as much as I liked without interference. By using a telephoto lens, a subject can be photographed to fill the negative from a great distance without the suject noticing. There must be nothing in the way, however. Consequently I was not able to use a telephoto lens for my still life subject because there were crowds of passers-by. They ruined my view all the time to some extent and often completely. I therefore had to get close up to my subject and, if the entire brassware shop was to be included in the photograph — and that was in fact what mattered to me in this instance — then a wide-angle lens had to be used. At some distance, unobserved, I screwed the lens on to the camera. I continued the diversionary manoeuvres described above and, foot by foot, the distance to the subject was right. Only then did I raise the camera, but not towards the brassware shop! It would have been spoilt by the crowds of people around. Also, I was not yet sure that I had found the best perspective. Once again I had to show interest in the distant mosque, this time with my camera ready to shoot: lens set to 1.5 metres (6'0 approx) and with the exposure settings required for the brassware shop. Once the merchant's natural curiosity about the strange photographer was satisfied he resumed his interrupted activity.

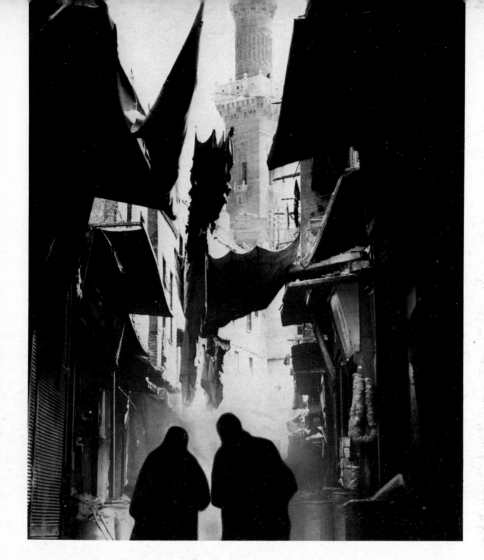

Bazaar in Aswan.
Such peaceful
scenes are not
found everywhere
in Africa.
50 mm lens on 35
mm: 125 ASA film:
1/250th at f/8.

This was the moment I had waited for. It was the work of seconds to bring the camera down, swing it round through 45º, point it at the metalware and position the unsuspecting, principal performer correctly in the composition.

Then the commotion started. Neighbouring merchants and several passers-by had noticed what I was doing. People converged on the spot at once from all sides and told the man, to his surprise, what I had done. But he would not believe it. I confirmed his belief, and gave him to understand that it was the beautiful dishes, bowls and boxes which had interested me and this also appeased the others. There upon everyone wanted to sell me some of the brassware!

4

Composition

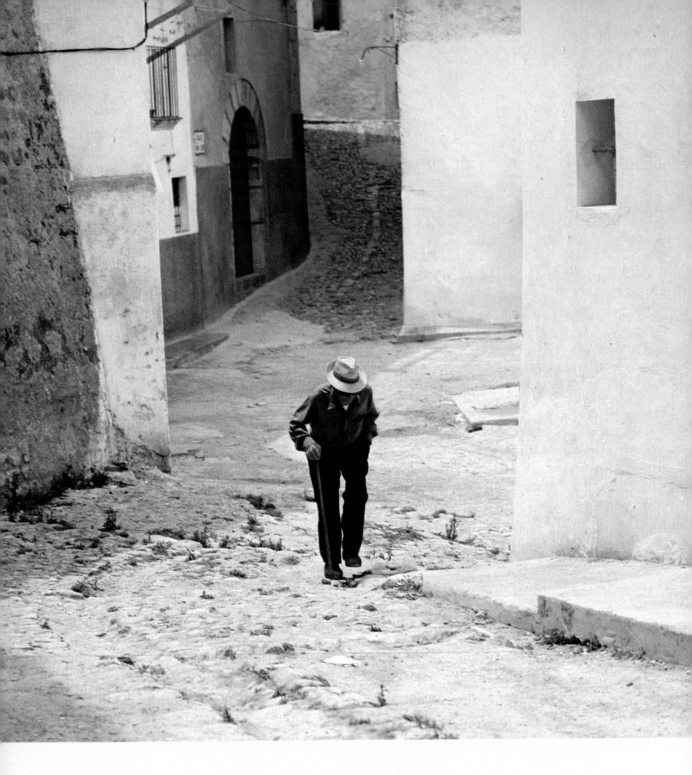

Contrast: large and bright, staggered walls: comparatively small, dark person.
250 mm lens on 6×6 cm: 50 ASA colour transparency film: 1/125th at f/8:
Sunny daylight around noon.

Contrasts

What would a beautiful woman be if there were no ugly women, cleverness if there were no stupidity, noise if there were no silence, colour film if there were no black and white? Without opposites nothing would make a special impression, nothing would catch the eye. Conversely, unhappiness would not be so dismal if there were no happiness and things would be really boring without their direct opposites; in fact it would be impossible to discuss the nature of an object or a condition if the contrasting object or condition were non-existent. Fortunately the world is rich in contrasts — large and small, fat and thin, male and female, healthy and sick, horizontal and vertical, rich and poor, solid and liquid, dead an alive — to mention but a few of its characteristics. Changing Dürer's words slightly, we can say: "Contrast is inherent in nature; if an artist can discern it, he can copy it." Black and white film provides a contrast with colour film but each also brings its own contrast problems. However, specific contrasts of *light*

Below: Strong contrast of large areas of light and shade.
50 mm lens on 35 mm: 50 ASA colour transparency film: 1/250th at f/5.6.
Sunlight in a narrow street in Venice.

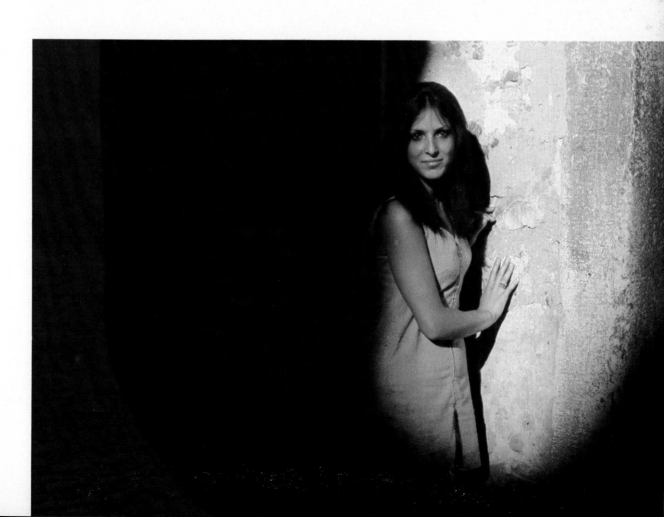

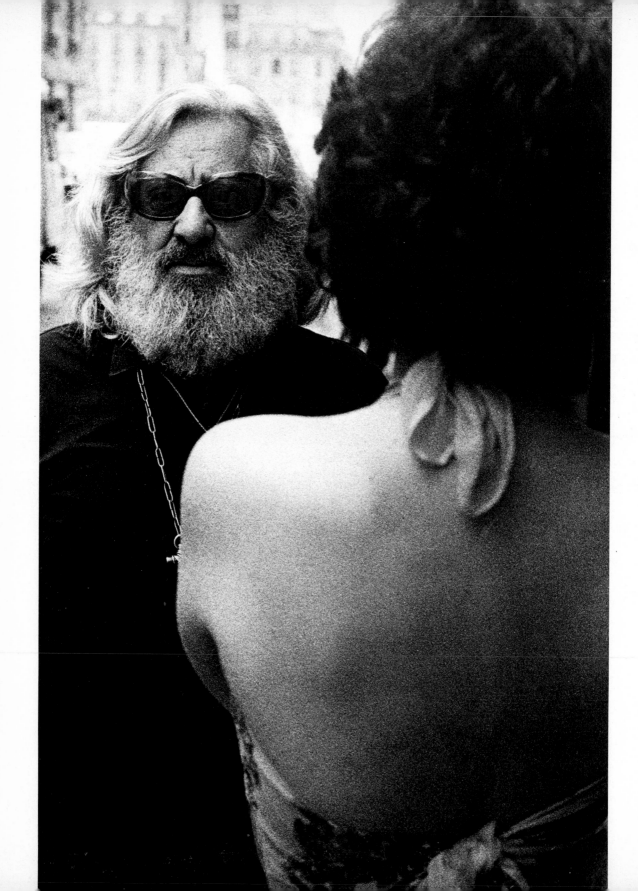

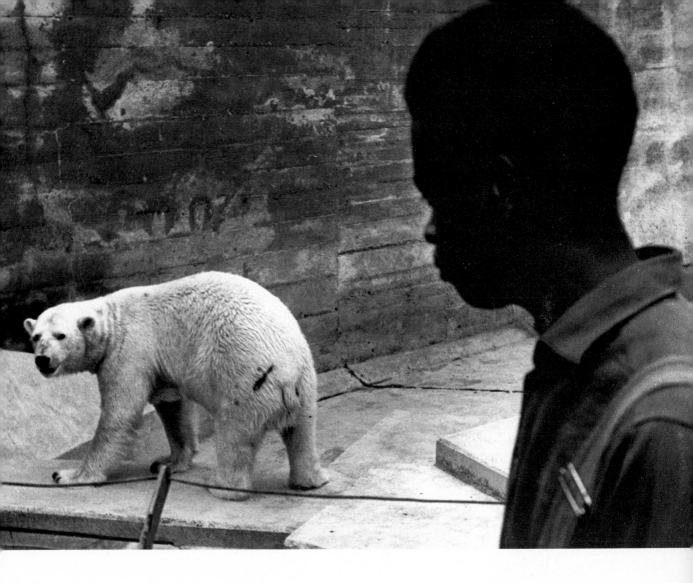

Left: The subject contrast lies in the juxtaposition of the bare-backed woman and the man who, with his beard, glasses and buttoned-up shirt, looks really well covered. A street scene from Paris.
50 mm lens on 35 mm: 100 ASA film: 1/1000th at f/2.

Right: Subject contrast (negro: polar bear) and also light-dark contrast (black: white).
50 mm lens on 35 mm: 100 ASA film: 1/125th at f/4. Hazy light.

and shade and of *subject* can be characteristic of both black and white photographs and colour photographs.

"Where light abounds, shadow abounds" says Goëthe, the illuminator of souls. He was referring to people, but what he says applies equally well to *contrasts of light and shade* in photography (pages 7, 34, 110, 164).

It is not only ten thousand watts of electricity or the equatorial sun which produce contrasts of light and shade. On the contrary, in a photographic context we should interpret the above quotation as meaning only that *direct* light produces stronger contrasts of light and shade than *indirect* light (page 83 "Direction of light

falling on the subject"). Yet 10,000 watts bursting forth on an object from the front produces no contrast of light and shade at all - everything is uniformly bright. On the other hand, candle-light or a single ray of sunlight used as side lighting or oblique lighting can produce dynamic contrasts (pages 2, 45, 55, 139, cover). The *shape* of the subject also affects the contrast of light and shade. There is a difference between an egg shape — ie an uniformly oval object — and an irregular object, such as a head, even though illuminated with the same light. The former will show relatively little contrast when *one* lamp is used whereas *one* side light illuminating a head may produce too strong a contrast.

There can be contrast in the *subject* even when there is very little light contrast. Examples are *black* hair against a *white* skin (page 191), a *red* dress against a *green* house wall (page 105), a *negro* and a *polar bear* (page 85). Frequently it is not until one subject is associated with another in a photograph that their differences and peculiarities become apparent (page 145).

The above list included a colour contrast, *red* against green. Contrast colours are the "complementary" colours, which are mixed from two primary colours. A mixed colour of the first order stands opposite the pure, unmixed primary colour which is its complementary in the colour circle. The three primary colours are red, yellow and blue; the mixed colours are orange, green and violet.

The complementary colour of red is therefore green, which is mixed from yellow and blue (page 105).

The complementary colour of yellow is violet, mixed from red and blue (page 78).

The complementary colour of blue is orange, mixed from red and yellow (page 97).

All these colours are found in the rainbow. The colours of the rainbow are of course continuous combinations and have to be photographed with care, especially since they easily lead to harshnesses and bright, varied colouring.

It is interesting to see contrasts of colour or of black and white tones in relation to *contrasts of relative sizes*. The impression which a contrast makes is determined largely by tonal emphasis. It is measured in surface area or, more accurately, sensed. A tiny patch of *red* provides not only a *colour* contrast against a vast blue/violet surface but also a contrast of size on account of the difference in quantity (page 56). Two coloured surfaces of the *same size*, contrasting only in colour and not in extent, are less interesting.

The same applies to contrasts of light and shade; a *small, dark* object in a *large, bright* setting can attract great interest (page 82); a little reflected light in a much larger area of darkness can produce a dazzling effect (pages 55, 87).

Sharp definition against lack of focus is another means of providing contrast in a composition. The more abstract the subject's surroundings in the out-of-focus range, as background or foreground, the greater the contrast to the sharp definition of the main subject (pages 89, 93).

In order to take photographs with an awareness of contrasts, an ability to *see* accordingly is required. Let us therefore begin again quite simply from the beginning.

Once children are aware that you have your camera trained on them they become models as in this photograph. For our little star to place her main feature in the right light was really quite professional. (Sunlight in the woods.)

80 mm lens on 6×6 cm: 150 ASA colour transparency film: 1/125th at f/2.8.

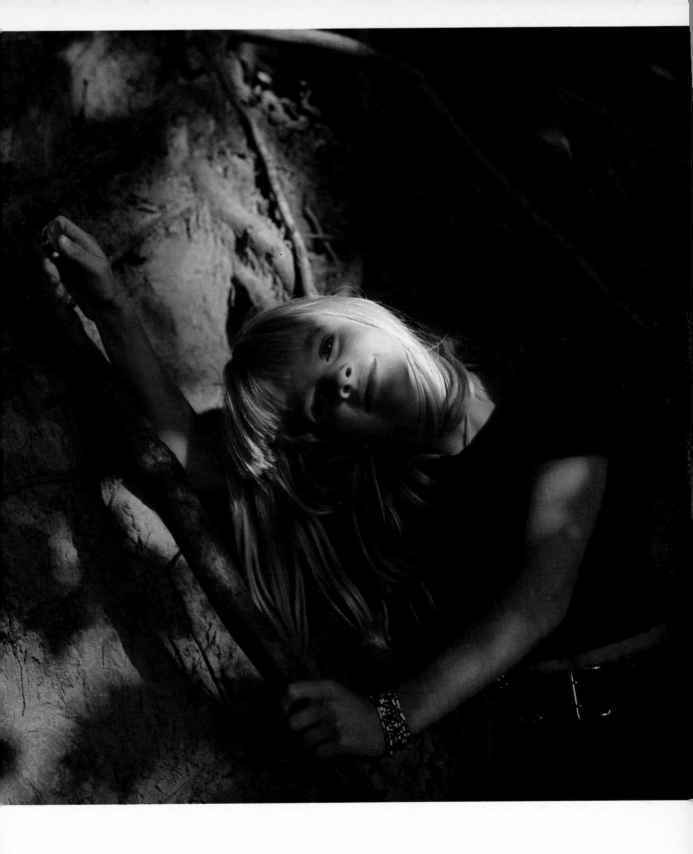

Seeing photographically

The difference between seeing normally and seeing *photographically* is that the latter is an attempt to see things either in black and white or in colour. Consequently, black and white subjects are photographed on black and white film, and coloured subjects on colour film.

I also believe that seeing photographically means seeing a limited area only. The more directly a subject is seen as a square-shaped composition or a vertical or horizontal oblong composition *before* the photograph is taken, the better the picture will be.

Seeing photographically is also *seeing with the focal length in mind*. Assessment of a subject

The photograph captions are on page 90

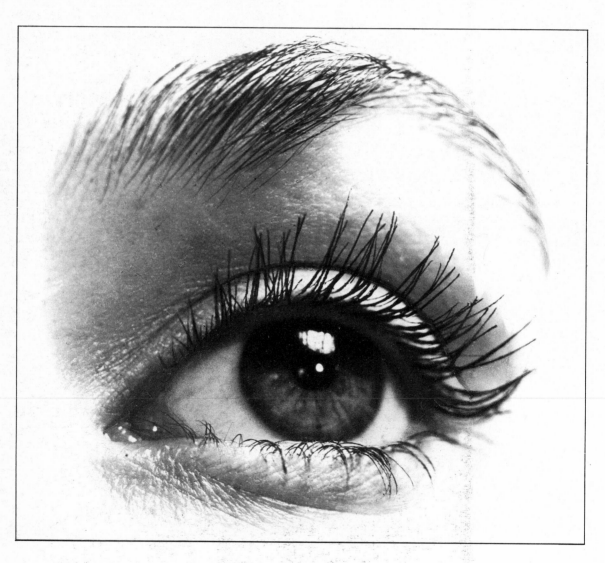

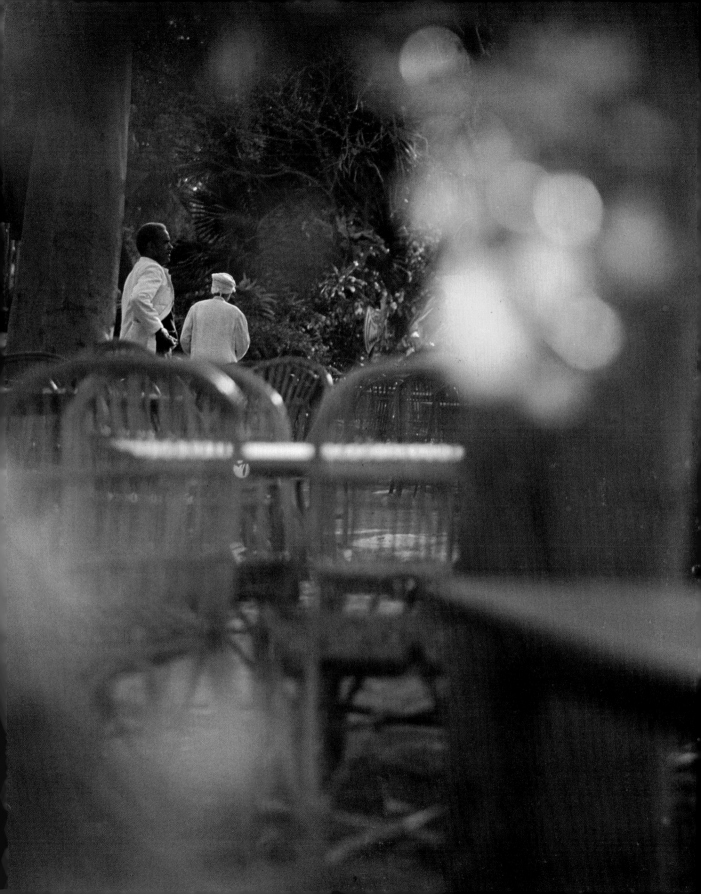

suitable - a wide-angle lens, a normal lens or a telephoto lens? The correct lens for the estimated camera position has to be considered. If the chosen position and lens prove unsuitable there will often be no time left to correct the mistake because the best moment to take the photograph will have slipped by.

Seeing photographically also means *seeing relatively*. The human subject must be viewed in relation to his surroundings, to a light effect or to other people. For example, the photographer sees a photogenic person in the street but his surroundings at that moment are not suited to that type of person, either in colour or shape. However, the direction in which he is walking looks more promising, with huge advertisements, cafes, etc. and the photographer presumes that at least *one* of them will provide a more fitting background. The photograph is taken when the assumption becomes certainty ("The subject's surroundings").

Seeing photographically means *keeping one's distance*. This is not counter the recommendation to "get as close to the subject as is just practicable", since it refers not to an *external* distance but an *inner* one. It is possible to maintain objectivity towards a subject, to "keep one's distance", even when working close up to him. There is a feeling of standing above a thing to appraise it coolly and objectively. From time to time it may be necessary to increase the physical distance between photographer and model.

Seeing photographically is a feast for the eyes. A picture promises to be good only if the subject is enjoyed to the full, savoured and sucked dry!

In certain circumstances, the *sense of hearing* also contributes to photographic seeing. Noises summon before the eyes whatever might be worth photographing round the next corner - children shouting, cronies enjoying a game of cards. As soon as such tell-tale sounds are heard the aperture, shutter speed and range can be set - before the sources of the noise have become aware of the photographer.

It may well be that a *good sense of smell* is needed in photography; seeing photographically may even activate all the sense organs, including the *sense of touch*.

Last but not least, seeing photographically

means sensing what is important to a photograph. Then no doubts remain about *how, where* or *why* a subject is photogenic. The subject determines whether black and white or colour film should be used and indicates the choice of detail, lighting, etc. The subject *dictates* everything. Seeing becomes and adventure; it becomes seeing photographically.

□

Page 88: Small subjects can be seen as large. 250 mm lens plus 55 mm and 21 mm extension rings on 6×6 cm, 100 ASA film: 1/25th at f/11. Two lamps of 500 w each as top and side lighting.

Page 89: Garden cafe in Cairo. Areas which are in and out of focus can be considered carefully with the reflex camera because they can be seen directly in the viewfinder. 250 mm lens on 6×6 cm: 60 ASA colour transparency film: 1/250th at f/5.6.

Colour

Colour photography is no more difficult than black and white - correct exposure guarantees a technically satisfying result. If this were not so, it would be difficult to explain why more than 50% of all photographs taken are now in colour despite the higher costs involved in comparison with black and white. Colour photography is likely to be even more popular in the future, since greatly improved processing helps even the beginner to achieve gratifying results with his very first colour films. When he gets his pictures back he finds them better than he had hoped, even better in fact than they had looked in reality. And he promptly orders more prints and colour films.

The tremendous colour range of negative and positive materials must also be an inspiration to the advanced amateur and the professional, quite regardless of colour composition criteria. Very fine nuances of red or blue and amazing colour depth, even with very strong lighting contrasts (page 87) when the eye can no longer see any colour differentiation, and delicate gradation of tones in subjects felt to be lacking in colour at the time of exposure (pages 82, 93), all stimulate consumer satisfaction quite considerably. Yet even the professional photographer would sometimes admit that some colour photographs are spoilt and go directly into the waste paper basket because they are too colourless or too gaudy.

It would of course be foolish to blame technology for the unsuccessful photographs when the blame really lies at the photographer's own door. Colour film always records only what is presented to it.

Consider, for instance, a magnificent red blouse on a person wearing a very smart lilac hat on her blonde hair; the sky is azure blue, multi-coloured sun umbrellas stand round about, green palm trees and gaily painted houses lie within the sharp focus range of the lens. In radiant mood and tanned a velvety brown one feels that the subject is sure to produce a colour photograph with beautiful colouring. Yet, despite all the superlative colours, the colour print or slide proves disappointing. *One* colour is so loud it kills the *others* dead, and it is impossible to see why it was considered important to the subject. Was the violet hat or the red blouse the most important feature? Are the lady's white teeth and

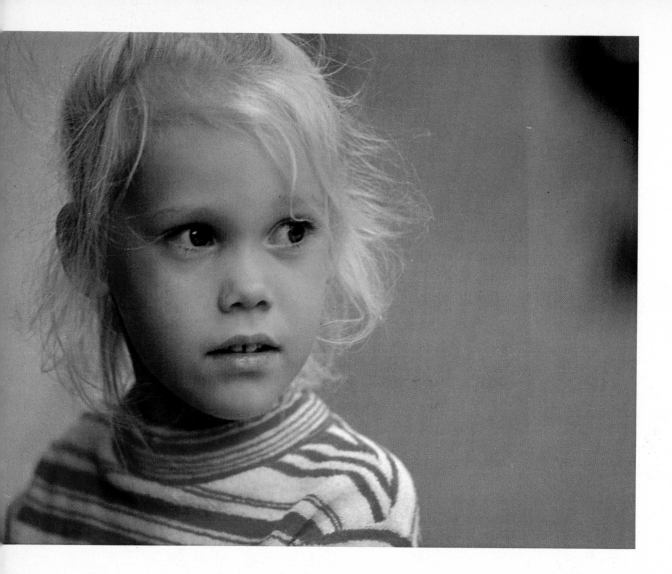

Above: The arrangement of the pastel-coloured
background, divided along the axis of the head with
pink on one side and bluish grey on the other, was
not deliberate at the time of taking the photograph.
Luck comes into it too, of course.
135 mm lens on 35 mm; 50 ASA colour
transparency film: 1/125th at f/5.6: daylight in the
open.

Right: By way of contrast, the colour composition of
this little fight in Ibiza was deliberate. The telephoto
lens reduces the distance to the subject, and both
foreground and background are obviously out of
focus which makes the colours look flat.
250 mm lens on 6×6 cm; 50 ASA colour
transparency film: 1/500th at f/5.6: sunlight at
midday.

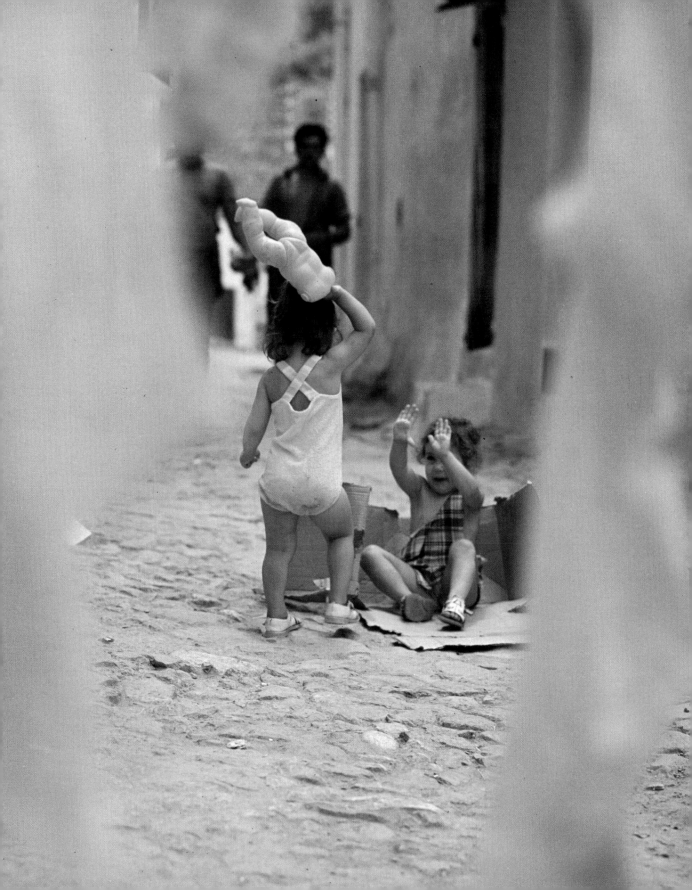

holiday tan prominent, or is it the newly acquired yellow handbag? It has become impossible to see the wood for the trees; because so many colours are combined, no single one has impact.

On the other hand, who has not had the experience of photographing a subject obviously lacking in colour, because at the time there was nothing more attractive to photograph? Yet, this very photograph turns out to be the best of the entire film for colour! Why? It contains little colour; in fact it might almost be described as monochrome because only a little complementary colouring is discernible. Its overall colour effect is nevertheless gay and has tremendous impact despite the subdued colours. How can this be? It must surely be because all the individual colours and the combinations of them enhance rather than detract from each other. Each colour complements the one next to it instead of presenting a garish juxtaposition of numerous clashing colours.

What is meant by monochrome and complementary colours? What are subdued and bright colours, pure and mixed colours and, above all, how is colour produced?

Colours in photography come from three sources: the colour inherent in the subject, the colour of the light and the colour characteristics of the film. (In addition, colour can be affected by different focal lengths and aperture settings giving large or small depths of field; and by employing colour filters during negative or positive processing.)

The colour inherent in the subject consists of mineral, organic or synthetic colour substances (page 92). In spring and summer, for instance, a leaf is green; in autumn it is yellow, red, violet, brown. Human skin may be reddish white, purplish red, yellowish brown or blackish brown; some minerals are iridescent with green, ranging from the brightest to the darkest shade; a car is red, yellow or blue etc.

The colour property of light is determined by light intensity or colour temperature which makes the colour inherent in the subject look lighter or darker, warmer or colder. It is determined partly by the position of the sun in the case of natural light and by various types of lamps in the case of artificial light. Natural light is warmer in colour in the early morning and in the evening (pages 34, 45) than in the late morning and early afternoon (pages 44, 67). It is coolest at noon (pages 21, 82). Incandescent light (pages 96, 97) is warmer than the light from halogen lamps and photographic lamps (page 56). There is also a big difference in colour effect between direct and indirect lighting. Direct sunlight at midday and combined spot-lighting produce strong contrasts of light and shade, with the result that colours are "washed out" in very bright areas and are "saturated" in very dark areas (page 87). Indirect light, on the other hand — diffuse light which is reflected by clouds or by objects surrounding the subject — produces strong colours in every shade (page 70). Slight under or over-exposure can shift the colour effect towards either masked colours (pages 74, 117) or towards transparent pastel colours (pages 13, 44). This happens at the time of exposure in the case of colour transparencies and during enlargement in the case of colour negatives.

The third colour factor is the film. Colour film is available in the speed range 25-400 ASA. The speed of colour reversal film can be increased by special development if necessary. For instance, a 50 ASA reversal film can be exposed as for 100 ASA and a 160 ASA film as for 400 ASA. Colour deviations and a reduction of basic darkness are inevitable during this process but are particularly attractive when they tend to produce abrupt, poster-like colour separations or monochrome colour concentration (pages 52, 53).

The three primary colours are red, yellow and blue. All other colours can be mixed from them. A single colour can be used in photography if it is shaded from light to dark. Incongruously assorted colouring is most easily avoided by keeping to a few colours (pages 31, 82).

In compositions containing *two* primary colours, the number of colours obtainable is *multiplied* (page 20) because two colours mixed together give a third; for instance, red+yellow=orange, blue+red=violet, blue+yellow=green.

Photographs containing contrast colours like the above are to be recommended because the juxtaposition or combination of red with green (page 105), blue with orange (page 97) or yellow with violet (page 78) — ie a pure,

unmixed colour with a subdued colour — is not nearly so crude and sharp as, for example, pure yellow next to pure red or pure blue next to pure red. Two complementary colours are pleasing to the eye and are not inferior in colour strength to two primary colours.

The effects of hot and cold color temperature are attenuated only slightly rather than cancelled out in complementary mixed colours. This means that red is a warm colour (page 67), blue is cold (page 20) and yellow lies between these two extremes (page 63) but the complementary of red, which is green — and green contains blue — remains cool (page 74). The complementary of cold blue is orange, which is a warm colour because it contains red (pages 96, 97).

The interest of a colour composition is also governed by the relative proportions of the colours contained in it. A small pink rose in vast greenish or violet surroundings can have tremendous colour interest (page 48). The smallest patch of green can attract attention in very much larger surroundings of a different colour (page 44).

Colour theoy is similar to music theory. A single drum beat is not music. Music is not produced until different notes are related to each other. A trumpet blast acquires musical quality only within a sequence of other instrumental notes. The same is true of colour tones which, when shaded from light to dark and mixed together produce a melody of colour.

Looking in the viewfinder of a reflex camera fitted with a powerful telephoto lens or with extension rings and ancillary lenses shows how colours can extend over a large surface area. Alternatively they can contract to form spots and they vibrate or seem to be alive (page 89) even though — or perhaps because — they lose their representational shape and fuse to form abstract images. This exercise algo shows that a small depth of field makes a three-dimensional subject look flatter — and colours benefit from this. The flatter a colour, the more effective it is. This rule can be demonstrated in that a three-dimensional object looks two-dimensional when seen with a telephoto lens or ancillary lenses (page 96). Subjects which are already rather flat are preferred and the colours are condensed in both cases (page 105).

To see colours better the simple trick of half closing the eyes is sometimes useful. In this way, only the larger shapes and colour relations are seen. The most important thing in colour photography is to look for colour harmony. It is perhaps not unfitting to pointing out that observing nature can train the sense of colour. With this in mind, the Impressionists — who sharpened our sense of colour at the beginning of the modern era — abandoned their studios for the great outdoors. Some colours in nature are bright, gaudy even, as in exotic fish and birds but even at her most strident Nature maintains the colour harmony of the whole.

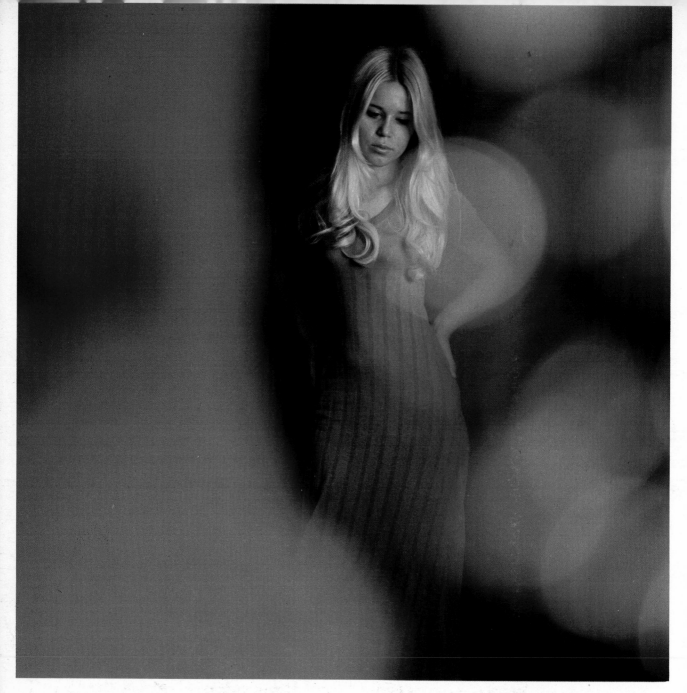

Above: This figure study is not in monochrome, nor is it in complementary colours. Its dominating colours are red and yellow, which largely mix to give orange.
150 mm lens on 6×6 cm, 160 ASA Colour transparency film: 1/60th at f/4: Two 500 w filament lamps and daylight.
Right: The orange of the facial area is the complementary colour to the blue of the light reflections and the background. Orange is warm in colour character, blue is cold.
150 mm lens on 6×6 cm: 50 ASA Colour transparency film: 1/60th at f/5.6: Two 500 W filament lamps forming a V of light.

See the section on "Foreground" (page) for an account of how the light reflections and disc shapes were produced.

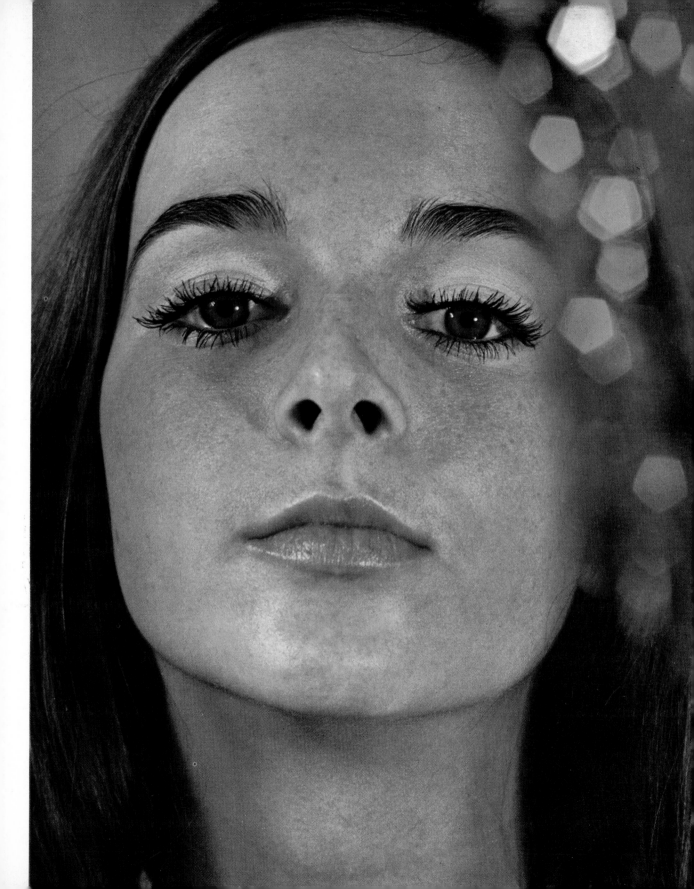

Black and white photography

A photographer decides to use black and white film, not simply because it is cheaper than colour film, but in order to take black and white photographs which are not only as good as, but in some respects are better than coloured photographs.

We see most subjects in a variety of colours and only a very few in the whole range of greys from white to black. Unfortunately there are no filters or glasses which can convert colours into monotone light and shade. Consequently we need to translate colours into shades of grey in our imagination.

It is always advisable to change the coloured subject into abstract black and white in the mind's eye *before* the moment of exposure. This is the best guarantee of a good black and white photograph.

There are good and bad subjects for black and white photography. The bad ones are pure colour subjects whose reduction to black and white would mean a diminution of quality. The good ones consist of high, average and low contrast subjects.

Subject contrast results from the intrinsic tone range of the subject and the type of lighting. The subject is characterized by strong, moderate or weak contrasts and these are either intensified or attenuated by the contrast of lighting.

1. *High subject contrast.* The subject already has strong brightness contrast such as black hair against a white skin, a bright dress against a dark background on a negro against a white background, etc. Such marked contrasts are easily recognized and, of course, provide an excellent basis for black and white photographs (pages 88, 99). Lighting also has to be considered. The strongest contrasts are obtained with lighting from above or below (page 164), with side-lighting or oblique lighting (pages 7, 14) and with backlighting (page 141). The light intensity may sometimes be so dazzling that shapes in the brightest and darkest areas no longer show through. Its effect on a black and white photograph is not usually harmful, however. On the contrary, the stronger the light the deeper the shadows; and the better the black and white effect. Even when all the medium tones — ie shades of grey — are lost, a black and white picture may gain graphic effect from the loss (page 186).

Black and white contrast is produced firstly by the dark hair and skin against a light background and, secondly, by lighting with a 500 w spotlight, which intensifies the contrast.
150 mm lens on 6×6 cm: 400 ASA film: 1/60th at f/4.

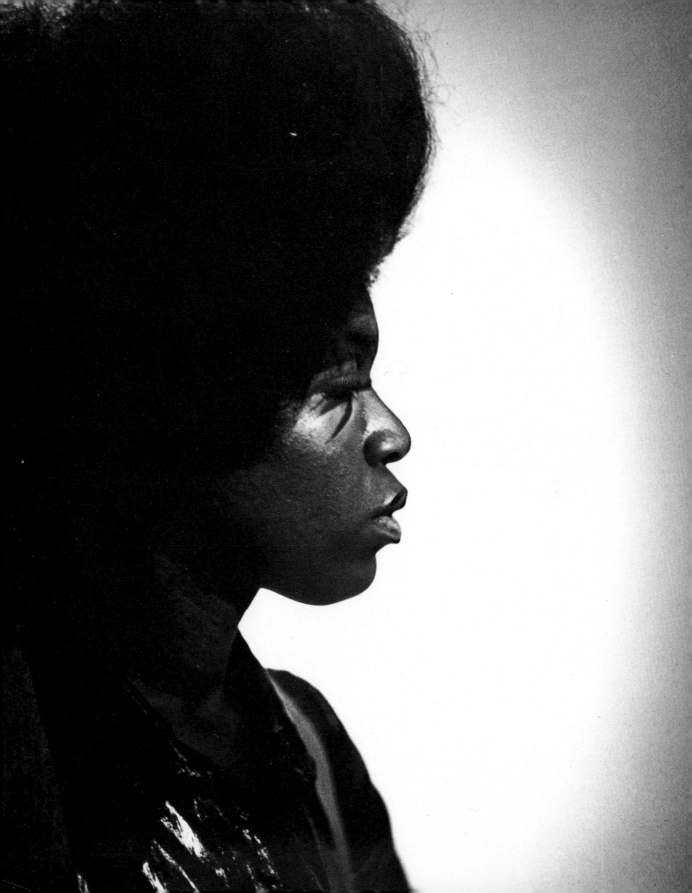

2. *Moderate subject contrasts* usually tend to be neither graphic nor atmospheric. Our eyes translate the impression or brightness into corresponding shades of grey which have the effect of providing relief and modelling. There is seldom and abrupt juxtaposition of pure white and black, such as is found in subjects in the first group. Here there are intervening shades of grey between the two extremes (pages 8, 72). The lighting is soft, not hard. (Indirect sunlight, direct sun in the morning and afternoon when it is not so intense as at midday; artificial light from a soft lamp or a broad beam of light, not from a spotlight.)

3. *Weak subject contrasts* normally contain no very deep black. They are composed primarily of light and bright grey tones (high-key). The lighting is diffuse and hazy, such as light reflected from clouds or indirect artificial light. In order to avoid insipid results, contrasting, flat or contrapuntal areas of tone are advisable since they provide solidity. The effect is often atmospheric (154). Black and white film is available in three speed categories, which can be classified as follows:

4. *Slow films* - ie between 25 and 80 ASA — give greater definition, high resolution and a very fine-grained negative emulsion (pages 16, 163).

B. *Medium-fast films* — ie between 80 and 200 ASA — give average definition and good resolution and are still quite fine-grained (pages 119, 145).

C. Fast and high-speed films — ie between 200 and 800 ASA — have grain in keeping with their sensitivity (pages 128, 171).
Bearing in mind the combination of suitable film material, photographic situation and processing method, the best results are obtained as follows:
Subjects with *high* contrast must be *generously* lit and the development time must be *short* (page 99).
Subjects of *moderate* contrast require processing in accordance with the manufacturer's recommendations. The speed and development time indicated give the least grain and the best contrast (page 72).

Subjects wit *low* contrast should be lit as *little* as possible and the development time should be *longer* (pages 128, 174).
The less colour there is in the subject the easier it is to assess strong, moderate or weak black and white contrasts. The stronger the colours, the more difficult it is to convert them into black and white in the mind's eye. The shades of grey do not necessarily contrast with each other as colours do. For instance, red, green and blue can be equally bright but are very different in hue and they provide considerable contrast in a colour photograph. On black and white film, however, the shades of grey corresponding to these colours are often confusingly alike. The same happens with other colour combinations; whereas colour film would produce very lively colour interest, the result in black and white is extremely boring unless filters are used to falsify the tones.
The use of a contrast filter causes the subject colours which are the same as the filter colour to be reproduced in black and white as a lighter shade than they would be if the filter were not used. However, a complementary colour filter will make them appear darker in the black and white print than in reality. Contrast filters are available in blue, yellow, green, red and orange. To take a practical example, the blue of the sky is to be made lighter — perhaps even white — in a black and white photograph in order to give a contrast of shade with the subject's orange dress. A blue filter is therefore required but the orange dress will come out darker - probably even black.

Surface area and space

The negative format is a two-dimensional *surface area* having only length and breadth. The subject is a three-dimensional body, which has length, breadth and depth. Every object is three-dimensional, even the thinnest sheet of paper; it has a specific thickness which can be measured and felt. Yet it looks flat when compared with the roundness of a rain barrel, for example. The question then is whether a flat or three-dimensional impression is produced by the object, or by the perspective from which it is photographed. A piece of cardboard will look flat if it is photographed with its flat surface parallel to the photograph surface (1). However, if the cardboard is turned round so that its narrow edges are visible, then a three-dimensional, perspective effect is achieved, which could not be more obvious if it were a large stone block (2). In the drawing an additional line and the shadow cast by the object heighten the three-dimensional effect. Those edges of the object which *vanish* into space, into the depths, *taper* to a common vanishing point (F), which would be evident if the straight lines were extended to their point of intersection (the dotted lines in the drawing [3]). The observer's eye level is also marked in the diagram and it is more easily recognized by the horizontal line, the horizon (H), which is drawn through the vanishing point.

Apart from the perspective, which results from the camera's distance from the subject, the angle the lens determines largely whether the subject looks flat or three-dimensional. Although the laws of perspective are most clearly noticeable

1 2 3

Above: Flat effect and three-dimensional effect illustrated by a piece of cardboard. See text.

Below left: Showing the composition of the photograph on page 104. See explanation in the text on the same page.

Below right: The composition of the photograph on page 102. See explanation in the text on the same page.

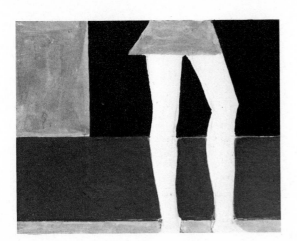

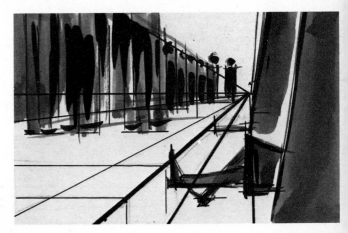

in wide-open spaces, landscape and architecture, they are no less important in relation to people. They are, however, more difficult to see (pages 14, 25, 119) although it is easier to assess depth in nude subjects (pages 47, 72). Wide-angle and normal lenses assist perspective effects; telephoto lenses compress spatial distances so that subjects look flatter, the longer the focal length (page 109). A flat or three-dimensional effect is also dependent on the depth of field; the smaller the aperture, the larger the depth of field and vice versa. A blurred background or foreground (pages 96, 193) emphasizes flatness; sharp focus up to the horizon suggests space (page 158).

Lighting also determines whether the subject will appear flat or rounded, two or three-dimensional. Frontal lighting and backlighting (pages 67, 186) make the subject look flatter than side lighting and top lighting (pages 14, 164). The late morning, midday and afternoon

Right: In Plaka, the old quarter of Athens. The angle of view determines the perspective; in this instance, the architecture heightens the three-dimensional effect (drawing page 18).
50 mm lens on 35 mm, 100 ASA film: 1/250th at f/5.6

Below: A footpath along the Seine in Paris. The kerbstone, wall and row of trees each follow a straight line to a common vanishing point. Both the latter and the horizon are hidden by the pedestrians. The perspective is illustrated in the drawing on page 101.
50 mm lens on 35 mm: 400 ASA film: 1/125 th at f/5.6

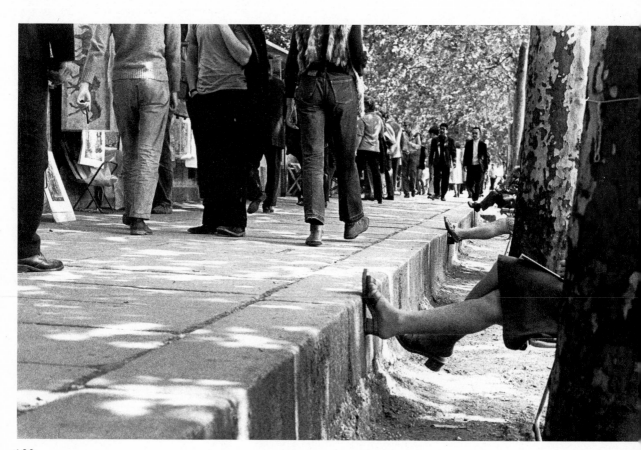

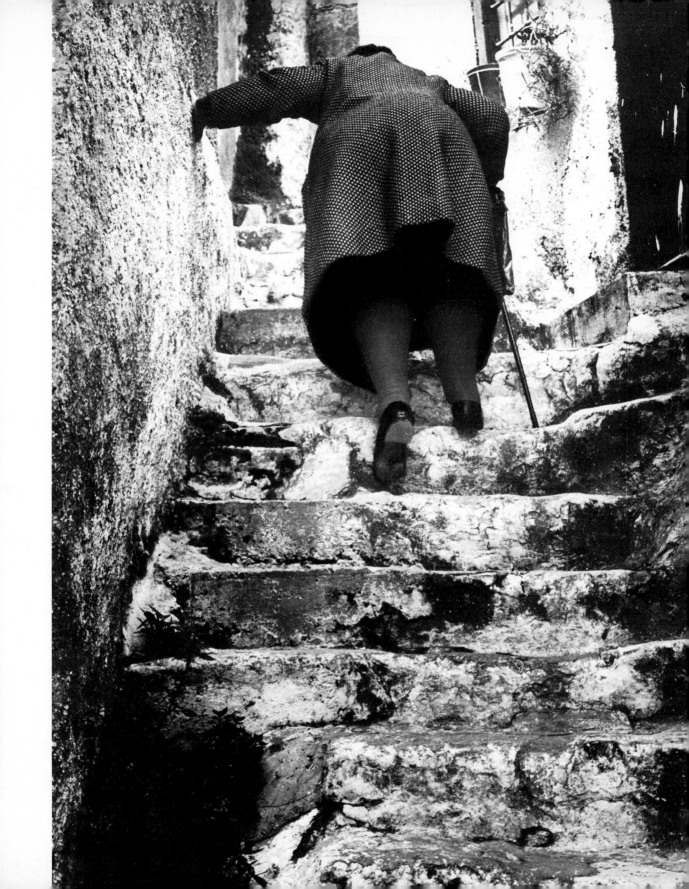

sun casts shorter shadows than the early morning or evening sun.

As already mentioned, one characteristic of colour is that it looks stronger, the flatter it appears (page 105). The opposite applies to subjects characterized by perspective foreshortening and by clear vanishing lines and points; they are seen at their most effective in black and white (pages 16, 102, 103). Planes which emphasize depth are easier to separate clearly in black and white than in colour. Light shades — white and light grey — stand out in the foreground, dark grey and black sink into the background, while medium shades of grey recede into the middle ground. Black and white is far easier to photograph three-dimensionally than complicated colour variations. Here again differences are noticeable. Warm, active colours — red, orange, yellow — stand out in the foreground; cool, passive colours — blue and violet — sink into the background; neutral colours — green and crimson — remain in the middle ground. However, it is very difficult to build up a three-dimensional picture in order of colour importance owing to the vast number of colours and their countless different shades (pages 117, 136).

The surfaces of the wall, window and pavement show no perspective distortion. The girl's legs and dress are also seen from the front to give a straight, flat composition despite the contrast between organic and inorganic shapes. See composition drawing on page 101.
135 mm lens on 35 mm: 160 ASA colour transparency film: 1/60th at f/5.6: Diffuse daylight.

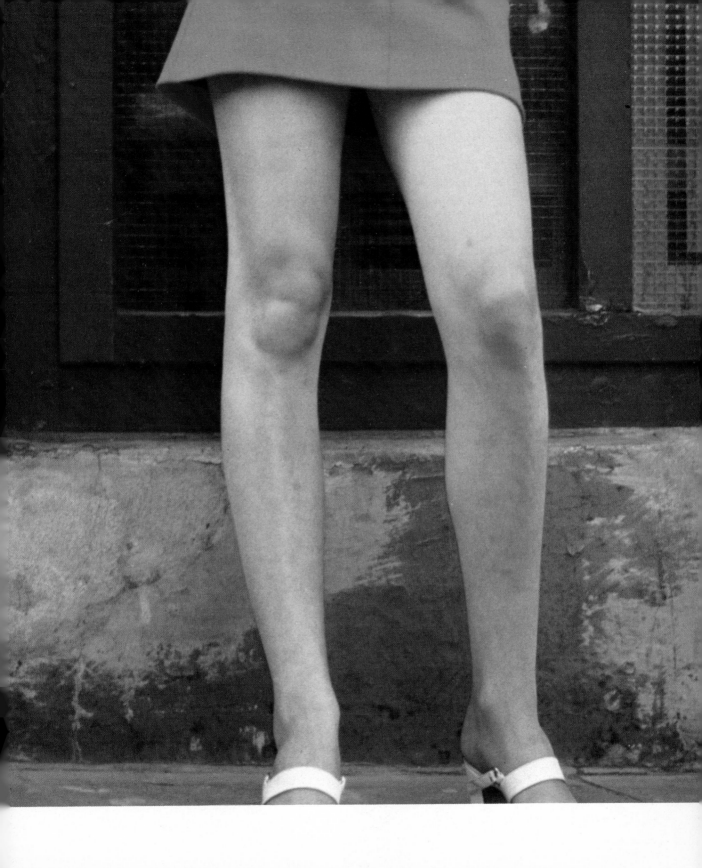

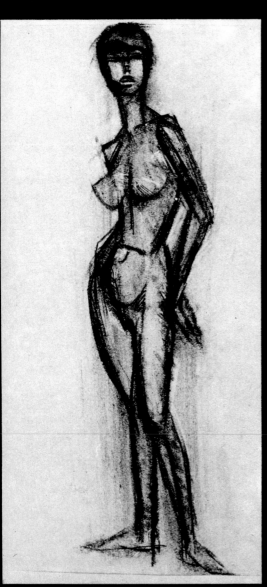

a

masks during enlargement.

The rectangle is the commonest picture format; the majority of all printed matter is rectangular, from a matchbox to a poster. However, this does not mean that a square photograph is worse than a rectangular one. The composition — in other words the sum of all the shapes, not just one from the whole — determines how good or bad a photograph is. Even an *empty* format consists of four sides of specific lengths: this surface area in itself defines a basic situation. The rectangle or square which I see in my focusing screen or viewfinder immediately forces me to translate a three-dimensional perspective impression into a flat, two-dimensional picture. The choice of an upright or horizontal rectangle (pages 13, 23), an extremely narrow rectangle or one which is almost a square, (pages 128, 129) or a square (pages 20, 125) can make a big difference to a photograph. When faced with the task of relating the subject to the picture format, a few very simple points need to be considered.

a) I have in front of me a person who is to be photographed standing up. The background is left out of consideration for the time being. An *upright rectangle* is therefore an easy decision. If the negative format is square, allowance must be made for trimming on either side.

b) The subject is lying lengthwise. The photograph is to show the subject full lenght rather than a closer view. Here again, the decision is easy: the choice is a rectangle, horizontal this time. If the negative format is square, some of the area along the top or bottom edge will not be needed.

c) The person is sitting. The decision is more complicated in this instance since either the rectangular or the square format can be used, depending on the angle of view chosen. If the correct choice is not immediately obvious, several photographs should be taken until

precisely the right one is found. If different negative formats are available when using this method, a change of lens and camera often works wonders!

There are rules of thumb for dividing up surface area; these are the golden mean (pages 69, 89), the central axis (page 170), the line of the horizon (page 158), symmetry (page 48), lack of symmetry (page 159), rhythmical components (page 34) and rectilinear, diagonal or vertical components. The *importance of colours* must also be considered when dividing up surface area and space because the overall shape is not always a matter of *straight* or *curved* outlines. In the photograph on page 20, for example, the diagonal formed by the seated figure and the cast-off shoes only makes photographic sense against the large blue, poster-like surface.

In the photograph on page 109, horizontal and vertical lines divide the rectangle into a number of smaller rectangles. Perspective foreshortening of the latter toward the bottom edge provides a three-dimensional counterbalance to the patches of red and blue in the top half of the picture.

A composition can also be defined as follows: when a subject is photographed in an upright rectangle, a quite definite idea, that of aspiration, lies behind the composition. When the sames subject is shown in a horizontal picture, a completely different concept - that of rest or

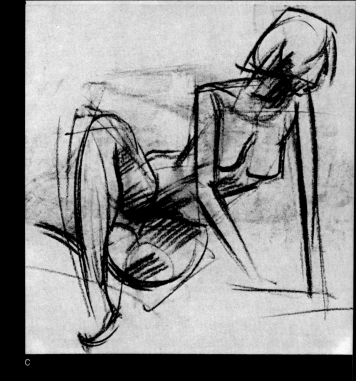

c

oppression — is implied. Square photographs project yet a third idea.

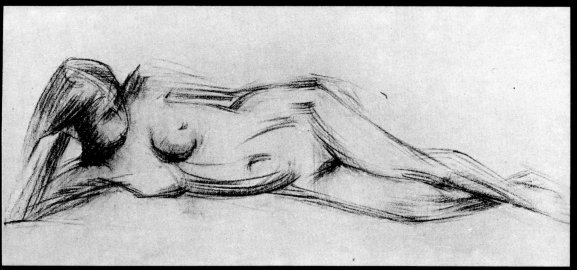

b

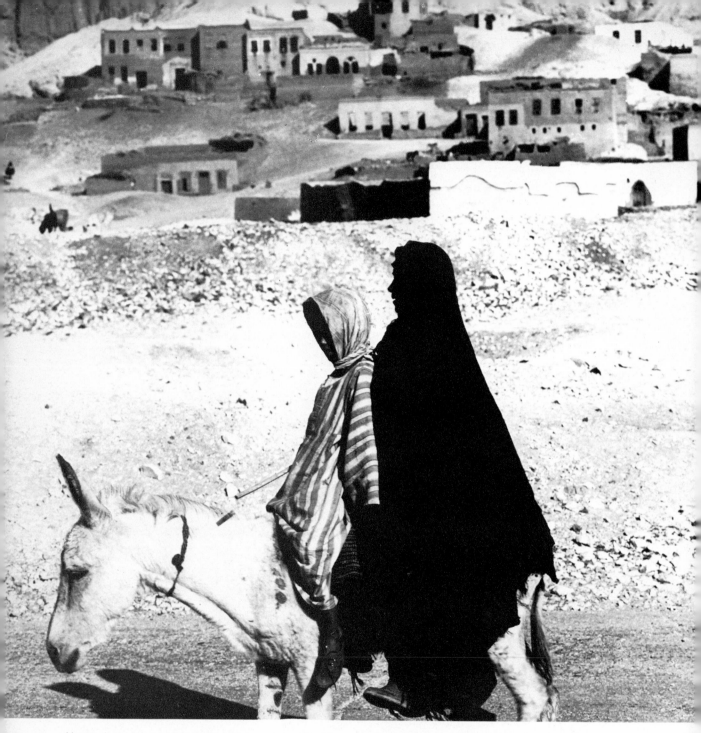

*Above: A square negative format leaves room to decide on the final format. In this case no trimming was
necessary.*
250 mm lens on 6×6 cm: 125 ASA film: 1/500th at f/5.6: Strong sun at the edge of the Sahara.

Right: Upright rectangular composition, subdivided into smaller rectangles by the windows.
150 mm lens on 6×6 cm: 50 ASA Colour transparency film: 1/250th at f/8.

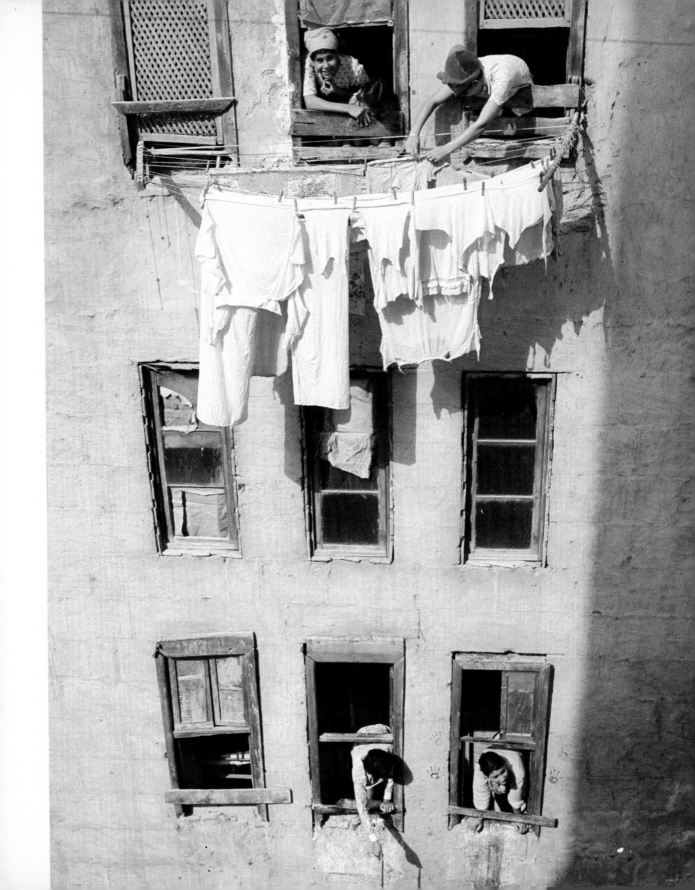

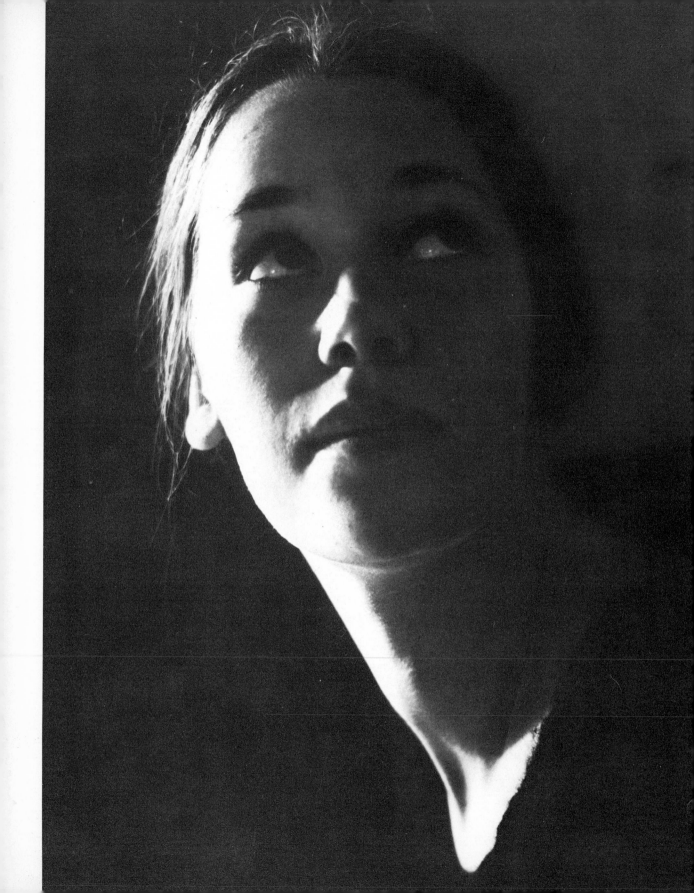

Rhythm

Music immerses mankind in rhythm, it flows in his blood; his movements are rhythmic; his heart and pulse throb to the same beat (or so it seems) and his body, roused by the rhythm and borne by the beat, begins to dance — swinging, circling, arching, turning, looping, curving. The geometric figures of the dance and the music which incites them are like the rhythmical shapes of a picture, each moving up and down, together and apart, twisting and shifting, flowing and merging. A movement has a beginning and an end; between the beginning and the end, the curve of the movement — the rhythm — is shaped. It shows direction and can be expressed in lines.

In the photograph opposite (page 110) the rhythm flows in a curve from *below upwards*. The upward movement comes from the turn of the neck and head and is enhanced by the upturned eyes. The side-lighting highlights the flowing movement.

There are other, different rhythms to discuss.

The detail photograph of an eye (page 88) consists of various circular patterns formed by the iris, the pupil and the surrounding curves of lids and brow. The eyelashes also harmonize. The subject is recognizable for what it is from the drawing, which shows these patterns in lines.

In the photograph on page 113, the line flows from *top* to *bottom*. It is explained by the increasing size of the persons depicted. The foreground — showing the youngest member of the family scene — is the most important part as regards both surface area and sharpness; it stands out from the rest. The middle plane — showing the girl — is no longer so clearly visible

Above: Showing the flow lines of the photograph on page 110.

Opposite page: 160 mm plus 21 mm extension ring on 6×6 cm: 100 ASA film: 1/60th at f/4: Side-lighting from a 500 w filament lamp.

Below: Drawing of the pattern of the photograph on page 88.

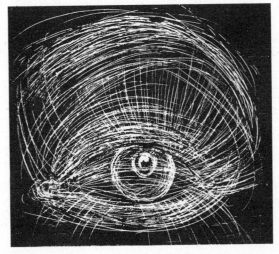

Above: Showing the flow of lines of the photograph on page 113.

Below: Showing the pattern of the photograph on page 96.

and it is smaller in surface area and less important. The least significant is the mother of the two children; her face is seen only as a blur which is proportionately smaller and pushed into the background. However, all three subjects are equally important to the flowing arrangement of the picture because the foreground would be quite uninteresting without the middle plane and the background. The flowing line, which is lit up against the dark background and forms a curve, was obtained by placing the subjects one behind the other in a staggered line, moving from small to bigger, to biggest.

In the photograph on page 96, "Girl's figure with light reflections", rhythm is again evident in the form of overlapping and floating orange circles, and in the movement of the foreground drapery as it swings from the top edge of the picture downwards, then out in a curve towards the right-hand corner. It is in direct opposition to the gracefully rising, yet inherently downward, flow of the girl's figure.

On page 141, in the photograph "Nude figure in oblique lighting", the supported, yet free-standing, position of the model's upright body produces rhythm and lines of light. The line of the landscape flows in the form of a question mark; it swings from the top left to the model's head in a short curve and then back from the most brightly lit point and along the body into a broad sweep of grassy area. Finally it swings back again from the left side to the bottom edge before sweeping upwards a little.

Right: The problem of photographing several people at once can be solved neatly by arranging them in a pattern such as a row.

150 mm lens on 6×6 cm: 200 ASA film: 1/60th at f/4: Poor daylight indoors.

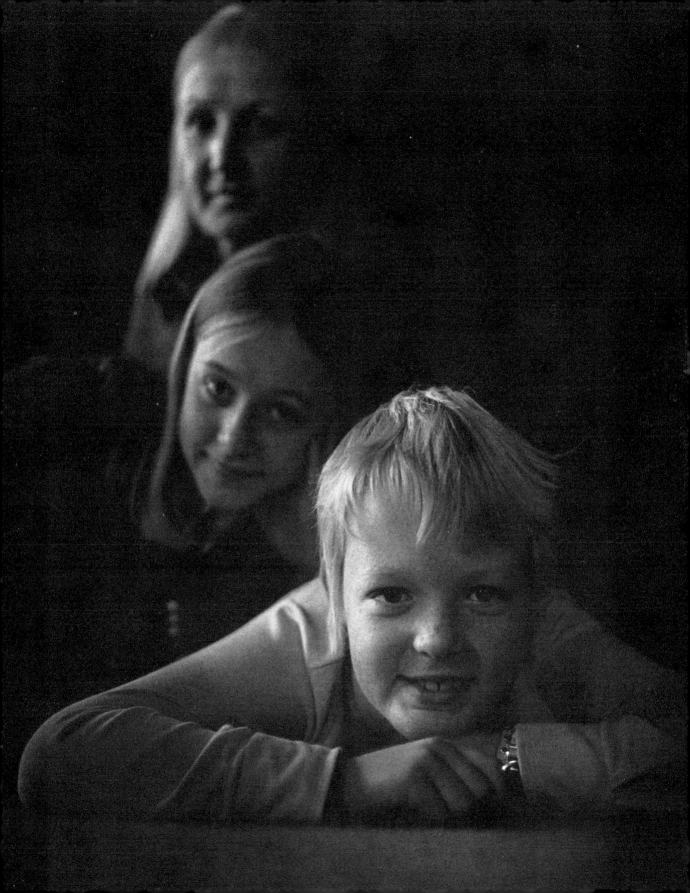

The flow lines of the girl's portrait on page 185 are quite clear. They follow the oval of the head and pullover neckline and the large and small curves of the shoulders.

Left: Flow lines of the photograph on page 185.

Below: The directional lines of the photograph on page 141.

(Left: Position of the body in its surroundings. Right: The flow of light.)

5

Photographic subjects

Figure studies

Everyone has at some time had the experience of catching a distant glimpse of someone in the street and recognizing the person immediately. At first only a shape is discernible yet, even without seeing details of face and clothing, it is beyond doubt Uncle O or Aunt B, your wife or a neighbour's child.

A person's stature, height, proportions need not be outstanding for him to be distinguishable from other figures even at a distance. A person of unobtrusive, average stature is easily recognized from afar. By and large, only the essential features are seen and unimportant details are disregarded, even from some distance away. A person's *bearing* is also highly individual; he may be sturdy or graceful, serious or arrogant, bent or straight. Another characteristic is body *movement;* it may be agile or clumsy, tense or relaxed. A person is, in fact, typified by his entire way of moving, as expressed so characteristically in dancing.

A person's appearance is further characterized by his clothes. Clothes make a figure interesting (page 13). In the photograph opposite (page 117) the attractive colour and drape of the dress emphasize the girl's figure. The body structure of the supporting leg and the resting leg, the function of pelvis, chest and arms as supports — in brief, body statics — are discernible under the dress.

Half and *three-quarter length* studies can emphasize the figure just as well as *full-length* studies (pages 59, 199); sometimes legs make a photograph (page 105).

The figure as well as the head may be important in a portrait. Here, however, the figure study is to be regarded as having representational value independent of the portrait. The photograph of the negress on the opposite page (page 117) is a figure study, not a portrait. The following photographs are also chiefly figure studies: the flow and dress of the figure on page 96; the submissive reclining figure of the girl on page 67; the sturdy figures on pages 16 and 70; the acrobatic turn of the body on page 132; the figure as an abstract element of composition on page 52.

The last photograph mentioned, the negro in the night club, makes it obvious that detail can be omitted in certain figure study experiments. Nose, mouth, eyes, neck or entire limbs may be shown less sharply to enhance colour, darkness, rhythm or body structure. It is of no consequence provided the omission results in a figure making a good photograph.

"Théâtre du Soleil" in Paris. The large hall with its stage requisites was a suitable place for figure studies.
80 mm lens on 6×6 cm, 160 ASA colour transparency film: 1/60th at f/2.8: Weak daylight.

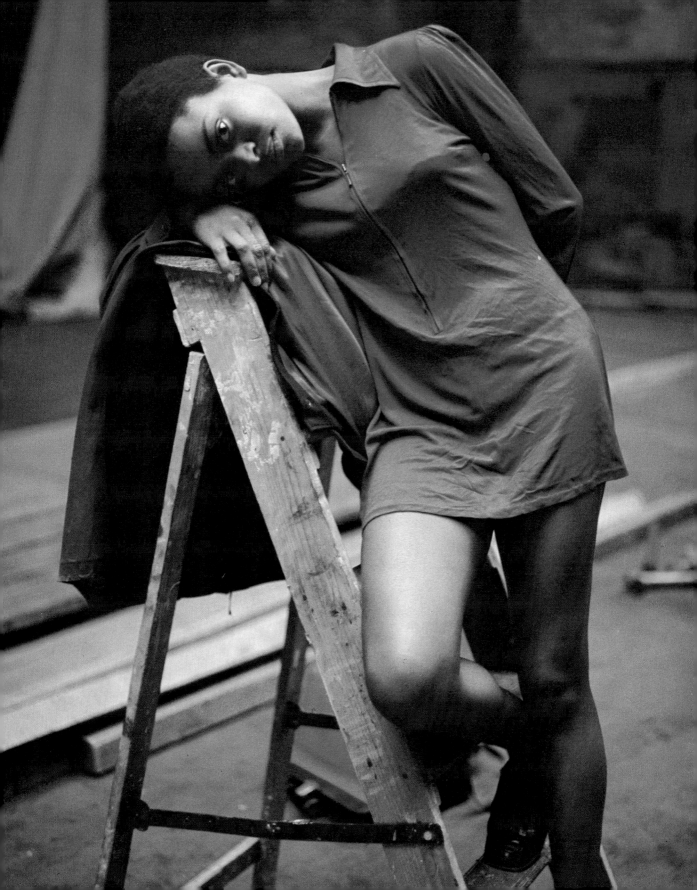

Portraiture

A well-to-do furrier once commissioned from me three drawings of herself for completion by Christmas. Two drawings were to be given to relatives as Christmas presents and the third was for the wall of her drawing room. A suitable payment was agreed verbally before the first stroke had been drawn. I had not even decided which material — oils, pastels or chalk — would best suit the lady when she cheerfully pulled some postcard-size colour photographs of herself from her crocodile-skin bag and pressed them into my hand. They showed my client in carnival mood with furs draped round her shoulders and champagne glass raised. Pleasantly she suggested that perhaps something of their gaiety and exhuberance could be shown in the three portrait drawings or paintings, since she was really just like that. To make the point, she set her shoulders back as if ready for anything. She added affably that if I wished to include the champagne glass it would suit her nicely and, if necessary, she would hold a glass in her hand during the sittings. Not all the time, though, because then it would be too tiring, but she could look as if she were drinking my health while I was painting or drawing.

Why am I telling this story? Because I believe that every *commission* for a portrait, whether a painting or a photograph, paid for or not, implies that it is for representational purposes. The desired — or, more accurately, the commissioned — portraits are not always intended for a drawing room wall, of course. They may be simply for display in the transparent pocket of a wallet or purse — the customer's own or that of a girl friend or boy friend — or they may stand on a bedside table. Miniature photographs may be pasted up in the fiancé's, wife's or husband's car as if to say: "Here I am. Think of your loved one! Drive carefully!" The portrait may be displayed in any other form capable of showing a three-dimensional person in two- dimensions — from postage stamp size to postcard size or even poster size.

Whatever the purpose of a portrait, it must have a positive effect since only a flattering image fulfils its representational objective. Unflattering portrait photographs, no matter how typical, are best used for police purposes and other official documents, other wise they will end up in the wastepaper basket. Every portrait commission,

In the case of this Swiss artist, the aim was to concentrate on his magnificent forest of hair. The perspective used — a rather low-angle shot — also shows clearly the compact mass of the head. A square photograph format seemed to suit the purpose.
150 mm lens on 6×6 cm: 100 ASA film: 1/60th at f/4: North light in a studio.

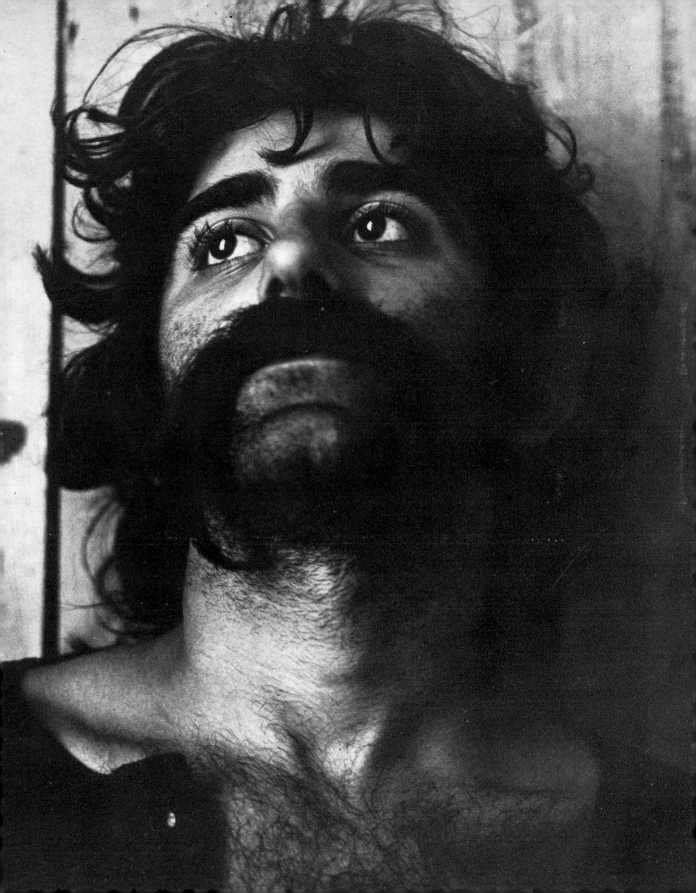

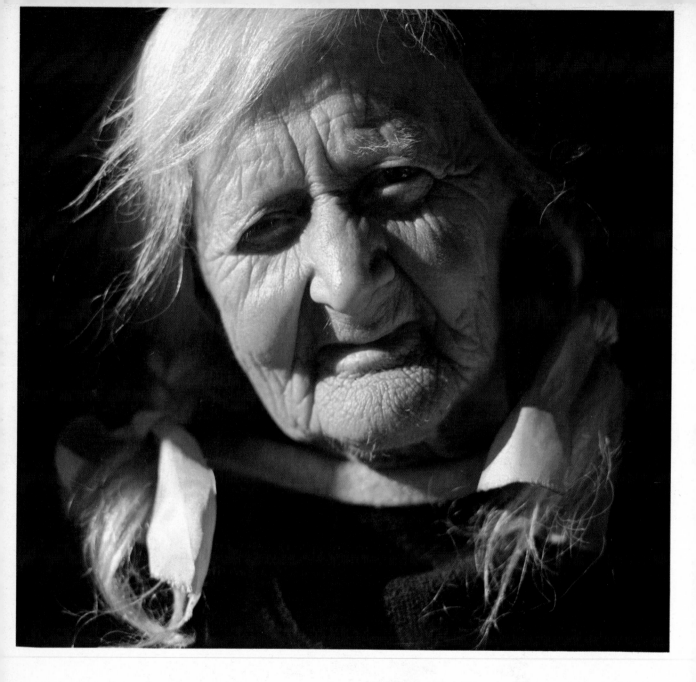

even the most important, involves the distasteful matter of vanity, based on the mutual, silent or clearly expressed understanding that an unfaithful but flattering portrait is preferable to a faithful but unflattering one. (Agreements to the contrary are rare, but the exception proves the rule.) Even when a photographer takes a portrait photograph to please himself alone, and entirely in his own time, he has a purpose, which is to

The photographer likes to make a portrait as characteristic of a person as possible. The head is usually the subject's most individual feature (left) but the figure may be no less typical (right) and at times even more typical than the head. If this is the case, a full-length portrait should be taken.
Left: 150 mm lens plus 21 mm extension ring on 6 × 6 cm; 50 ASA colour transparency film: 1/250th at f/5.6: sunny daylight.
Right: 50 mm lens on 35 mm, 200 ASA film: 1/500th at f/5.6.

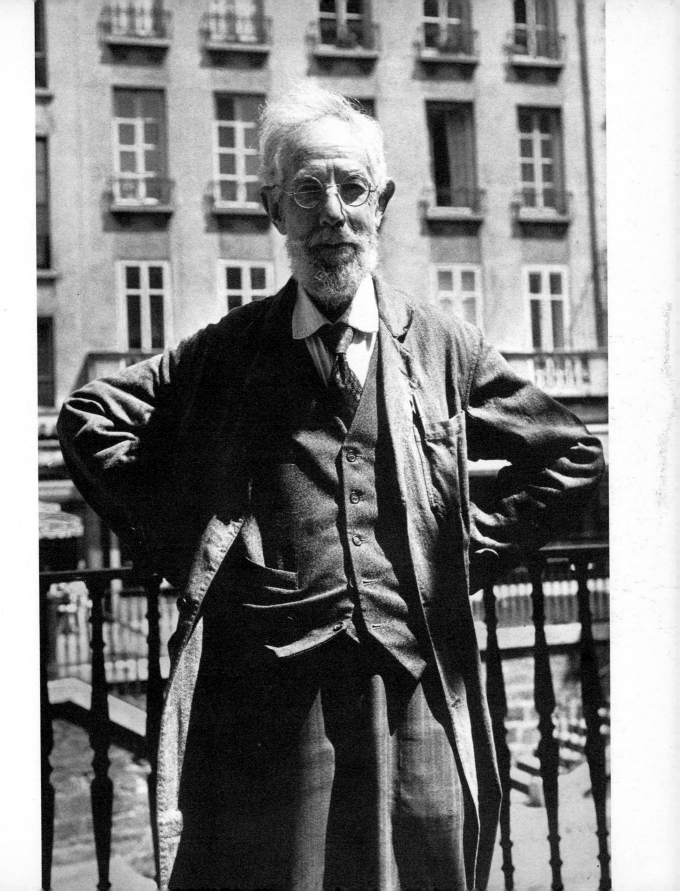

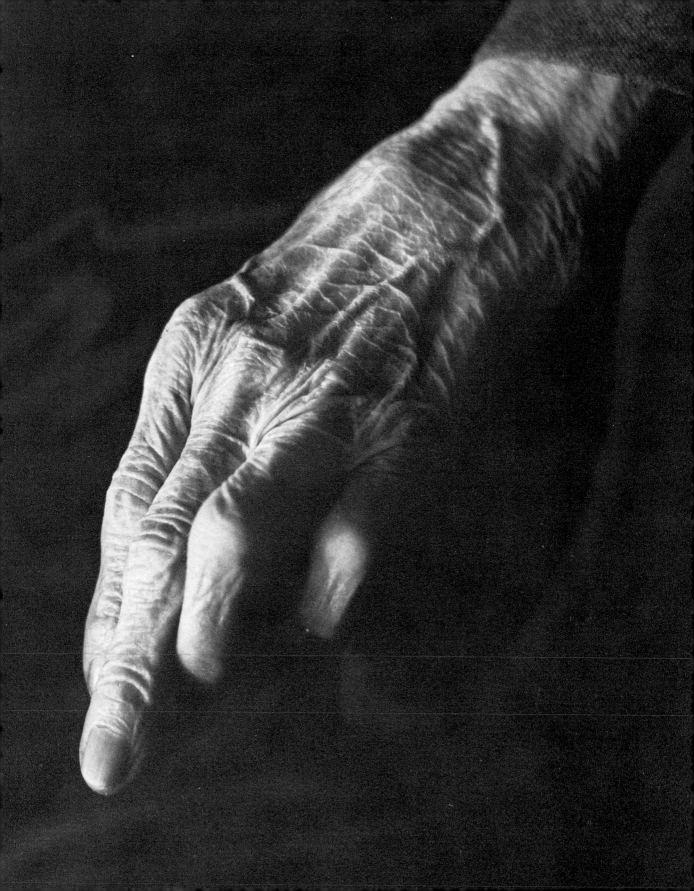

depict his chosen subject — or just one feature of the subject (page 122) — as typically and as characteristically as possible. This end should of course justify *any* means, particularly that of faithful representation.

Perhaps it is not really so very difficult to pick out something unique, something typical in another person - those characteristics which distinguish him quite clearly from other individuals and which make him stand out from the crowd. They enable us to recognize a person at a glance and to say simply "yes, that's him". And if a second or a third person recognizes him from the same features, these will be his distinguishing characteristics. Yet difficulties arise when the chosen features, rightly or wrongly presumed to be characteristic, have to be expressed in a drawing or photograph in the form of a portrait. When I was a student learning to draw and paint portraits, I found that I did not know what to make of my model - nor of myself. My instructor then described the *model's importance* to me as follows: "That head must become your world! There are things happening in it!" Another occasion, when I was just drawing without being at all critical and without paying the slightest attention to the model's proper shape, he said: "You cannot treat something as unique as a person as if it were just anyone! Before you begin to draw, you must try to become completely detached. Walk round the sitter once, twice, as many times as you like and look at him very carefully! And only when you feel that you have seen enough, that you know your subject by heart, should you go straight ahead and draw; and then the more boldly you draw the better!" Can any better advice be applied to photography?

Another difficulty develops between photographer and subject when the latter notices that the photograph is not going to be taken from his "best side" and he thinks that the photographer is trying to see behind his façade. The subject may feel so annoyed in this situation that he is no longer himself. (Only very few people show no sign of their feelings in their faces.) Even when every effort is made to reassure the sitter about the "unfairness" of the photograph, such attempts usually cause him to adopt a pose which does not reflect his feelings. Affected friendliness in front of the camera is far worse

Fortune tellers are not alone in reading hands; photographers also find the hand a most expressive feature.

Left: Old woman's hand. 150 mm lens plus 21 mm extension ring on 6×6 cm: 200 ASA film: 1/60th at f/5.6: Daylight indoors.

Below: Trainee model's hand. 150 mm lens plus 21 mm extension ring on 6×6 cm: 100 ASA film: 1/30th at f/5.6: 500 w filament lamp as side top-lighting.

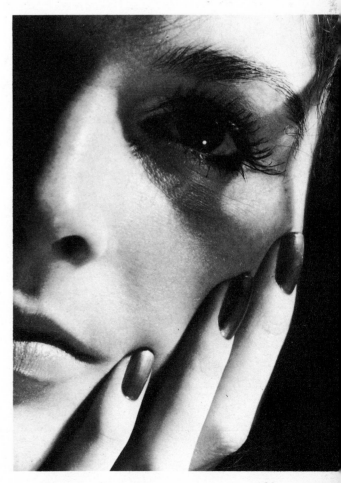

even than a poker-faced grimace, which may look comic. In portraiture it is advisable that one of the participants — the photographer — forgets himself completely, and puts himself in the other person's place. The subject, for his part, should not affect an unnatural mood; he should remain true to the sort of person he is. It would be ideal if the camera and its operator could be invisible so that the subject need not be aware that he is being photographed. The easiest way to photograph a subject at his most natural is to use a telephoto lens. It may also be useful to go to see the subject in his own surroundings; he is usually more himself there

Right: A person can be characterized by considering where his or her heart lies. Photographed with hazy backlighting.
80 mm lens on 6×6 cm, 50 ASA colour transparency film: 1/125th at f/5.6.

Below: A "face full of character" also tolerates repeated re-copying of the normal enlargement on to lith film, as in this case. See page 76 for the technical data.
30 ASA lith film processed in a lith developer.

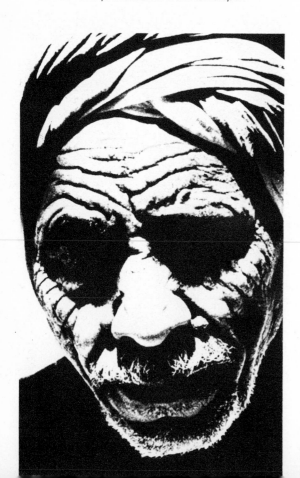

than in the atmosphere of a photographic studio. His *natural* surroundings are usually the "four walls" within which he feels at home (pages 113, 174), but they may also be the street or place where he lives (pages 82, 121). His place of work (page 64), the places where he spends his spare time (pages 125, 145), or any place to which the subject feels attracted will make a suitable setting for a portrait (page 171).

A more comprehensive idea of a person can be formed in this way, even though it indicates only the *means* and not the *end,* than by staying exclusively in the studio. The photographer will also meet people who would never go to a photographic studio of their own accord because they consider themselves too poor, too ugly or too old; or because they cannot imagine that such places exist. Such encounters provide both photographic experience and human experience. They gainsay any stereotyped ideas about portraiture (page 120) and this in itself is a refreshing experience.

It may be that the purpose of such studies is to find a perspective which shows clearly the cubic structure of a head (page 25, 119). It may be that the shape of the head is shown in clear relief (page 14) or mottled (page 42), or that an attempt is made to typify a person by showing him against specific colours (page 52). Even though such studies may not exhaust the concept of portraiture and even though they may be only *heads* or *figures* which are not definitively *portraits,* they show that any characteristic aspect of a person is definitely worth photographing.

Old people are the easiest to photograph in a way expressive of the person concerned because their characteristic features are very pronounced. The study of portraiture should therefore not be made unnecessarily difficult by photographing only young people or beautiful girls. Its objective is attained far more quickly with a "face full of character" (page 27). The more powerful and strong the face is, the better. The technical problems involved are also less daunting; films can be developed to give too much contrast or they can be wrongly exposed but the end result need not be wasted on account of these flaws, since there is a great deal of latitude when photographing a person of character

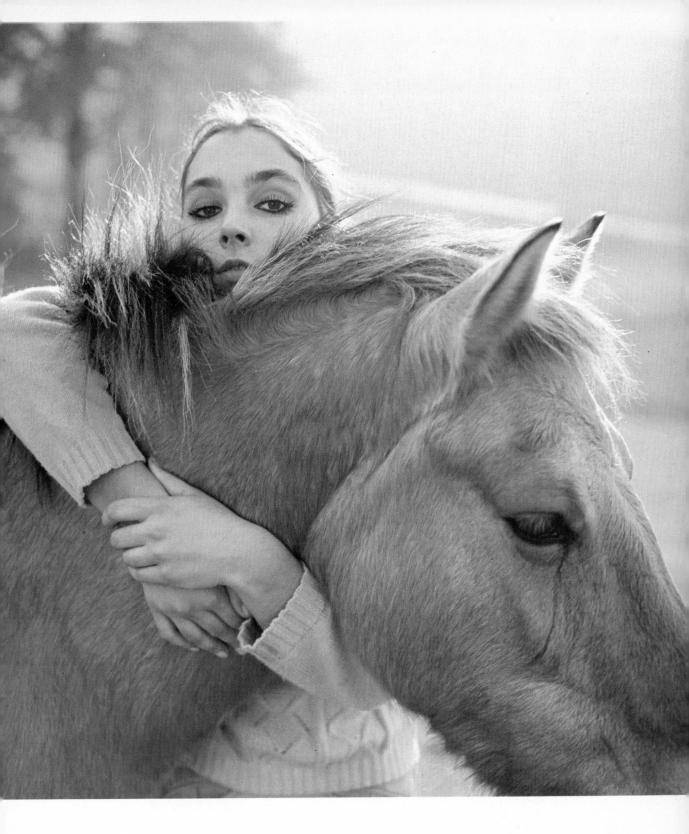

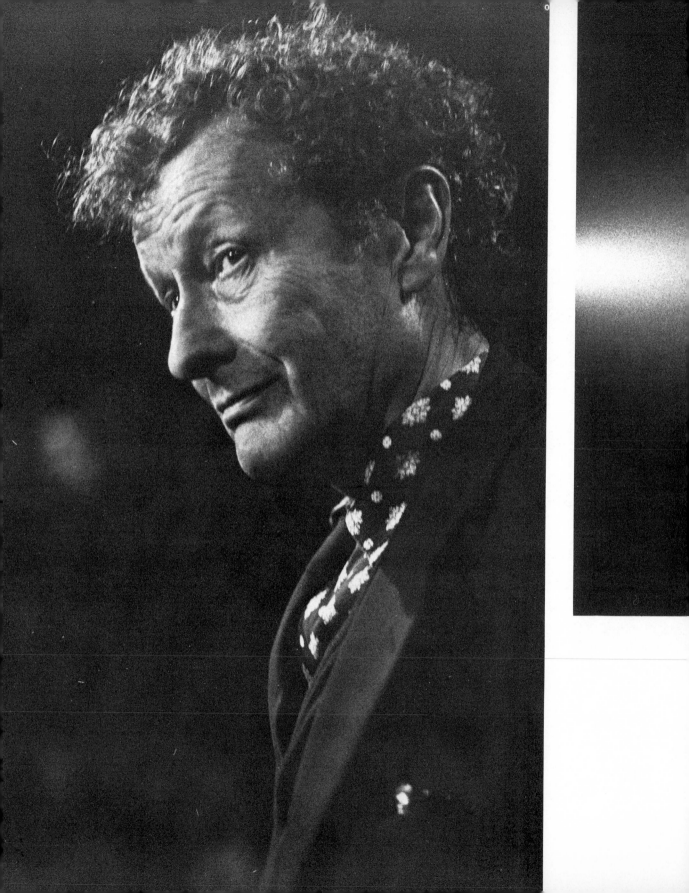

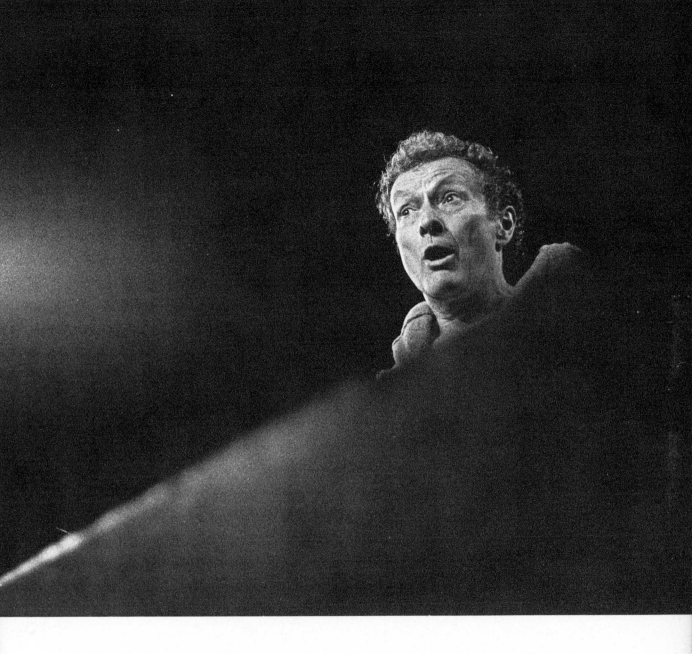

A single photograph can never say everything about a person. A comprehensive series of photographs may therefore tell more. The five photographs of Jean-Louis Barrault (pages 11 and 126-129) show this man of the theatre (director, producer and actor) more clearly than any single photograph from the series.
Photographs on pages 126/127/129:
50 mm lens on 35 mm: 800 ASA film exposed as for 2400 ASA and given a correspondingly longer development time at a higher temperature. 1/60th at f/2.

Photograph on page 128: Jean-Louis Barrault in private.
150 mm lens o 6×6 cm: 800 ASA film: 1/250th at f/11: Hazy daylight.

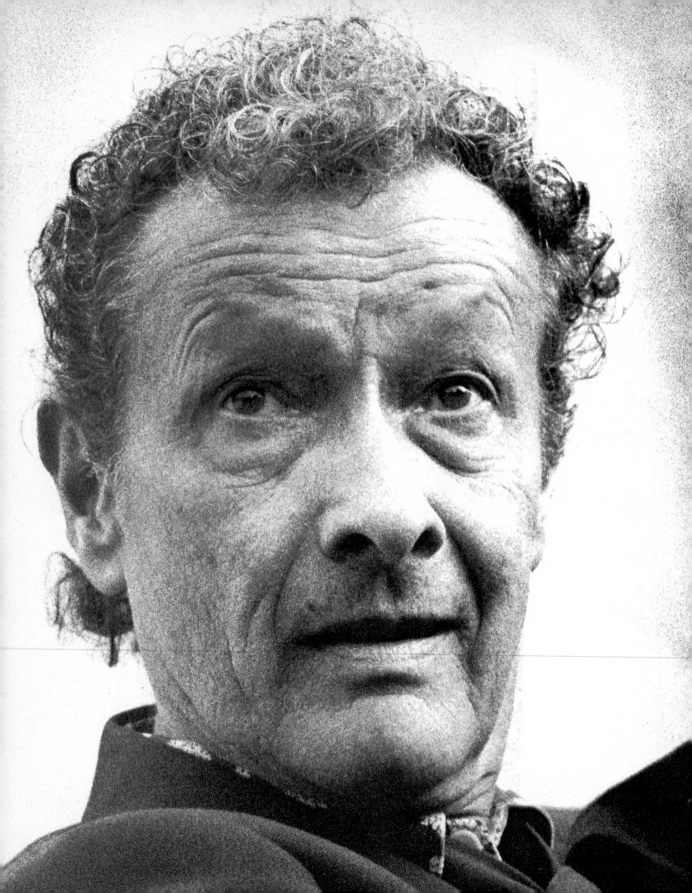

(page 195). To put it briefly for anyone wishing to experiment, beautiful girls are bad news and wrinkled old people are best (pages 77, 124). Portraiture is not restricted to showing only the head; half-length and full-length portraits (pages 56, 70) and every conceivable combination — such as head with hands (pages 58, 155), a person in typical surroundings (page 78), people with animals (page 159) — may be more expressive of an individual and can also be more photogenic than if the portrait is kept strictly to eyes, nose, mouth and ears only. (Olaf Gulbransson required his students to regard nudes as portraits.)

Enthusiasm is a big help with a subject as tricky as portraiture. If it is lacking, the photographer's attitude to the subject is wrong. Theatre producers sometimes prefer their performers to overact rather than underact when they are rehearsing their lines so that their performance extends beyond the footlights right to the back row and any imperfections show up clearly (page 127). Their movements must also be over- emphasized rather than understated if they are to be expressive (pages 121, 150, 175).

The photographs of actor-producer Jean-Louis Barrault are to be regarded as a *series* of portraits (pages 126 to 129). The first photograph which shows him in three-quarter profile is the best likeness; the stage study (page 127) is not really a portrait. However, it complements the other photographs because it represents the portrait of an actor whose stage profession is of importance to his character. The full-face portrait (page 128) is not as good a likeness as the near-profile view (page 126) because Barrault's strong profile — his bulging forehead, protruding nose — cannot be seen so clearly from the front. There is nevertheless something typical of a theatrical person in this photograph — his ambition. The direct side view does not characterize him as well as a compromise between the two extremes. The half-length photograph with the slightly averted profile shows Barrault, the *producer* at rehearsal — rather than Barrault the private man (page 129).

Left and right: Jean-Louis Barrault
(Photograph captions on page 127)

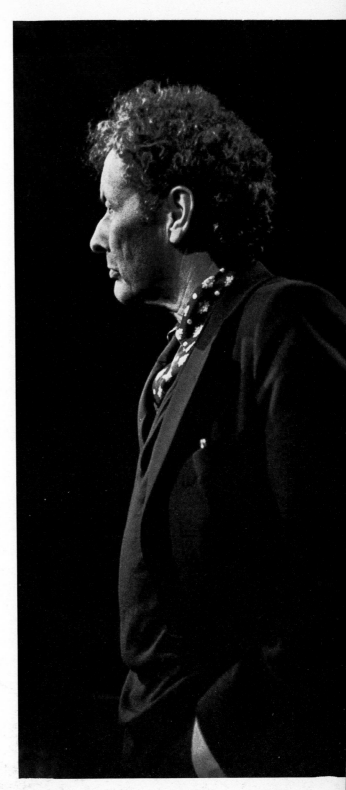

Right: A photograph may have appeal even when children pose for the camera (Urchins from Nubia). 50 mm lens on 35 mm: 100 ASA film: 1/125th at f/2: Backlighting.

Below: Very natural portraits are obtained when children feel at home. 80 mm lens on 6×6 cm: 100 ASA film: 1/125 th at f/2.8; Daylight plus filament lamp.

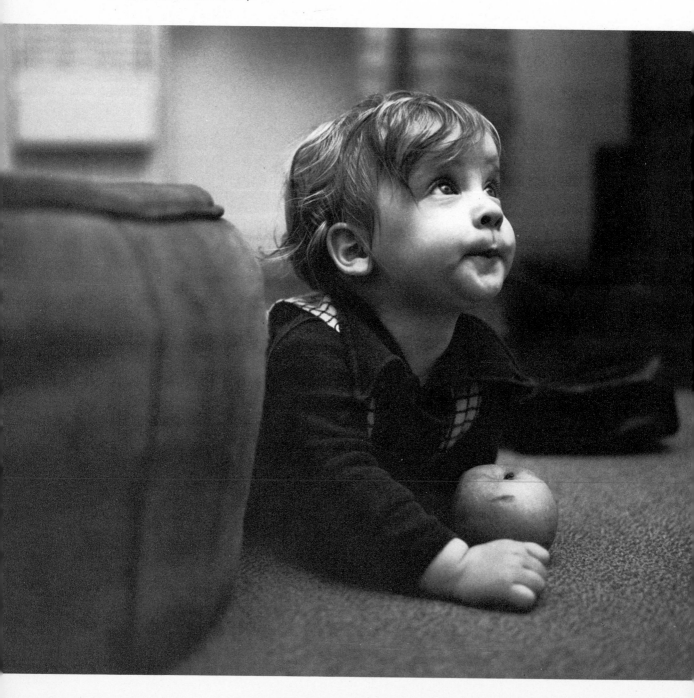

Child photography

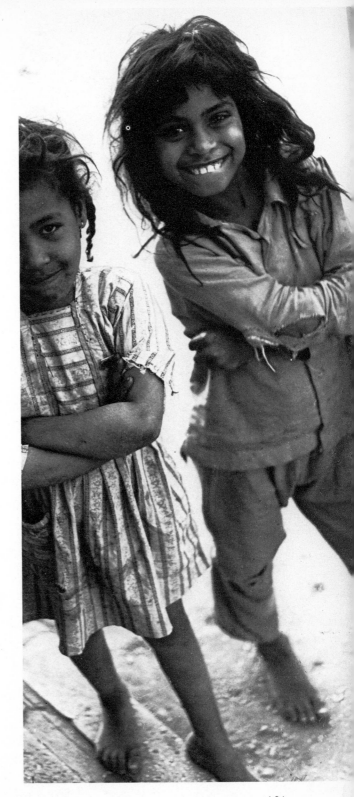

Although children can be photographed like adults as portraits, nudes or figure studies, they are placed in a separate group here. The world of small children is, after all, different from the worlds of adults (page 153).

Anyone who observes children and who observes how absorbed they are in their games (page 93), how they become immersed in the things around them (pages 8, 176), can appreciate their basic preoccupation with everything. Children have not yet been dhtgrted from this preoccupation by affection, airs and graces to the extent that we have; there is no break between them and the world (page 133). Even when children want to *pose* for a photograph — as is often the case in southern countries (pages 21, 131) — or act the fool (page 134), the impression the make is not embarrassing; it can be comic at times (page 132).

Since children's emotions and reactions obviously stem from a particular cause, it is not difficult to anticipate a stumble over an obstacle, the subsequent fall and crying and screaming, and to be suitably armed with a camera at the right moment. At this point let me recommend a camera to those fathers and mothers who feel nervous and helpless when faced with their offspring's screeching manifestation of life. Because when the screaming starts and one of the parents, so armed, steps in front of the shrieking child to photograph him during his outburst, the parent will be amazed at how quickly even the loudest little throat is silenced. The child's entire being is now concentrated on inquisitive inspection of the camera above his head and his anger is completely forgotten. And looking, even when it amounts to staring, is a far quieter manifestation of a child's presence than crying! (page 130).

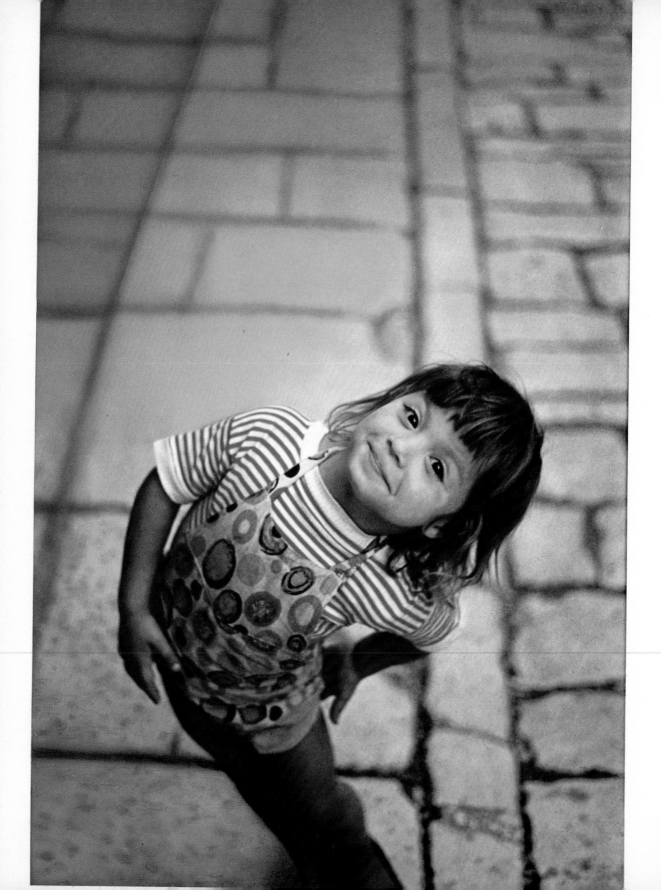

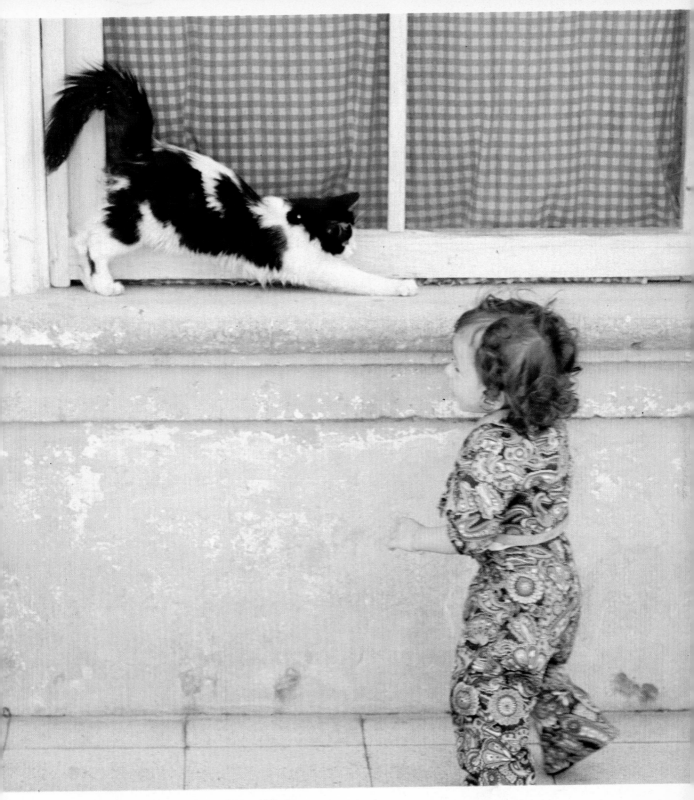

Captions to photographs are on page 135.

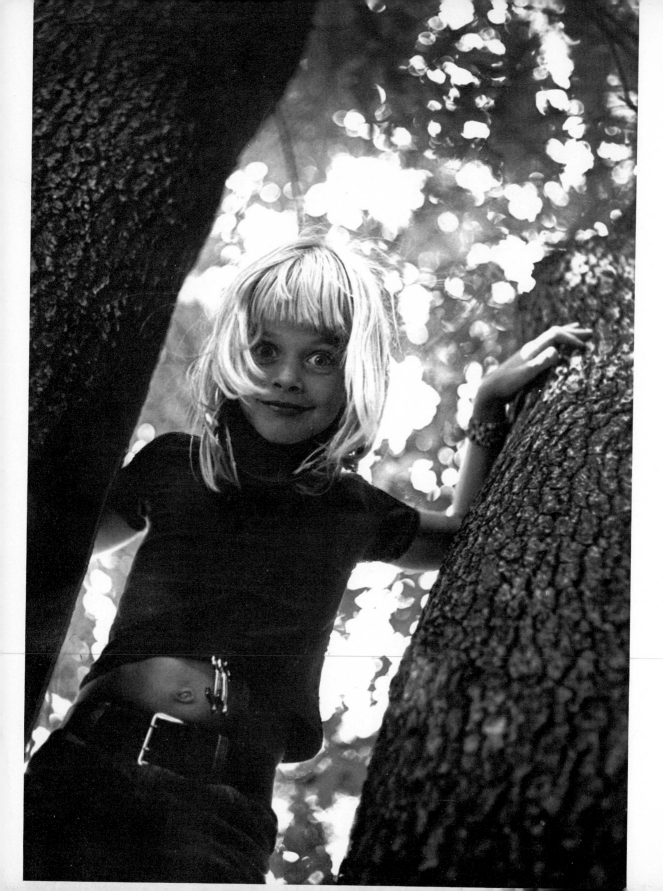

Photograph on page 132: Smaller mortals prefer to look upwards for their points of reference and this gives a bird's-eye view from an adult height.
50 mm lens on 35 mm: 50 ASA colour transparency film: 1/250th at f/2.8: Indirect daylight.

Photograph on page 133: Animals and children react naturally; the photographic moment has to be seized quickly.
150 mm lens on 6×6 cm: 64 ASA colour transparency film: 1/125th at f/4.

Left: Children have characteristics which are naturally displayed when they are photographed, e.g. acting the fool.
Lens: 135 mm lens on 35 mm: 100 ASA film: Backlighting.

Right: Detail from the photograph on page 200.

More delicate emotions and movements can also be sensed with the camera. The large eyes of small children are not equally photogenic at all times. That certain "moment" comes only on exceptional occasions - goodness knows what causes it (page 92). Care must be taken to guard against light reflections in the iris which might lead the little one's aunt to conclude that they are the first spiritual stirrings of her little darling - although they are merely the light from some dazzling object in the vicinity. Allowance must also be made for any slight breeze which makes thin strands of hair look even more transparent (pag 154). These and countless other childhood experiences are kept on permanent record only if they are photographed (page 87).

Less dainty children are equally interesting. Many a photographic problem which can be overcome only under favourable circumstances when working with adults, is readily solved when photographing proper little ruffians (pages 93, 157). Experiments with viewpoint, bird's-eye view and worm's-eye view, are also relevant here. They provide an ideal occasion to test one's own reactions. Admittedly it makes the stiff and the knee tender but that is no reason for leaving the camera at home (page 200).

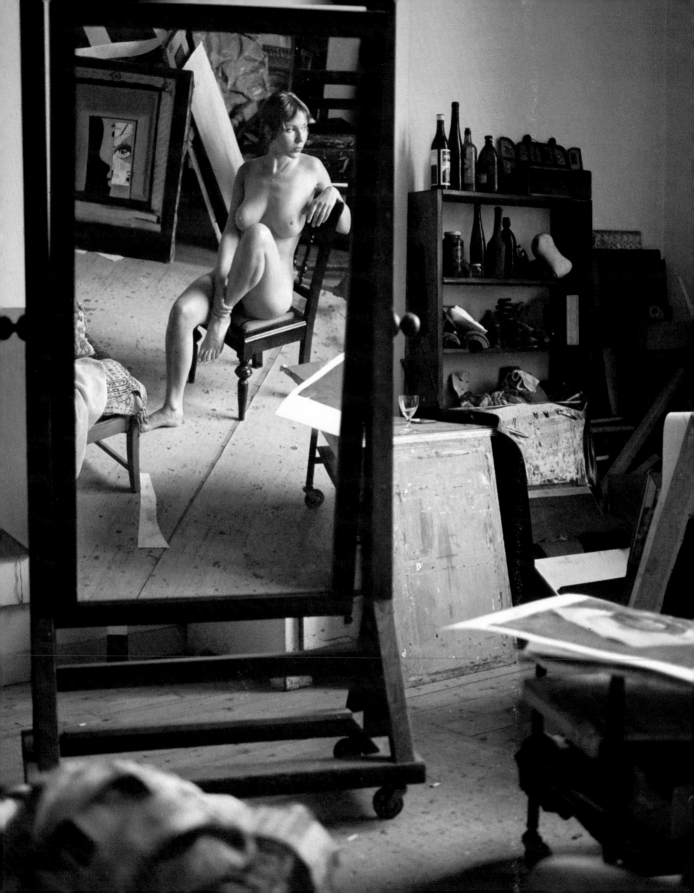

Nudes

In reality, a body is always seen in a three-dimensional situation. A three-dimensional idea of the subject is gained once the photographer has decided which objects — a piece of furniture, a wall or a tree (page 161) — are to stand in front of and behind the model. This is a useful start in nude photography. The nude photograph "In an artist's studio" (left - page 136) is given an illusion of depth by the reflection in the mirror. *Two* areas of space are combined to form *one* picture: one area is part of the actual studio, the other is the reflection which shows the middle ground and the background. The three-dimensional arrangement is not that of the usual photographic composition, since the main subject, the nude, occupies a very small area in the background instead of being in the foreground and filling the photograph as is customary. The photographic colour rule — warm tones in the foreground and cool in the background — is not confirmed here since a cold reddish violet dominates the foremost plane and a warm-coloured note is embodied in the nude in the background. When looking at the picture the eyes involuntarily jump about. There is a desire to bring the nude forward and push back the penetrating violet and acid yellow. An exciting and disturbing effect is produced within the confines of the large frame of the mirror.

Even if foreground and background are rejected in favour of having the nude fill the entire photograph, the body should still to be shown as a three-dimensional subject with height, breadth and depth. Three-dimensional aspects are less readily seen when the model is standing (page 48) than when she is crouching, sitting or in some other less relaxed position (pages 72, 142, 197). It is always useful to think of the parts of the body as cubes and to arrange the lighting. The legs can be thought of as columns, the pelvis and the trunk as a square and a cube, the neck as a cylinder, the head as a sphere and the arms as tubes (pages 47, 163). Of course, the structure of the human body is really complex but reduction to simplified geometric surfaces and shapes helps to train the imagination (see drawings on pages 73, 162).

It also facilitates considerably an understanding on *how the body works*, of how the parts behave in relation to each other. If we consider the example of a nude model in a standing

In an artist's studio.
80 mm lens on 6 × 6 cm; 50 ASA
colour transparency film; 1/15 at f/8;
north light.

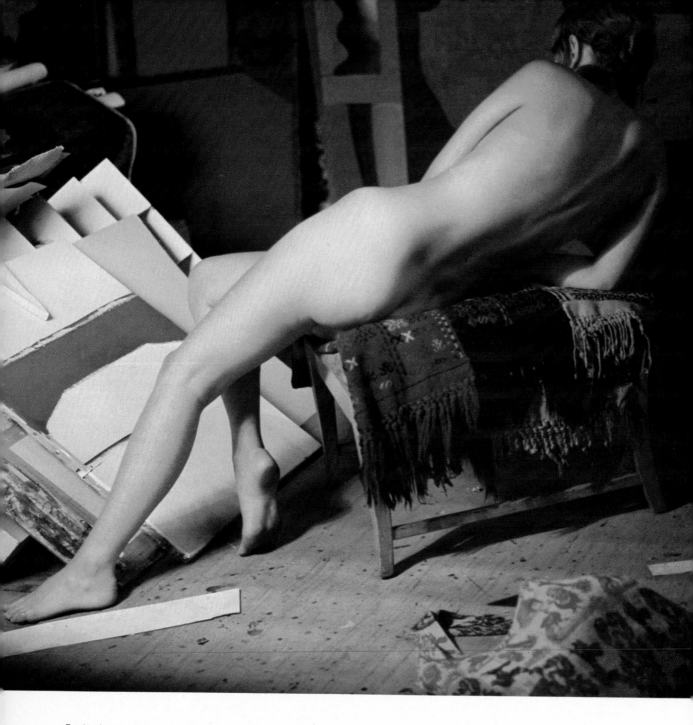

Both photographs were taken in combined daylight and artificial light using daylight transparency film. The seated nude was lit from the front by a 1000 W soft beam. The kneeling figure was lit from the side by a 500 W photographic lamp. The additional daylight was important as scattered light, — because of its brightness value and because of its effect on the colours ("Mixed light").

Left: 150 mm lens on 6×6 cm; 160 ASA colour transparency film: 15th at f/5.6
Right: 80 mm lens on 6×6 cm; Aperture: f/2.8 at 1/60 Film speed: 18 DIN. Colour transparency

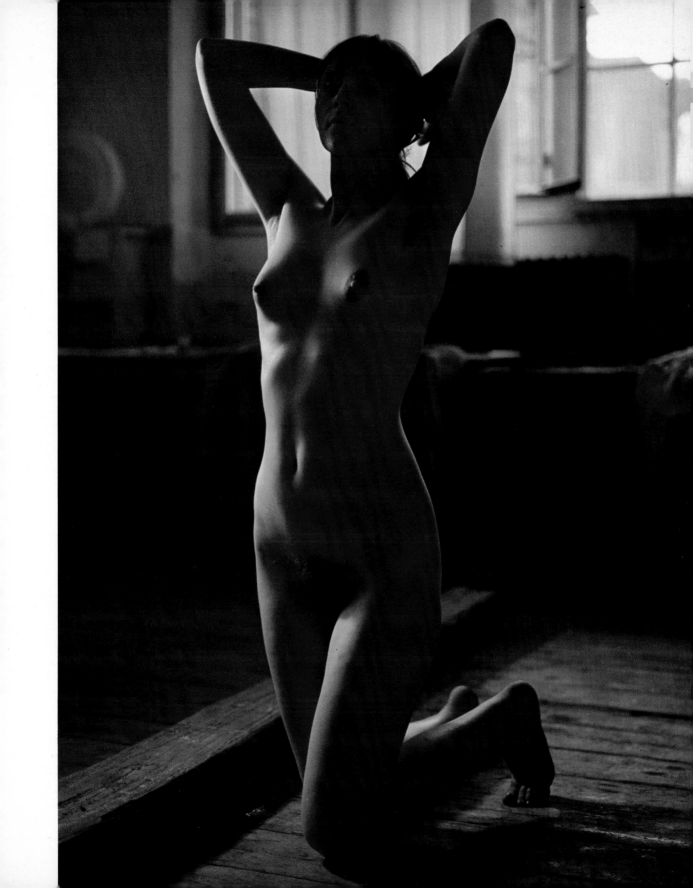

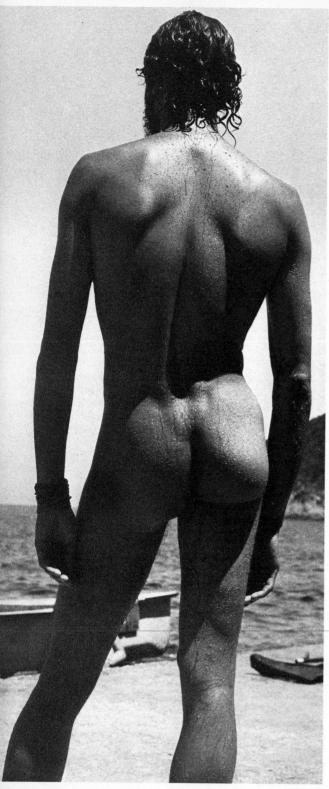

position and resting on the supporting leg, with the other leg free to move, we can see clearly the significance of rhythmical characteristics, laws of support and load, counterpoise etc. in the living body (pages 140, 141). When *one leg takes no weight* the *supporting leg* and pelvis move outwards; the pelvis assumes a sloping position and the line of the shoulders tilts in the opposite direction: this is best seen directly from the front or back (drawing page 143). The head inclines to the side to redress the balance as a counterpoise to the top of the body which bends the shape of an S; this is seen most clearly along the spine. The seventh cervical vertebra then lies vertically above the heel of the supporting leg. If a vertical line is drawn between these two points, the axis obtained is the equivalent of the stick on which a grapevine climbs and finds support. We are now entering into the science of forces in equilibrium or that of stress and strain in load- bearing structures. They form part of the study of statics and are also important to the photographer. Deliberate photographic composition is possible only when points of overlap are clearly visible and points of separation are quite distinct. To compose means to put together. This can be achieved only with knowledge of the individual parts, the building blocks, and with the ability to distinguish between them (page 164).

The photograph on page 138 shows a composition in which the nude fills the entire format but diagonally from top right to bottom left. The shape is not affected by the supporting arm and bent leg which prevent the body from slipping. Similarly, the shorter diagonals in the background strengthen the main diagonal, because they run in the opposite direction. There is little depth but the modelling on the figure gives form and shape. This effect was achieved with a 1000 w soft beam of one metre (3.3 ft) diameter. The light source was round and cast light over a broad area. There was also some very soft daylight shining into the room from the studio window. The photograph was taken on daylight reversal film which explains the predominantly warm and monochrome character of the colours. The kneeling nude figure (page 139) is interesting on account of its atmospheric effect. It was

Photo captions on page 143

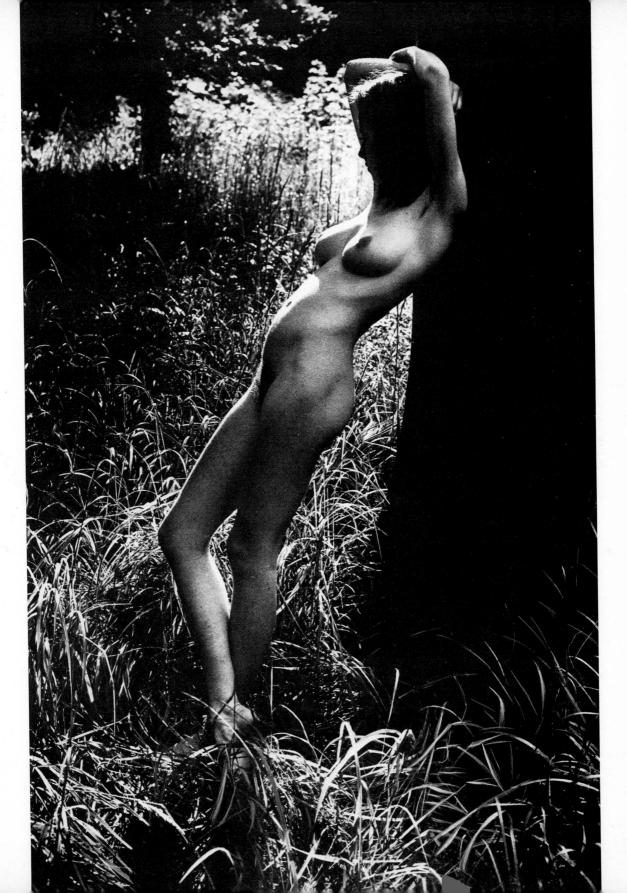

The model's movement was crucial. I found her
most photogenic during the seconds when she was
still looking for the painful thorn in her foot.
150 mm lens on 6×6 cm: 50 ASA colour
transparency film: 1/125th at f/8.

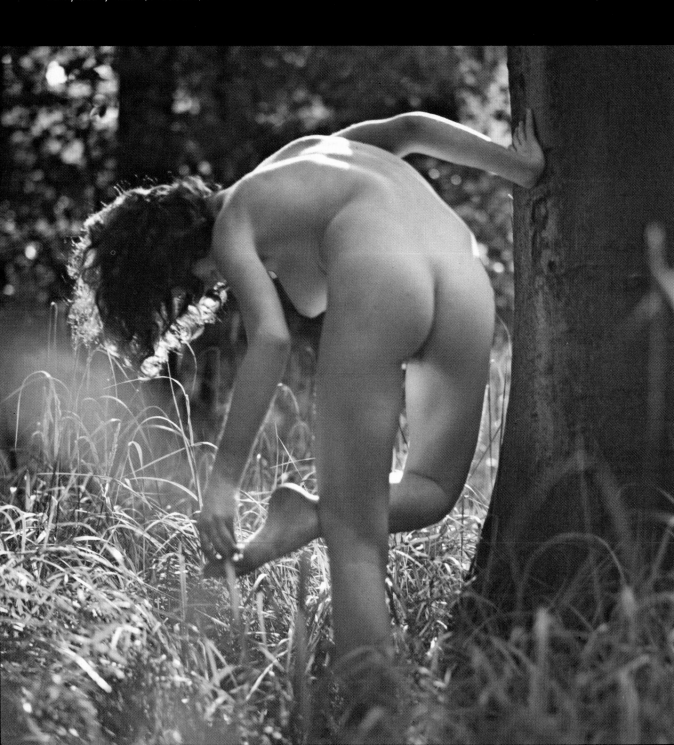

illuminated by two sources of light — a 500 w filament lamp on the model's left and weak daylight which entered the room through the studio window. The photographer has to watch for the right moment even when the model is in a static and well-balanced position. Clear differences in quality are noticeable when several photographs are taken with slight variations in the model's position and the camera viewpoint (page 188). The two nude photographs on pages 48 and 142 should show that the way *artificial* light is used can be the result of experience with *natural* light. Backlighting was used for both photographs; in one it was supplied by *natural* sunlight, in the other it came from an *artificial* sun - a 500 w lamp. "The girl with the thorn in her foot" was photographed towards the end of a busy session in the late afternoon, just before sunset. Owing to its flexibility, the light has the effect of lighting from below and produces soft, transparent modelling in colour. Details show through well, even in the shadows, in comparison with backlighting effects produced in *strong* sunlight. The yellowish red from the sun's glow is just the right complementary colour for the predominantly green of the surroundings. The *cold-warm* colour interest is further enhanced by the cold violet tone of shaded areas of the figure.

The nude study of the "Girl with rose" on page 48 was photographed in pale neon light with additional weak daylight; the cold colour character comes from the use of a film for artificial light. A 500 w filament lamp placed behind the model, warmed not only the colour atmosphere but also her back. (Apparently it was quite pleasant because it was otherwise noticeably cool in the artist's studio.) The colour effect of the light from the filament lamp is decidedly *warm*; its yellow reflection along the body can be regarded as parallel to the natural lighting effect already considered. Stray neon light and daylight impart a bluish violet colour to the shaded areas, just as in the "Girl with the thorn in her foot"; the bluish-green surroundings are similarly cool. While on the subject of composition, especially colour composition, notice that the pink rose provides a point of colour contrast with the deep blue jeans.

Drawing: The flow pattern in a standing figure often takes the form of an inverted S from the head tilted sideways down to the centre of the figure.

Photograph on page 140: The supporting leg and the leg at rest produce counter-displacement of the pelvis and shoulder line.
50 mm lens on 35 mm: 125 ASA film: 1/1000th at f/8: strong sunlight.

Photograph on page 141: The model was given minimal instructions on body posture and only then as far as the distance from the tree was concerned. But for the protruding, unsupported pelvis, however, the flow line (in the form of an inverted S) would have been far less photogenic (Drawing page 114). 50 mm lens on 35 mm: 100 ASA film: 1/500th at f/5.6: Oblique lighting when the sun was low.

Couples and group photographs

A new level of difficulty arises when only *two* people, not to mention large numbers, are to be photographed.

The difficulties are not just doubled when photographing a couple, they are multiplied many times over. The relative proportions and body sizes of the two people have to be *shown separately* on the one hand and brought together on the other. The basic laws of composition still have to be applied: for instance, uninteresting symmetry has to be avoided by choosing an angle of view which gives an interesting perspective. This problem is particularly relevant to photographs of couples because, with two people, there is a strong temptation to show them standing side by side, equally balanced. However, the photograph can be given unity by the use of sharply focused and blurred areas and by intersecting planes, so that the most important items are brought into prominence at the expense of the least important (pages 113, 131, 174).

The aim of photographs of couples or groups is to produce a whole and not a summation of parts. Relations have to be sought between contrary shapes and colours, perhaps at times between two very different people, such as white and black, big and small (pages 170, 176), male and female (page 145).

Trying to produce a photographic composition of two opposites assumes knowledge of their complementary needs. Of course, a modicum of luck is also needed to achieve photographic cohesion in which two or more people coalesce, if only for a brief moment, to provide a picture of a couple or group (pages 23, 108).

In his "Confessions of Felix Krull, confidence man", Thomas Man recounts the following: "Dreams of love, dreams of delight and a longing for union - I cannot name them otherwise, though they concerned not a single image but a double creature... But the beauty here lay in the duality, in the charming doubleness... because - I firmly believe - they were of primal indivisibility and indeterminateness, double; and that really means only then a significant whole blessedly umbracing what is beguilingly human in both sexes."*

* Thomas Mann: "Confessions of Felix Krull, confidence man." Translated from the German by Denver Lindley. Publishers: Secker & Warburg.

Composition drawing for the photograph on page 176. A group of figures is made impressive by combining several elements into a single whole, in the shape of a triangle, for instance.

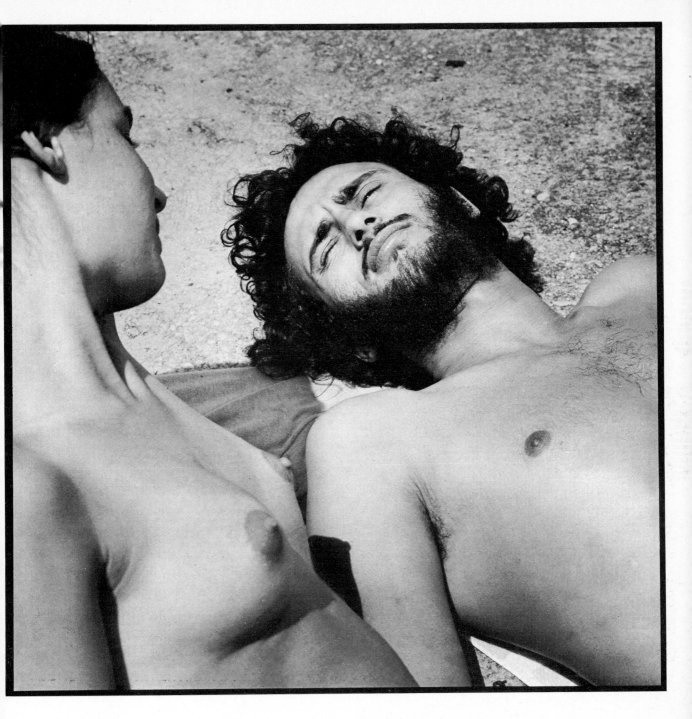

Photographs of couples present no problem when everything goes as smoothly as with these two models.
80 mm lens on 6×6 cm: 100 ASA film: 1/500th at f/8: strong sunlight.

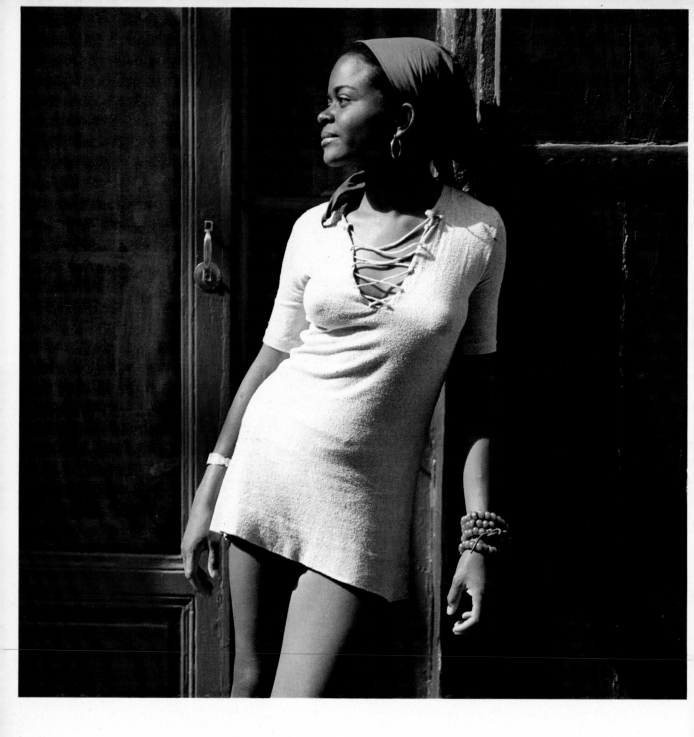

Marianne leant against a door and immediately
made a beautiful picture.
150 mm lens on 6×6 cm: 50 ASA colour
transparency film: 1/125th at f/5.6: strong afternoon
sun.

Marianne
in Arles

As usual in high summer, brooding heat hung over the red tiled roofs of Arles, van Gogh's town. The swallows which abound there flew their zigzag path through the narrow streets that were full of strange smells. Whenever the swallows ceased their crying, silence reigned; the place seemed uneasily still as if every living thing were paralysed.

The festival held in Arles at this time of the year had been well and truly concluded with bull-fights in the amphitheatre. A piano recital by Sviatoslav Richter was scheduled for that evening and he was the reason why I had stayed on for an extra day. The magic of this city held me in its spell for another afternoon and evening.

As I passed through the streets and across squares I saw children at play beside their mothers who were busy with some domestic chore. A small girl stepped from deep shadow into a bright patch lit by the sun which shone through the gaps between the rows of houses. A dog sat on the kerb as if turned to stone. Further on a cat came running across a yard, settled down beside a puddle full of washing water and drank. Everywhere in house doorways, on steps, on benches, in parks and avenues, I saw old people taking a rest from life. They looked as if they had sat and rested for an eternity in one and the same place, rooted to the spot (page 42). The sound of voices and music came from the wide-open doors of a bistro. A young lad, carrying something heavy in his arms came out, ran to the opposite side of the street and disappeared into a side-street as suddenly as he had appeared.

A turn of the head sufficed for a portrait.
150 mm lens plus 21 mm extension ring on 6×6 cm: 50 ASA colour transparency film: 1/125th at f/5.6: direct sunlight

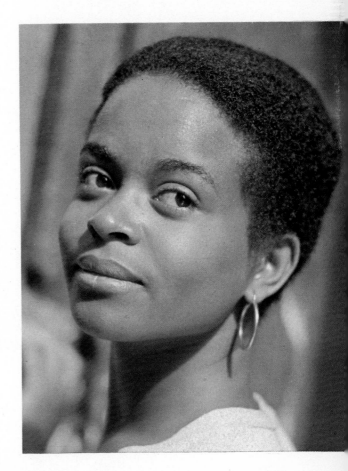

147

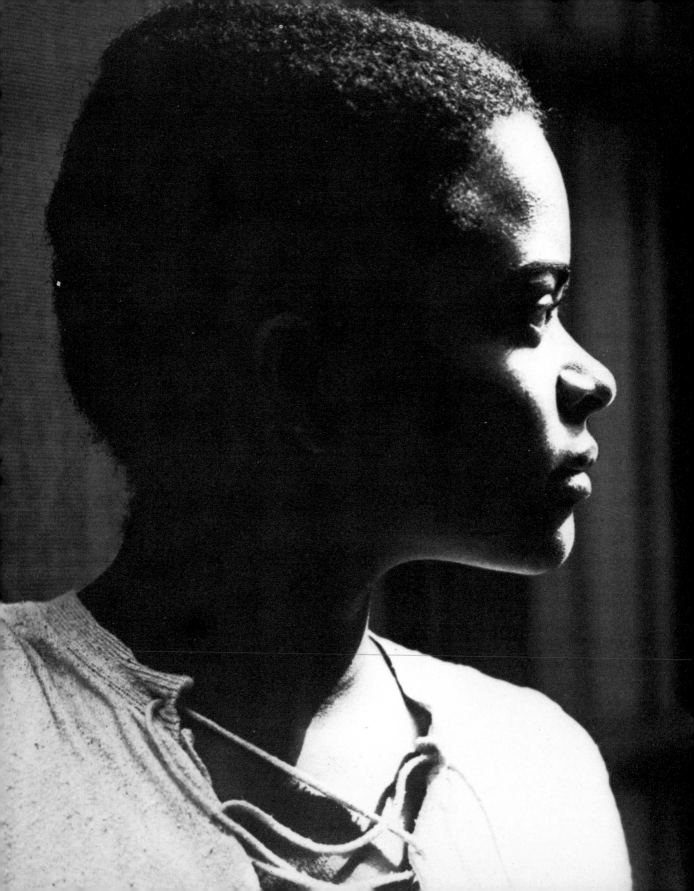

It was not suprising that I fell into a dream. Yet I was not startled when I saw Marianne as she hurried past me with short, rapid steps. Her gloriously graceful, swinging-swaying walk and the pitter-patter of her sandals on the pavement filled me with deep delight as and I stood still to let her pass. I felt that I already knew her, as if she was already long familiar to me, even though we were now meeting for the first time. Captivated by her appearance I felt at once that I had to go after her: yet something held me back. It was not until the empty street, which had been so suddenly filled by the sound of her footsteps, was silent again that I became aware that I had for some time been following the direction she had taken. I ran after her until I could again see clearly her brown neck, on which the evening sun was shining, her arms, which contrasted so darkly with her white dress, and her fine head with the blue scarf round it. Then I saw her legs which fitted in so well with the rest of her and I could not take my eyes off her - everything around me became vague and hazy. I was soon so carried away by the way she moved that I was no longer aware of where I was going.

Our path went straight on for a good while, then suddenly turned right and after a few steps she

turned into a doorway which seemed familiar to me; it continued past a gatehouse and up a broad, stone stairway into a large room with photographs hanging on the walls, which I again felt I knew. Then I realized where we were: it was a photographic exhibition by the American, Edward Weston, that I had visited the day before.

Marianne was obviously looking for something. Only three chairs and the pictures on the walls were to be seen. So I asked her what she was looking for - and I looked around quite involuntarily without really knowing what I was looking for. She showed me with her hands. She made a neat circle with them, spread out some fingers which were also bent inwards and finally made jumping movements with them. I had no idea what she meant. Then she added, looking at me round-eyed, her head tilted to one side, "Croak, croak!" So that was it - she was looking for a frog! I had to laught out loud because her voice sounded so funny. Then she laughed too, perhaps because my laughter echoed so strangely in the empty room. I asked her if the frog was green, yellow or black, whereupon she laughed even more loudly, especially as I was on the floor trying to get the frog to move by making frightening noises. But no animal jumped out — there was no living thing resting anywhere. It was only at this point that Marianne, still laughing, informed me that the missing frog was made of silver and that it was a brooch which had been hanging on her necklace; she showed me the chain.

We soon realized that it was going to be difficult to find the lost frog. Instead I suggested that we take a few photographs. So, when we were back outside, she sat on a kerbstone at my request, leant against a crumbling house-wall and then against a brown wooden door. While she was being photographed we spoke about everything imaginable. I asked her where she came from. "From Guadeloupe", she replied. I wondered if she was alone. "I'm with my uncle." "Did you come straight to France?" "Yes, to Paris." "Have you been in France long?" "Yes, several years." And so on and so forth... After a while we stopped talking — it was just like being in a fairy tale. She posed as she thought fit and I photographed her just as she was — I was totally absorbed in her. "Michelino." I heard her

The southern afternoon sun gives strong contrasts of light and shade. It made Marianne's profile look particularly striking.
50 mm lens on 35 mm: 125 ASA film: 1/500th at f/5.6.

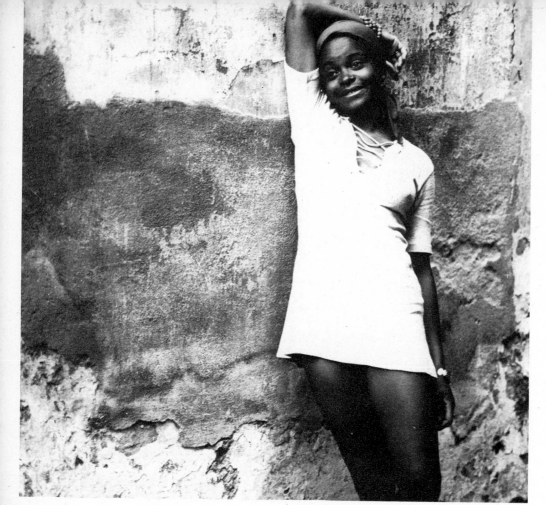

150 mm lens on
6×6 cm: 50 ASA
colour transparency
film: 1/60th at f/4:
black and white
print from an
intermediate
negative.

say after a time, and I felt as if she had called me tenderly in this way, by my first name, all my life long. "Michelino, I must go now; I have to go back to Paris today. How could I have forgotten? I must go now, quickly!"
She scribbled her address on a piece of paper - she was filled with eager curiosity to see the photographs - then she was gone.
Afterwards, I photographed reflections of the sun on house-walls and flowers in front of garden walls until it was quite dark. Then the evening began, an evening full of the promise of music - Beethoven, Schubert, Prokofiev - under a starry sky in the cloisters of the cathedral of St. Trophime.

6

Special
effects

Atmospheric and graphic effects

Our dreams and memories occasionally reflect indistinct or harsh images that are registered with the eyes open but are only "seen", as it were, with the eyes closed. The effect of the images is described as atmospheric if the pictures are indistinct, nebulous and value, or if they stretch into space thus giving an alluring illusion of depth and a sensation of being drawn down into them. By way of contrast, their effect is said to be graphic if the images are large and flat, as on a poster and with no illusion of depth' or if they are characterized by harsh tones, such as vertical, horizontal and intersecting lines or unbroken patterns, strong contrasts of light and shade, lack of detail.

If it is accepted that pictures are reconstructions of dreams and memories, then surely similar atmospheric and graphic effects can be produced in photographs — perhaps even together (page 153).

If this supposition is investigated further it is found that many photographs have atmospheric content which was frequently the *primary* reason for taking them. Examples are an exotic garden in unreal light (page 78), the sparkle of artificial lights in a large city street (page 50), the play of wind and the light in the hair of children and young girls (pages 8, 34, 154). One might even assume that from sunrise to sunset (page 38), from the soft air of spring to winter's frost, (pages 45, 55, 125) it is atmospheric sensations that lead photographers to produce similar affects in their photographs.

On the other hand there is the graphic element. It is surprising how vital it proves to be on investigation. This is not only true of advertising graphics which in the opinion of market re-

a
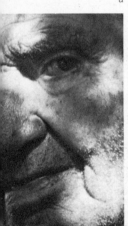
b

d

a) Patches of sunlight and shade produce an atmospheric effect with sharp focusing (detail from page 42).
b) The blurred grey tones of the background in the photograph on page 50 emphasize the evening atmosphere.
c) The subject (pattern of the material) itself is graphic in effect and its effect is enhanced by use of tone separation (page 191).
d) The profile contour is in itself graphic (page 99); solarization (page 195) reduces it completely to black and white.

Right: Pentidatilo, a small village in Calabria, southern Italy. The taut line of washing has a graphic effect and the coloured, impressionist background has an atmospheric effect. The orange patch comes from the sun, which was reflected in the lens.
50 mm lens on 35 mm: 50 ASA colour transparencey film: 1/50th at f/5.6.

c

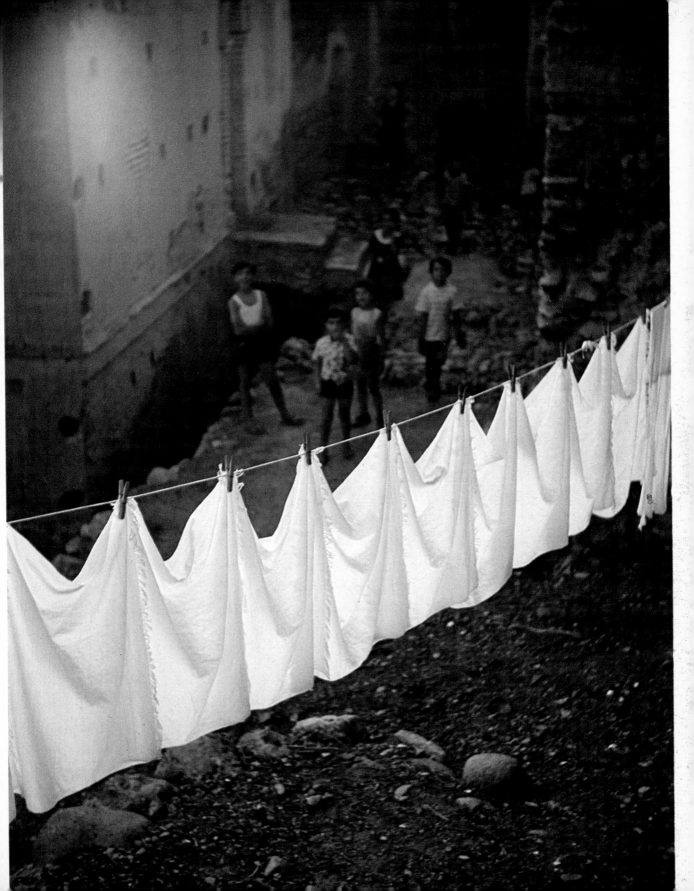

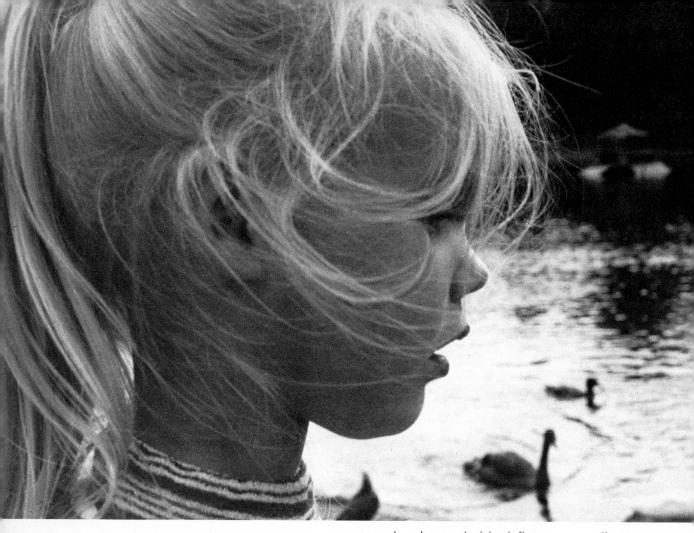

Above: An indistinct background and a windswept foreground produce an atmospheric effect in this picture of a child.
135 mm lens on 35 mm: 400 ASA film: 1/50th at f/5.6: hazy daylight.

Right: The effect of the silhouette-like profile is graphic, firstly because of the model's posture and secondly because of the backlighting. (1000 w halogen lamp shining on to a white wall, from which it is reflected back with uniform brightness.) 150 mm lens on 6×6 cm: 200 ASA film: 1/250th at f/5.6.

searchers have a decisive influence on our lives; it applies above all to architecture, streets and the horizon, which impose graphic effects on us (pp 13, 82, 105, 109). In addition, there are vertical and transverse lines (pages 16, 21, 60, 69, 132, 170), the countless surfaces of the rectangle, square, trapezoid and circle, which are to be seen everywhere — in dishes, doors, cups, cobbles and tables (pages 23, 121, 146, 172). Even when a person is removed from such surroundings and is placed against a neutral background graphic effects are still present. A white or tinted background surface produces a poster-like effect because of its uniform tonal values and because it lacks depth (pages 99, 186).

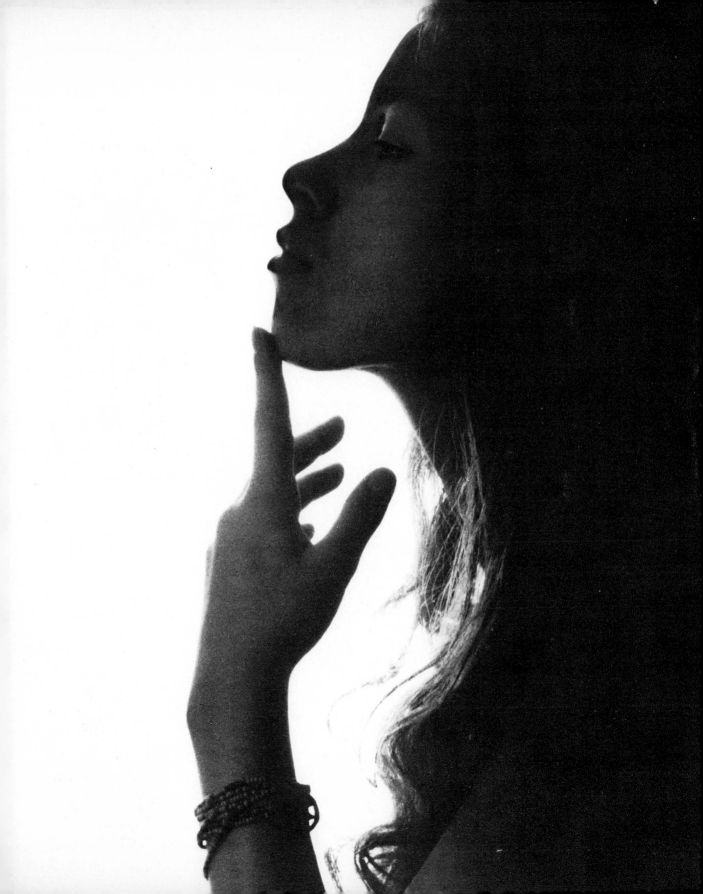

The photographic moment

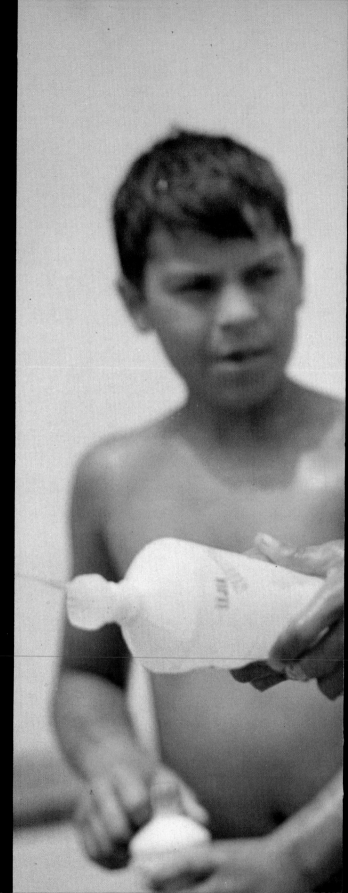

As the camera button is pressed a brief click is heard. This moment of exposure is not what is meant here by "photographic moment", however. "Photographic moment" refers to whatever inspires the photographer to take the picture. The stories leading up to "photographic moments" vary considerably. They may be long or short ("Marianne in Arles", "Photographic still life with figures"); they may happen in a trice or build op over an extensive series of photographs from which the best moment is subsequently selected. There are chance successes and very finely calculated photographs. The point common to them all is *hitting on precisely the right moment to take the photograph.*

The right moment to take the photograph on this page (page 156) was very brief. The reflex camera shutter *clicked* and the jet of water *spurted* out; both happened at precisely the same moment and there was not a second left in which to adjust the camera. Fortunately it was already correctly set, otherwise the shot would have been missed.

On the other hand, "old man walking in a village in Spain" was patiently awaited (page 82). The man in the picture came slowly down the road leading past the row of houses in the background, and into the square.

A brief moment caught with a modicum of luck, as is usually the case with "snap shots". 150 mm lens on 6 × 6 cm: 50 ASA colour transparency film: 1/500th at f/4.

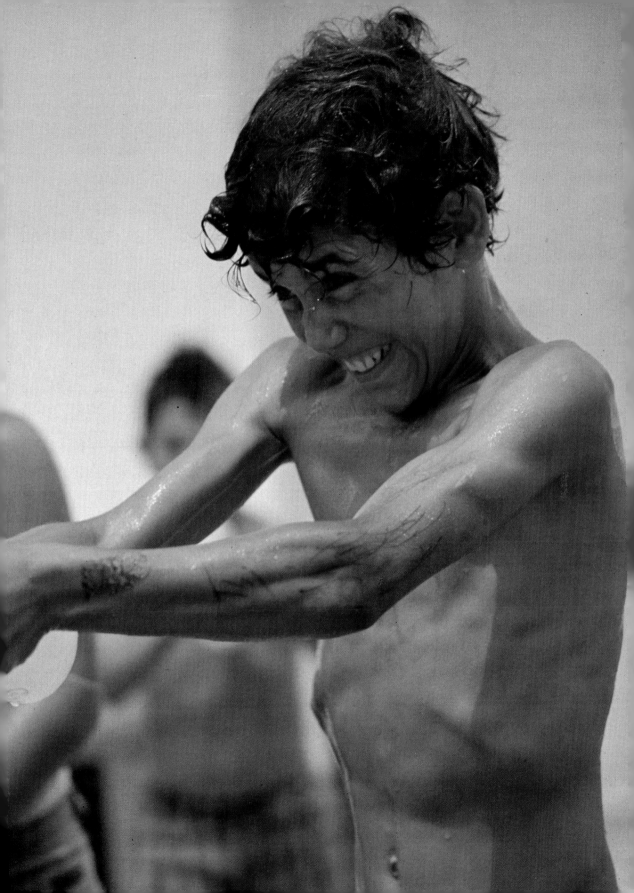

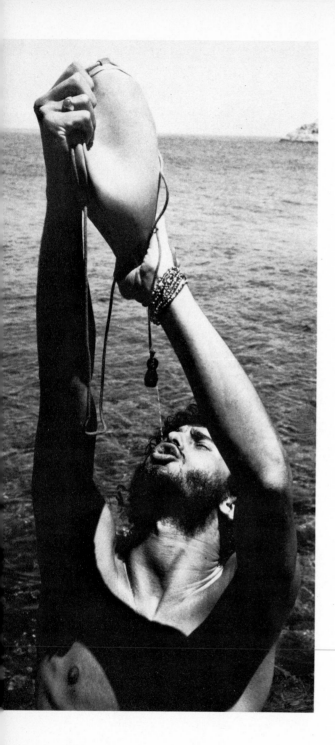

The picture shows precisely where he was going: he was making for the steps on the right. Not every step he took promised to provide the right moment for a photograph. The man would have to reach a certain spot if the whole point of the composition — his smallness relative to the massive house walls which emphasized the loneliness of the Sunday walker — was to be made. There was therefore a relatively long waiting period before the photograph could be taken since it took the man some time to reach the right point.

The climax to the incident of the children fighting with a doll (page 93) also came as no surprise. The composition, which includes a blurred foreground and some washing, shows that there was plenty of time for preparation; position, angle of view and exposure time were chosen without haste. The children's photogenic behaviour was anticipated and the photograph was taken as the doll reached its highest point. Courting couples usually behave more affectionately than those childres (pages 23, 69). Yet here again, the best moment to take the photographs had to be well timed, even though the couples took plenty of time over their embrace. Other, widely varied opportunities arise; for example, during conversation with a subject (page 27); from a movement by the model (pages 142, 161); when passing casually alongside or behind a subject (pages 133, 169, 198); moving subjects for which the photograph has to be timed especially well on account of perspective (page 55); and so on.

Photographic moments are not simply a matter of clicking the shutter. Nor are they always snapshots in which chance plays a part; they are situations requiring a balanced composition (page 159).

This was a lengthy "moment".
50 mm lens on 35 mm: 100 ASA film: 1/500th at f/5.6: strong sunlight.

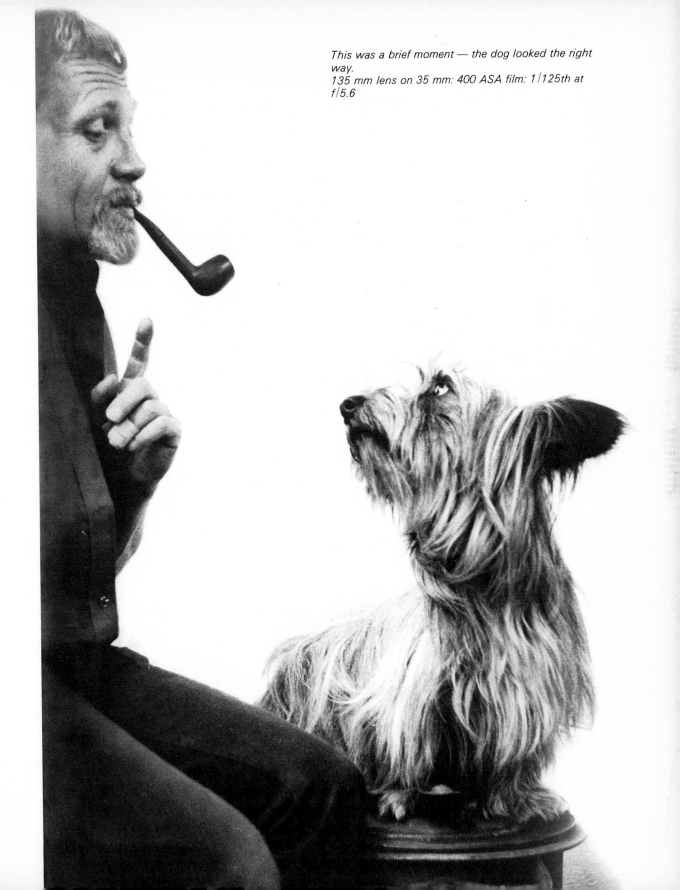

This was a brief moment — the dog looked the right way.
135 mm lens on 35 mm: 400 ASA film: 1/125th at f/5.6

Dynamic and static effects

There is no need to ask nowadays whether inertia or dynamics determine our way of life; the pace of our lives is governed by movement. It may therefore seem surprising to discuss static, restful subjects just for once, since they are now frequently considered boring, lifeless, dead — in short, old-fashioned. Converseley, anything which moves, flows, travels or flies is considered interesting and up-to-date — in short, 'modern'. In photography such differing trends can be explained very clearly with reference to nude subjects.

A figure study — whether lying, sitting or standing — is a static subject if the model is arranged to clearly illustrate the function of support points, the mechanics of the skeleton and the basis of standing, sitting and bearing surfaces. Interest and harmony stem from the details of the model's proportions, such as slim limbs together with a powerfully built trunk, a large body with a dainty head, a strongly defined profile or a broad, flat face when seen from the front, etc. A static photograph can be made interesting by the opposing functions of support and load, standing leg and resting leg, three-dimensional situations with perspective fore-shortening (pages 29, 72) and the difference between the graphic and contoured features of the model (pages 47, 164). A still static nude subject demands all the skill a photographer has (page 197) if colour (page 139) and focal length (page 193) are also taken into account.

The most photogenic viewpoint for the photograph on page 163 was quickly found; it was the point from which the three-dimensional relation of arms and legs was most apparent. The lighting — daylight in the studio — was easily controlled because the model was sitting on a turntable. I decided to use a medium telephoto lens to achieve a more compact and compressed shape than a normal lens would have given. The static compactness of the figure is thus enhanced. If the telephoto effect had been *too* strong there would have been no perspective left at all; this was not desirable.

When a photograph is carefully arranged and perhaps has a good deal of time spent on it, the *moment* of exposure is not as crucial to its success or failure as when experimenting with movements because the latter involve animation and spontaneity (pages 161, 186). The amount

Right: In some cases the dynamic effect of a nude figure is expressed particularly clearly in movement. The mottled background was provided by the ruins of a house in a southern country.
80 mm lens on 6×6 cm: 64 ASA colour negative film: 1/500th at f/2.8: direct sunlight.

Below: The drawing shows the swinging movement.

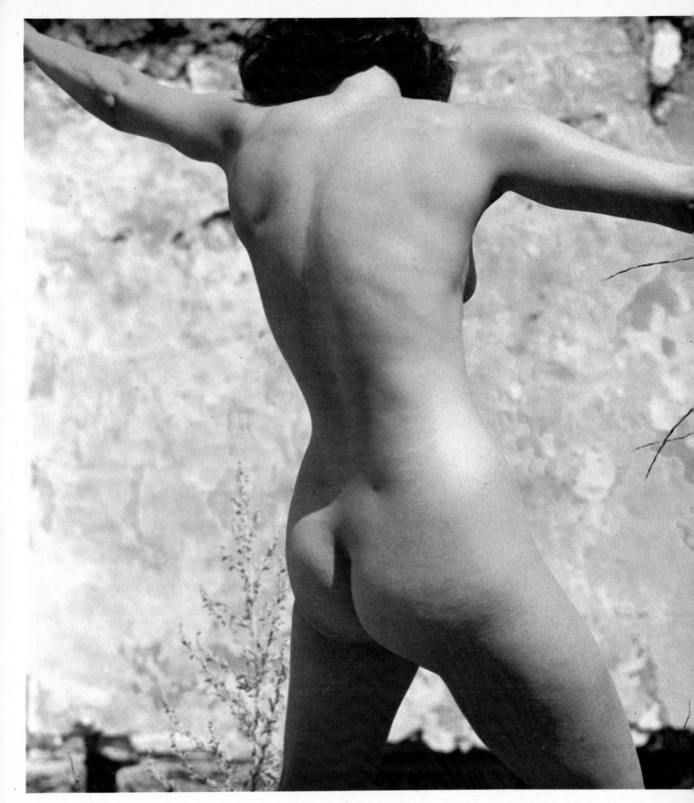

Still, static subjects show clearly the function of supporting points and load-bearing points in the body structure. The purpose of the drawing is to indicate the proportions by volumen.
150 mm lens on 6×6 cm. 40 ASA film: 1/15th at f/5.6: Daylight from the north.

of film wasted on moving subjects is far greater than that on photographs of still subjects. I usually begin by using black and white film for such studies because it is cheaper and I use colour film only when I know my model's ways almost by heart. It is advisable not to change the camera position too frequently when photographing movement. Sometimes different viewpoints are obtained simply by having the model move. The camera viewpoint must provide a favourable background for the photograph because the best movement is pointless if the scenery detracts from it. Suitably coloured backgrounds are safer than fussy backgrounds. The colour photograph on page 161 was taken in a very small space (not larger than 2 m 6·6 in) in width and 50 cm (2 ft) in depth) inside the ruins of a house by a doorless entrance. The

entrance cannot be seen in the photograph because the model's hands which were resting against the doorpost on either side were omitted. In the background there is a ruined wall which is out of focus and which has its paint peeled off in parts, giving a mottled effect. The photograph was taken with a very short exposure time of 1/500th at f/2.8, firstly to show the movement in sharp focus and secondly because the larger the aperture, the more blurred the background. The model was left to cope as she pleased with the rather uncomfortable scene of action. She tried movements for which she required a support or in which she at least needed something against which to rest, push or lean, or from which to hang (drawing of movement, page 160).

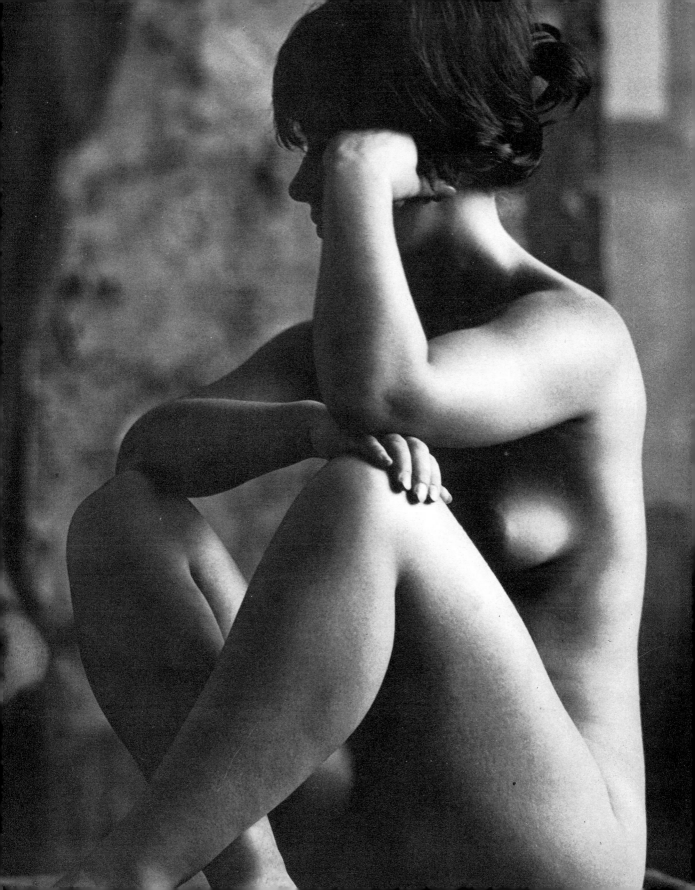

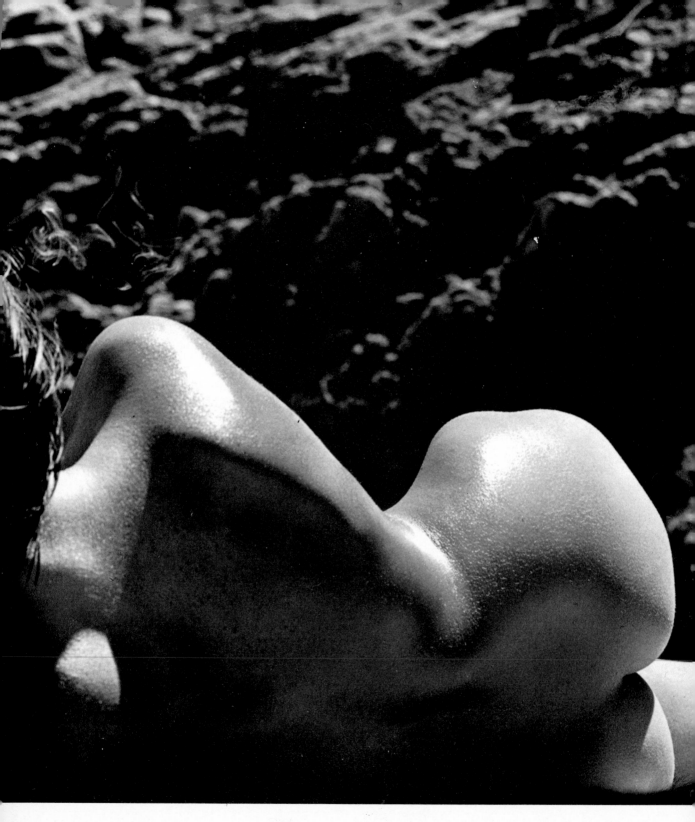

Effects which consolidate or break up shapes

In onder to judge whether the shapes in a photograph appear compact or broken up, we must first define what we mean by shape.

Shape denotes chiefly the outline or the external form of an object. With people it means the figure or the head and, with reference to their proportions, it means whether they are big or little, fat or thin, bent or straight, long-legged or short-legged, broad-shouldered or narrow-shouldered.

When *internal* shape relationships are also involved, it means the function of the limbs, such as the joints, their capacity for movement and the body postures which result from such movement.

However, the concept of shape is not yet fully defined because a movement, the source of power and substance which produces the power to build bones and form tissue, muscles and sinews, has its origins in the vital functions; it is a shaping process. According to the sculptor Rodin, "a shape is forced outwards from inside" to give volume and three-dimensionality. In the "Ancient Torso of Apollo" by Rainer Maria Rilke, we read "... and does not exceed its bounds like a star". Every strong shape is expansive.

If we follow the process by which a piece of sculpture is produced and if we see how one piece of clay is added to another around an iron core; how large relations of form are modelled, held, smoothed out and finally look from every angle as if cast from a mould; or if we see how the sculptor feels his way around an undisturbed block of marble and breaks into it piece by piece until he reaches the kernel of the figure he has in mind, then we are indeed given the impression that a force from some indefinite centre determines the dimensions, curvature and tautness of a shape. The *production* of shape in the fine arts is, however, quite a different process from that of the *reproduction* of shape in photography. Since a creative process beyond the scope of photography is needed to produce shape, in photography there can never be any question of *shaping*, let alone of the *consolidation of shape;* only *effects* which consolidate shape can be used.

Photographic representation is the characterization of a form; it is the position, attitude, dimensions of a body and the aesthetic aspects

According to the sculptor Rodin, "a shape is forced outwards from inside".
250 mm lens on 6×6 cm: 100 ASA film: 1/250th at f/16: strong sunlight

of a surface shape or, as Rudolph Binding says of the sculptor Georg Kolbes, it is "the curvature, the fullness, the tangibility, the effect of juxtaposed or moving limbs, the tautness of the skin."

A description has already been given in various sections of this book of methods which can be used either to consolidate and heighten a photographic impression or to make it essentially abstract. The methods, which need to be applied before the shutter is released, covered interchangeable lenses, including the long-focus lens which can be used to isolate a subject from superfluous, distracting foreground and background material; the suppression of detail with the purpose of omitting everything unessential; lighting arrangements inspired by light *impressions* and not merely by light intensity values; photograph formats; suitable film, etc. These methods of making a photographic composition more concentrated can be used equally well to achieve effects which *consolidate* shape and effects which *break up* shape. A disjointed effect in a photograph also needs to be made as clear and concentrated as possible. These two different effects must accordingly spring from the subject. People must be photographed as nature made them, showing whether they are big or small (this need have nothing to do with body size but may be a matter of broad cheekbones or scarcely noticeable cheekbones, for instance); how they dress, soberly or flamboyantly.

There are people with strong shapes and people with weak shapes, just as there are statuesque, picturesque, colourful and striking people. Although full, well-rounded cheeks are the opposite of wrinkled, hollow cheeks, these characteristics do not indicate whether they are strong or weak in shape. Cheekbones which have lost their covering of flesh may be so prominent that they epitomize the consolidation of shape. A chubby-faced shorthand-typist is not strong in shape — in the artistic sense — simply on account of her chubbiness. The substance — whether a shape is forced outwards from the inside — determines whether a shape is photogenic or not.

Regardless of whether subjects are loosely knit or compact, *large* related shapes, a *bold* breakdown of surface area, a *bold* three-dimensional arrangement, unbroken curves and flow lines, and *comprehensive* verticals, horizontals or diagonals always have the effect of consolidating shape. The purpose of the whole is to express the simplicity and the compactness of a shape (pages 16, 56, 77, 148, 164).

It is logical that a style directly opposite to the above must have the effect of *breaking up* shape. This style therefore involves *small* surface areas which show little or no relationship to each other, *interlocking, intricate, crumpled* shapes, which result in a *trivial* three-dimensional arrangement, *frivolous* curves and flow lines and *fragmentary* verticals, horizontals and diagonal (pages 42, 47). The photograph of a girl with strands of hair hanging over her face is a further example (page 167). The shape of the head, which in itself is rounded, does not look compact because it is broken up by intermittent flow lines and curves, uneven, disorderly crisscrossing lines and small surface areas.

Chaos, disorder, asymmetry and disharmony can of course be shown in photographs. And when they are photographed convincingly they are just as good as attempts to achieve simplicity, compactness of form, symmetry and uniformity. This comparison of effects which consolidate shape and effects which break up shape was therefore intended not as a value judgement but as an explanation of two different photographic concepts. Everyone must decide for himself which effect he finds attractive.

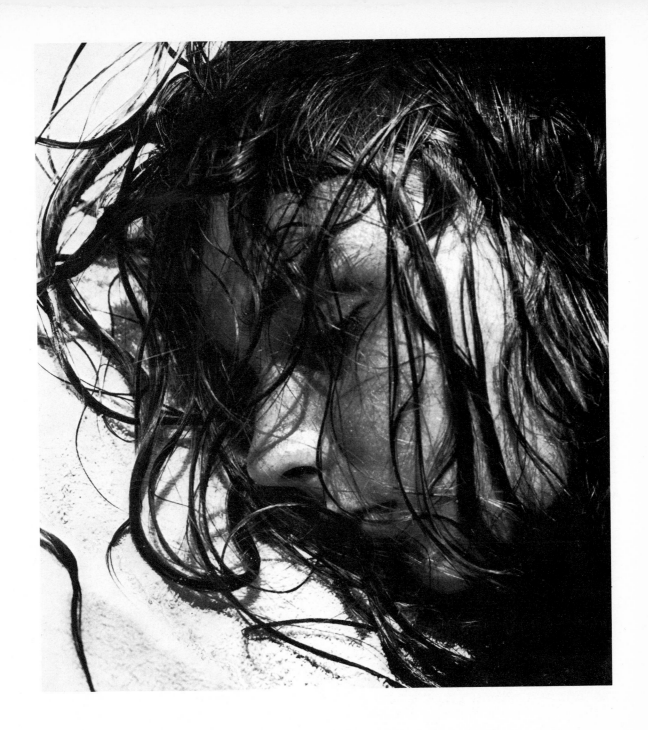

Uneven, criss-crossing lines break up the shape.
150 mm lens plus 21 mm extension ring on 6×6
cm: 100 ASA film: 1/250th at f×11: strong sunlight.

Documentary and reportage photography

Documentary photographs are not usually produced for the photograph album. They are generally supplied on order to an editorial office which requires a pictorial report, or they are used for the purposes of commercial art. A photograph illustrating a cookery book is also a documentary photograph if it is informative. Documentary photographs inform, but they also describe living situations and explain factual matters, both as individual photographs and as a series with or without text. In a *series* of documentary photographs, one photograph is arranged next to the other in a row and the subject is made clear by the connection between each one.

Documentary photography covers a wide range of subjects such as tulip growing in Holland, the coronation of a sovereign, a description of a catastrophe, a football match or a photographic report on life in an old people's home.

A single photograph from such a series may — but must not necessarily — be recognizable as a documentary photograph. Considered alone, a large photograph of a tulip is simply a photograph of a flower. The tulip will only become informative as part of a *series* of photographs on Dutch tulip fields if it provides information on a *special* tulip plant — whether it is long or short-stemmed, yellow or red, or whether its leaves have two or three points.

Obviously a photographic report on the architectural style of a street or town presents quite different problems from those of a sporting event, in two respects. Static objects can be photographed at leisure, using a large bellows camera on a tripod. On the other hand, a dynamic event — a handshake between two politicians, a particular movement of an animal, the flash of a film starlet's eyes — has to be seen and focused in fractions of a second. A handy and easy-to-use camera is more suitable for this purpose. Miniature and medium-size cameras are the most practical for life photography. The practice of documentary photography requires not only a knowledge of photography and the necessary technical equipment but also specialist subject knowledge. What is the use of extremely fast reactions when reporting on a boxing match if the photographer knows nothing of the rules of the game and he reacts quickly but at moments which are of no interest to boxing fans? What is the use of infinite photographic patience and the best equipped whole-plate camera for architectural photographs if the photographer knows nothing of styles of architecture?

Documentary photographs describe a situation; here, a corridor in the art school in Düsseldorf photographed by "walking behind" the subject. 50 mm lens on 35 mm: 400 ASA film: 1/125th at f/2: poor daylight.

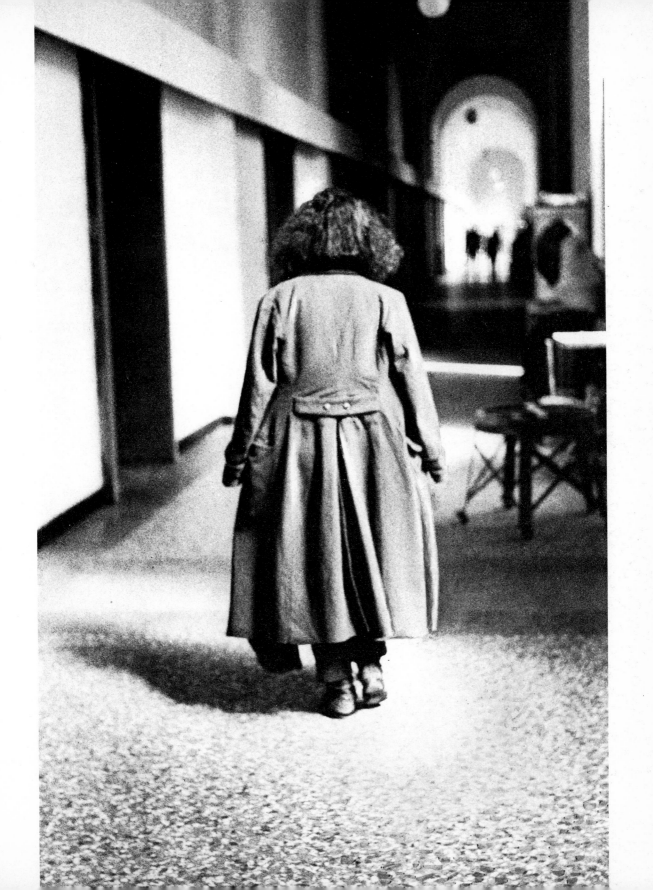

I had just finished taking a series of photographs of Düsseldorf Art School for my own pleasure and in my own time, when I heard, just before the end of term, that the Association of Friends and Patrons of Düsseldorf Art School wanted a representative collection of some one hundred photographs of the School for the bicentenary of this time-honoured institute. The photographs were to show particulars of the current activities of lecturers and students. This led me to fill several gaps in my collection of photographs in orden to meet the needs of friends of the School.

There were still no photographs of some lecturers, for instance. They had previously seemed rather unimportant from the specifically photographic point of view but could certainly not be left out now if the report was to be complete. The Director himself, Professor Eduard Trier, was not yet represented in my collection and there were no photographs of classrooms to give the feel of the atmosphere in the School. Photographs showing students at work were also to be included at the request of Professor Heerich.

Report on an art school

Right: One of my main concerns while making my photographic report was, where possible, to record the students in a creative phase.
50 mm lens on 35 mm: 400 ASA film: 1/125th at f/2.8.

Below: During the official Open Day, the School is open to young and old.
50 mm lens on 35 mm: 400 ASA film: 1/125th at f/2.

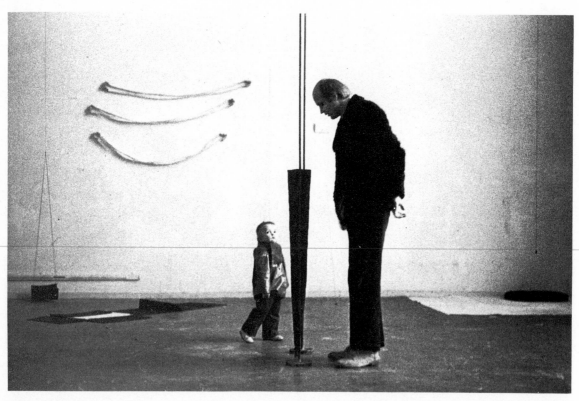

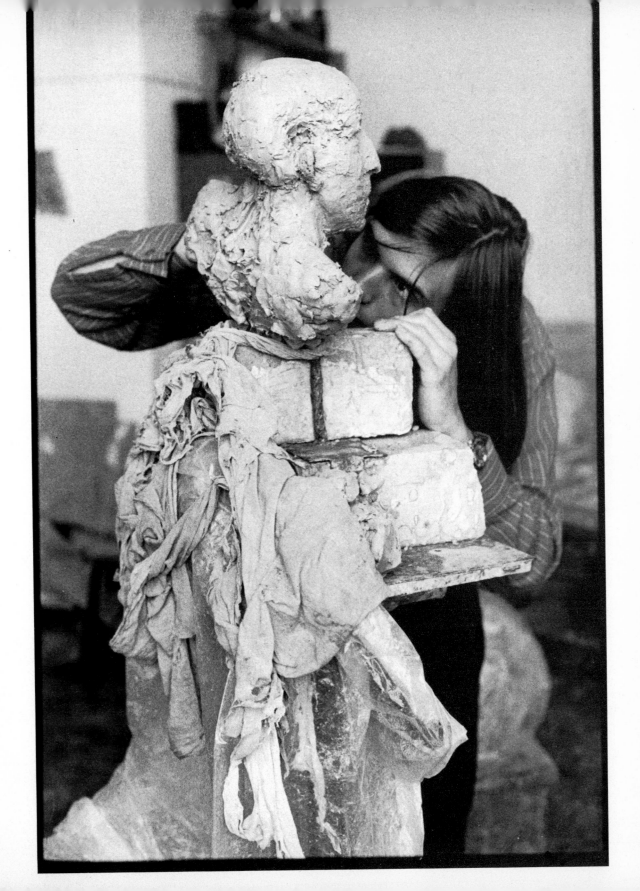

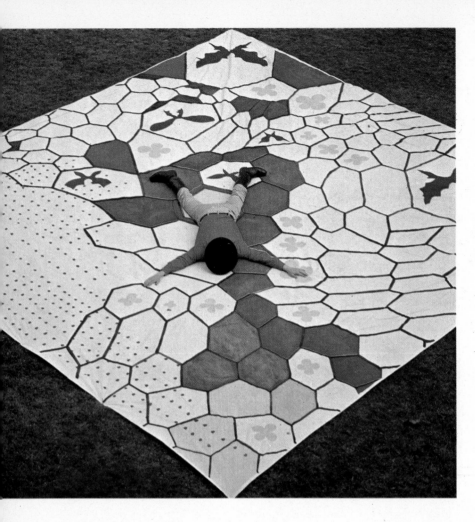

Left: Anatol, policeman and action artist in one. He called his work, on which he lay stretched out, "honeycomb". The photograph was taken from the second floor.
150 mm lens on 6×6: 64 ASA colour transparency film: 1/250th at f/8: subdued daylight.

Right: The Spartacus Forum after completion of the judging. Huge sculpture made of papier mâché with girl and dog made of flesh and blood and cock made of plaster of Paris painted all over.
80 mm lens on 6×6: 160 ASA colour transparency film: 1/125th at f/2.8: scant daylight from the studio roof.

With this new assignment in mind, I visited the Art School again and took photographs from basement to attic. I caught on film virtually everything which came before my camera — rubbish bins, professors, fire-extinguishers, caretaker, wheelbarrows, porter, bottle batteries, students, rubbish dumps, lecturers, negroes and assistants, cleaners and Gothic angels, sleepers and art historians, philosophers and drug addicts. Time was pressing! On the last day before the end of term, a number of extra items which had been put on display for the photographic survey would be put away again.

An example will suffice to show how very adaptable the photographer sometimes has to be in documentary photography in order to attain his objective and project the quintessence of a subject. Just as I was beginning my project on photographs of "clasroom subjects with a working atmosphere" in Professor Heerich's class, a student's crossed legs in short trousers appeared in my viewfinder. The legs were attractively placed and photogenically hairy. My first thought was to ask the owner of these."live objects" to move to a different place so that I could have a clear view of the iron and wood frames which were the subject of the photograph. Then I noticed that the legs might fit in very well because the contrast between his flesh and the wood and iron was really quite effective. At least they would form a foreground and the photograph would thereby gain in depth.

To return to the point: having gone through the list of staff from the cleaner to the Director, I

172

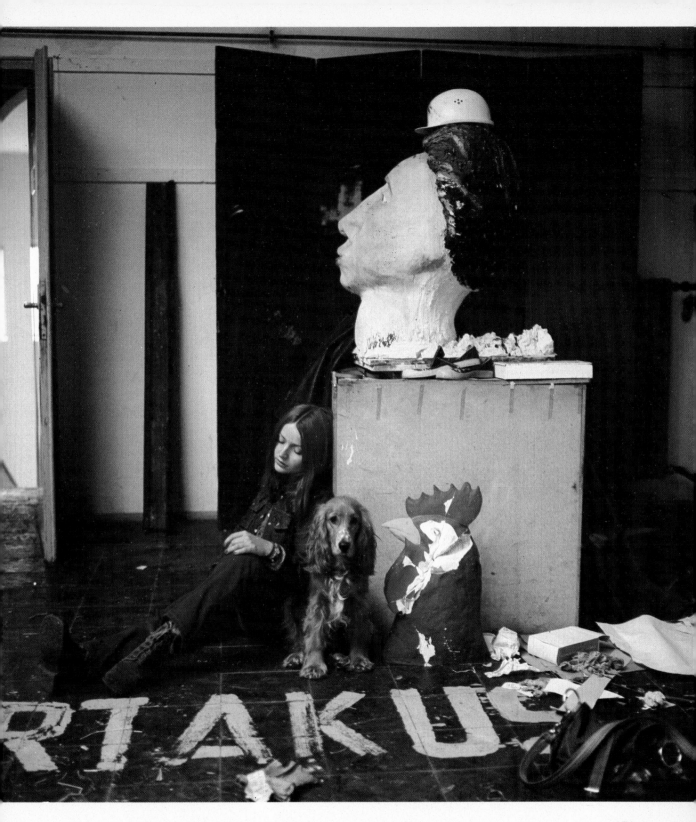

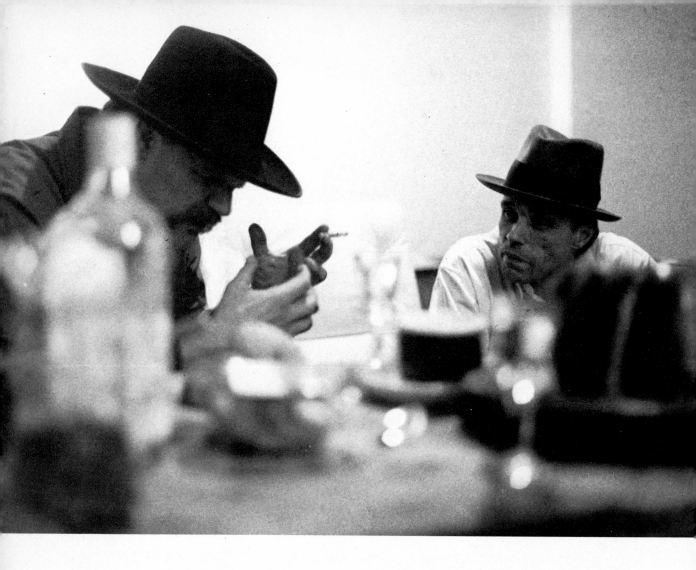

proceeded to photograph "corners", "ceilings", "floors" and "walls", in which and on which there is always a jumble of everything possible and impossible lying, hanging, floating or falling. When the photographs were ready they met with the approval of those who knew the Art School. This was probably because the variety of items in such a "photograph of objects" provided a person looking for something specific with the opportunity to seek out in his thoughts the particular item which — according to his perception of art — he found pleasing. Meanwhile he could dismiss from his thoughts those things which — again according to his views of art — gave him no pleasure.

Above: Nocturnal art discussion. Anatol (on the left) explains to Beuys what a sculpture is. Meanwhile, the potato which he had squashed in direct illustration of his subject lay under the table.
50 mm lens on 35 mm: 600 ASA film: 125th at f/2: neon lighting.

Right: Barbara Tapeser working on a bust of herself.
50 mm lens on 35 mm; 600 ASA film: 1/125th at f/2: daylight from the north.

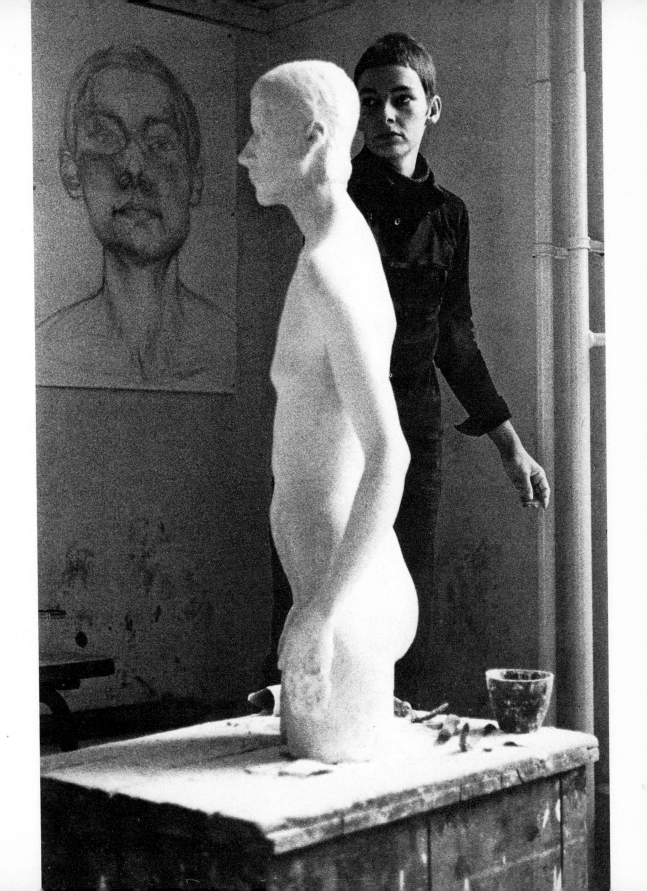

I now wished to add livelier photographs of young art students being as creative as possible to the photographs I had taken of formal art objects.

I set off on my photographic reporting session at about eleven o'clock in the morning. I should have known better; the photogenic high spots of art school life are not to be expected at such an early hour but once I had adjusted to the School's life style everything went quite well.

The School was at its busiest just before and after meal times — eat-art-time, in the artists' jargon. A photograph taken between a quarter to one and a quarter past two stood the best chance of looking lifelike.

However, at the Art School it is possible to be wholly creative later in the day and in the evening, once you have got into the swing of taking photographs. The world is never boring when you have your camera slung round your neck!

☐

Art student with his "early work".
50 mm lens on 35 mm: 400 ASA film: 1/250th at f/2.8.

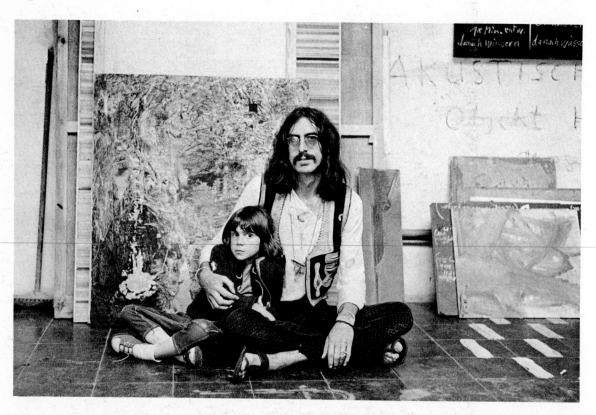

176

7

Black and white
processing
and allied
processes

Darkroom

My first experience of black and white processing technique was gained as a rather passive observer in the photographic department of an art school. It was not even the processing of my own negatives which I was watching because I was busy with quite different matters in painting and graphic art classes and at that time never even thought of taking photographs; besides, I had no camera.

However, taking photographs and processing photographic material are two different things. Because I still feel that it was not some shining expensive camera seen in a shop-window display which led me to become a photographer but rather my first acquaintance with black and white processing, it is perhaps fitting that I devote a few words to this experience.

The photographic studio, a wonderful, high-ceilinged room with a gallery all the way round, large windows which could be darkened and a wall full of assorted lamps, screens and tripods was interesting, of course, but it was not the real reason for my curiosity. This was aroused by some much smaller rooms which were reached along narrow side-corridors and had orange-coloured lamps above their doors. The lamps were lit or not, depending on whether the darkrooms were engaged or unoccupied.

These laboratories were forbidden to anyone not wearing a white overall or at least carrying in their hands or under their arms something which was clearly recognizable as a piece of photographic equipment such as red or yellow paper envelopes of various sizes, coloured plastic boxes and dishes, scissors and cameras. But I had no such things and had to be content at first with external impressions and with studying the people who, eyes blinking, shuffled out of the dim red, green or orange light of these rooms to look at some developed test strip or negative in the daylight. I listened to their disgruntled comments when a test had gone wrong, or joined the circle of students admiring a successfully enlarged print.

The photographs were mostly of a considerable size — roughly 50 cm × 60 cm (20×24 in) — and on that count alone inspired respect, no matter how simple the subject. One photograph might have shown a tree, gnarled and deep black, standing out in sharp contrast against the clear white of the sky. Another may have been of some womanly creature, clad in wide trousers and leaning against a wall or jumping down from somewhere, and photographed from a low angle so that the head looked disproportionately small. Someone remarked that the subject was one of our group. Thereupon the photograph had to be inspected again since no-one had even suspected the resemblance to Katya as the privileged young lady was called. Now we knew in black and white how startling the results of the camera can be we were more than a little surprised.

However, deliberately odd-looking effects were kept within limits. Most subjects were easily recognizable as familiar objects. Photographs made to look very abstract and graphic — such as the structure of house walls, woods and grasses, scrap heaps and pavements — or copied to give high contrast or taken on a very coarse-grained negative to give poster-like effect, revealed clearly in very simple black and white, things which often failed to make an impression in reality. Again, we were more than a little surprised by these effects.

There was also always some production process to follow, such as enlargement of a detail to intensify an impression; enlargement on different grades of hard paper to give varying impressions of one and the same subject. There were also comparisons to be made between the surface effects of gloss-finish and matt.finish;

the difference was quite considerable. It was interesting to note how the photographs became really effective pictures only once the dry print had been lined on the back with hot adhesive foil and had been pressed onto a cardboard base with a flatiron. Now they were ready to exhibit on a wall where they looked far more effective!

We often sat quite happily on a table and let our legs dangle while other people were busy squeegeeing wet paper enlargements on a highly polished metal surface before placing them in a print dryer, just as the baker places his bread rolls in the oven. When the paper stopped sizzling the drying process was complete. At the other end of the room clammy strips of film were hung in drying cupboards which were as tall as the films were long. Their electric heaters made a loud buzzing noise which gave some indication of the heat in which the celluloid strips were vibrating, hardening and drying. Meanwhile, other students were cutting their completed strips of negatives into sections of equal length and putting them into transparent covers which they then collected together in folders, like stamps in an album. Yet another colleague wound a fully exposed film back into the cassette, took it out, turned it round importantly in his hand a few times, threw it briefly up into the air, carelessly caught it again and then looked at the orange lamps above the darkroom door to see if he could develop his film straight, "hot from taking photographs" as he said. If all the rooms were taken he would nevertheless knock on a door and ask to be let in. After some considerable time, the door would open a little to show a green light and blinking eyes, whereupon the person outside would squeeze inside.

Once I was the one who asked to be let into the darkroom and at a suitable moment someone quite readily showed me the operations involved in negative processing and print development. However, I must confess that I have never been seized by a creative urge in the darkroom, neither in the past nor in the present, no matter how tricky the subjects of the negatives or how huge the enlargements. At times, when work in the darkroom lasts too long, I am overcome by a state of collapse which makes me feel miserable. Thus devoid of enthusiasm, I doubt if I can provide you in subsequent chapters with such stimulating information as that passed on to you by other people who perhaps find darkroom work exciting. Perhaps you may remember the film "Blow-up", which mystifies the straightforward rites of the darkroom into the celebration of an orgy; happy the person who has the psychic and financial means to make it such fun. For myself I find work in the darkroom — despite all the splashing about — a really dry and tedious business, although I would not deny that a certain curiosity to see the negatives and prints always drives me back again into that solitary cell. But on each occasion I am delighted when it is time to switch the light on again.

Nonetheless, the gloomiest thing is often the most essential. It is in fact advisable to process your own black and white films because only the person who exposed the negative can bring out the best in the latent image. Enlarged prints from the same negative can also be so different in character that the only advice is not to entrust this part of the creative process — and this is what it is in the final analysis — to someone else. The simplest methods give the best results and these are a well-developed film and a properly enlarged print. In listing my own darkroom equipment, I run the risk of losing the respect and esteem of many a pretentious amateur and Sunday photographer, but perhaps my admission will encourage anyone who restricts himself as I do.

On one side of the room there is a 6×9 cm enlarger, which can also be used for 35 mm negatives. (I acquired it by chance from a precision tool maker whose hobby was photography; he bought a model railway with the money he got for it!) The enlarger should also be suitable for colour prints. I have never yet used it for this purpose, however, since I always found this work too involved and time-consuming as well as too expensive. Colour films are processed more quickly, more cheaply and better in a special laboratory.

Next to the enlarger, on the same table-top, there are three plastic dishes measuring slightly more than 30×40 cm (12×16 in). The first is used for the positive developer, the second for the intermediate rinse and the third for the fixing solution; they are, of course, used for processing prints and are only used for developing nega-

tives when flat films are being processed. For each of the three trays I also have a pair of photographic tweezers for turning the photographic papers and flat films over in the solution. There is a basin next to the table-top; the basin is also slightly larger than 30×40 cm (12×16 cm) (larger prints are developed and fixed folded over in the dishes and are washed in the bath-tub). Above the table there is a yellowish green darkroom light that can be switched on when prints are being processed. A shelf holds two tanks for developing negatives, two opaque plastic bottles taking one and two litres of developing solution and a couple of light, transparent plastic bottles door the intermediate rinsing solution and the fixer. A cord, with assorted clothes pegs hanging from it, is stretched along the curtain rail. When the "firm" is fully employed, freshly developed films ranging from wet to dry dangle from the cord.

The entire room can, of course, be darkened during the day. This is how it works. Two wooden guide rails are mounted on the window frame to right and left; a plastic black-out material runs up and down in them. The venetian blind is pulled down below the window sill to prevent any further daylight from entering the room. That is it; I would rather not describe the rest of the room! It prompted one recent visitor to call it a "dark lumber room", even though the old couch had already been removed at the time of his visit. A Spartacus student, who later got married, took it away and a trunk in which old bills are kept stands in its place. Photographic papers lie on top of the trunk. I almost forgot to mention them, yet they are so important!

This is not the type of darkroom which is usually mentioned in books, of course. There is one consolation for me and perhaps for many another, too: there are said to be some photographers who make their enlargements in clothes cupboards and other who rinse their films in the developing tank in their trouser pocket.

When a black and white film is fully exposed, I feed the roll of film into the spiral groove of my developing tank - in the dark, of course. Once this is done and the tank is closed, the light is switched on again. The negative developer is then poured into the tank which is then agitated constantly for the first minute and every thirty seconds thereafter. On completion of development I pour the developer down the sink because I usually use non-reusable developer. If the developer is to be re-used, and this depends on the manufacturer's instructions and on the development time and dilution, then I pour the used developer into an opaque plastic bottle to prevent it from spoiling.

I next run water for some time into the developing tank, which still has the film in it. After this intermediate rinse the tank is filled with fixing solution. This process again lasts for the period indicated by the manufacturer. After fixing the film is washed. If a film is very important to me and I want to keep it in perfect condition for years to come, I wash it for three-quarters of an hour. I wash less important films for twenty minutes, to save time. Films which are used only for a single purpose and are then thrown away are washed for ten minutes only. Even these timings are relative, however, since thorough washing depends to some extent on the vigorousness of the rinsing process.

After the final wash there is time to breathe again because the operation is pretty well over except for the drying process. But "process" is a big word. No-one talks of drying "process" when the washing is drying on the line. And films dry in just the same way as washing: they drip. To prevent drip-marks, I add a wetting agent to the water just before removing the film from the tank. The water then drains off better and streaks are prevented.

Print processing is no more complicated than developing negatives. In fact it is simpler because you can see what you are doing. I place the dry strips of negative, which are as free from dust as possible, on the negative carrier of my enlarger between the sheets of glass - and project the image, lit by an opal lamp, on to the enlarging frame with which the desired size of print can be accurately obtained by means of adjustable masks. With the lens aperture fully open the image is brought into sharp focus, just as when taking a photograph, and the lens is then stopped down by one or two stops. I seldom determine the exposure time by making *test strips* with different time exposures. I usually place a small piece of the paper which I want to use for the final print over the most

important part of the image, expose once for an estimated time and wait for it to develop. During the development time I place a full-size piece of paper into the frame. I then expose it for precisely the same time as the test piece, it the test pieces shows that the exposure was right, or I expose it for a slightly longer time if the test piece is too light or for a slightly shorter time of the test piece is too dark. Naturally, this is largely a matter of experience. It must also be remembered that the bright green light, in which the enlargements are being made and examined, is not the same as daylight. If the enlargements look slightly *too dark* in this light, they are usually right in daylight. To begin with, it may be advisable to make a test strip on which three to five different exposure time are given in stages.

After being fully developed for approximately one-and-a-half minutes, followed by brief fixing, the strip is inspected in daylight to see which of the exposure times — which you carry in your head or which you mark on the paper in pencil — is the best. The final print is then made.

Before fixing, the print can be rinsed in an intermediate acetate bath to stop development and economize on fixing solution. The paper is then fixed for roughly five minutes in a freshly prepared fixing salt solution, and for a correspondingly longer time if the solution is not so fresh. The final wash, in running water, takes roughly half an hour and it then only remains to dry the prints. A print dryer is preferable because it is quick and it is suitable for drying both matt and glossy finishes but resin coated papers should only be dried in special dryers because the resin has a low melting point.

Development papers come in six different grades of hardness: extra soft, soft, special, normal, hard and extra hard. They are necessary because the contrast range of negatives differs. A hard paper compensates for a very soft negative and a soft paper for a very hard negative. The norm would be a negative of average subject contrast, which would give the right result on a normal photographic paper (grade 2). Howeveer, deviation from the norm may be ideal at times when a sensitive, soft gradation of tones (grades 1) or a very contrasting one (grades 4 and 5) is required. Similarly different results can be achieved with positive developers that produce high contrast and low

contrast prints. Differences in tone gradation of up to one degree of hardness can be obtained with the same grade of paper. However, two dishes are needed for this development process because the prints have to be developed alternately in high contrast and low contrast developer. Alterations to the composition can be made during enlargement by partial re-exposure and shading of those parts of the print which need to be made stronger or weaker in tone. The commonest reason for this operation is that light details up to the edges of the photograph divert attention from the main part of the subject; they disappear out of the picture. These areas are given more exposure. The rest of the subject is protected from further exposure by the hand or a piece of paper which is impervious to light and is cut to size for this particular purpose. During exposure, the hand or paper is moved up and down in circles between the lens and the enlarging paper. This prevents sudden changes from light to dark and the blending looks authentic, which is, after all, the object of the small, or even sometimes the big, correctional lie.

The purpose of the opposite trick, shading, is to make parts, which are too dark and have lost detail to stay light. The hand or a piece of paper are again used as described above to prevent light from reaching these areas of the image.

The unorthodox development of negatives is more complex than manually controlled printing. For instance, experiments can be made with higher or lower development temperatures and a correspondingly longer of shorter development time, using solutions of varying concentration. The general effects of low-contrast and high-contrast superficial or penetrating developers can be explored. However, it is advisable to become thoroughly familiar with normal processing methods first. They are always indicated in the directions for use and provide a basis from which to become generally familiar at a later date with special and unorthodox processes. If there were no standard, the results of all experiments would be fortuitous.

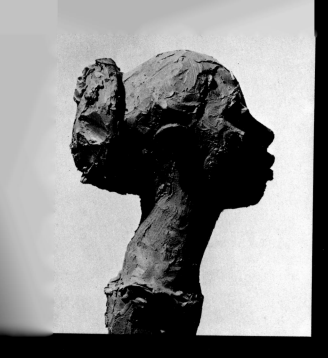

Photograms

We are now turning to a subject which takes us away from photography to graphic creativity. By way of examples I changed the drawing of a tramp and the sculpture of a mulatto girl into "photograms" in the following way. The subject was transferred on to black or opaque paper, using straight lines wherever possible. The drawing was then cut out with scissors or a knife and the cut-outs placed directly on to hard photographic paper beneath the enlarger. The exposure time depended on whether the un-covered areas were to be deep black or light, medium or dark grey. When a graphic image with several tones together was required, then an equivalent number of cut-outs and exposure

Above: Clay sculpture from a living model.

Bottom right: Photogram made with pieces of paper cut from a drawing of the clay model.

Bottom left: Photogram made with square pieces of paper.

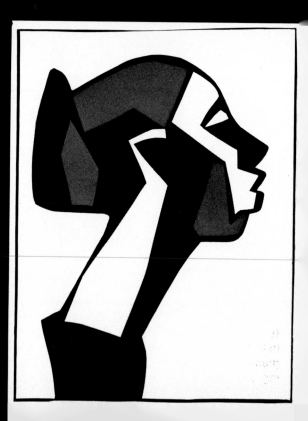

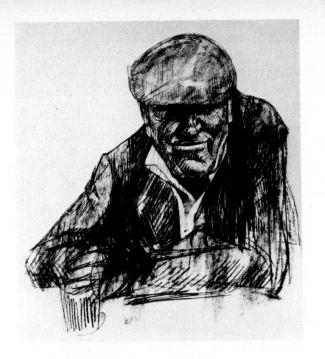

times were necessary. The resulting print was developed in positive developer.

Photograms can also be produced from objects such as scissors, cotton, leaves and teaspoons, or your own hand can be placed on the photographic paper and exposed. Abstract compositions can be practised with torn or cut pieces of paper (top right and bottom left) and can later be made into photograms, as described above.

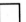

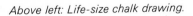
Above left: Life-size chalk drawing.

Above right: Photogram made from torn pieces of paper.

Below: The tramp, changed into a graphic picture with cut and torn pieces of paper.

Photographic
derivations

rich in contrasts or which have large, bold surfaces or linear light contours, or both (pages 185, 195). Subjects with structural interest are also suitable (pages 150, 191).

We shall see how graphic effects are produced.

☐

Graphic methods are as much methods of reproduction in photography as in the liberal and applied arts of woodcuts, lino-cuts, copper-plate engraving and lithography. The photographic negative provides a basis for various derivations. Just as in the liberal arts the imprinted materials — wood, metal and stone — impose a different form of treatment on the artist — cutting and scratching with knives, dry-point engraving and acid etching — so the different films, papers and chemicals can influence photographic character. Thus, when hard enlarging paper is used, the final prints look more graphic than when normal or soft grades of paper are used; the coarse grain of fast film produces a graphic effect and in the graphic methods using a texture screen and solarization, which will be discussed later, the graphic effect is again influenced by the photographic material.

Why try achieve a graphic effect in a photograph? Firstly, because it is fun to make the subject of a photograph look so abstract that it passes beyond our customary view of reality. Secondly, because commercial artists and photographers working on commercial assignments frequently have to convert a photograph into areas of pure black and white with no intermediate tones so that a text can be incorporated into the photograph. The text on book covers, record sleeves, posters and the like is far more legible on a large, uniform background than on an irregular, patchy surface. Poster-like effects are always desirable in advertising material: they attract the eye more than pictures with a wide range of tones. The reason for using photo-*graphic* methods may also be financial: line etching with only *one* shade is cheaper than half-tone etching.

Abstract photographic results are not dependent on chance alone and photographs can be taken with the intention of using them for graphic purposes. Suitable subjects are those which are

Harsh lighting, which gives strong contrasts, provides a good basis for conversion to a graphic picture. Here direct side-lighting was provided by a 1000 w halogen lamp.
150 mm lens on 6×6 cm: 125 ASA film: 1/15th at f/5.6.

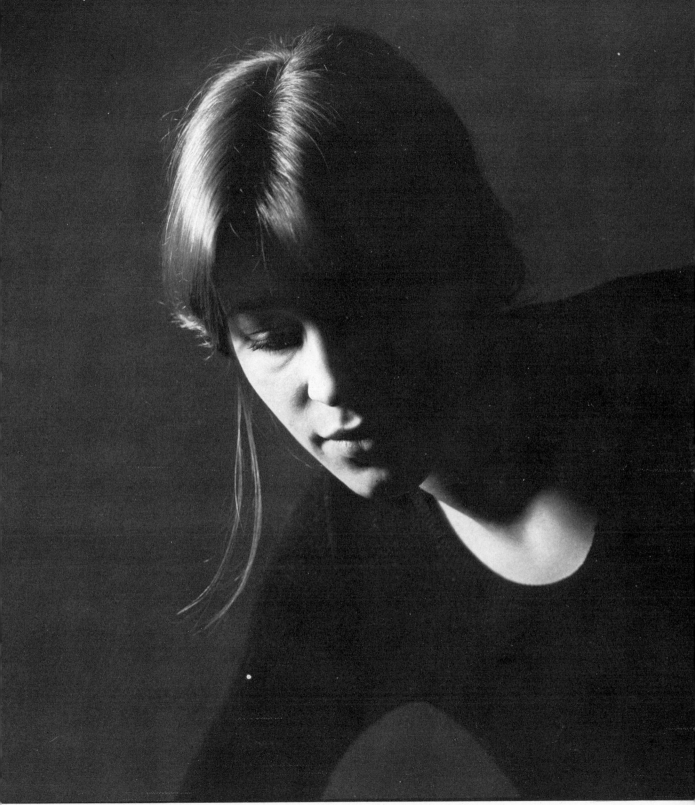

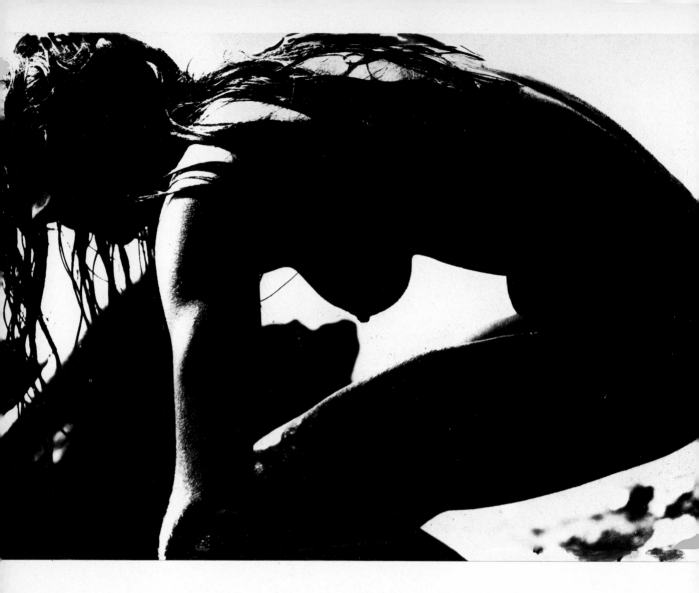

Printing on hard paper is the simplest graphic
method and is often striking in its bold poster-like
effect. If a high-contrast film is also used, as in this
case, the middle tones are almost completely
reduced.

50 mm lens on 35 mm 25 ASA film: 1/1000th at
f/5.6.

Printing
on hard paper

I was standing on an escalator behind a bald-headed man. We were moving up out of a dark subway into sunlight. Suddenly the bald, round dome was lit up and stood out startlingly in sharp contrast against the black jacket of the person above. The single, simple shape of the skull produced the effect of a first-rate poster; it was the model, the archetype of the bald head, the bald head *in itself*! I had left my camera at home; a deplorable state of affairs when presented with such a fine opportunity. Nevertheless I followed this suggestive subject, of necessity, to the top of the stairs, where the man in the black jacket disappeared to the left leaving the bald-headed man with a white wall as his background. He now looked grey and insipid because there was no strong contrast of white against black even though the sun shone down on him as brightly as before. He would no longer have made a good black and white photograph; I felt sorry for him and I felt extremely sorry for myself!

When *hard* or *extra hard* paper is used to give a graphic effect in a black and white enlargement, the middle tones or in other words the shades of grey present in the negative are reduced to pure black and white. A very contrasty negative is of course required for this purpose. If copied on to *normal* paper, it would give a print with pure black and white and clearly graduated shades of grey in it. If the negative is *too soft*, giving only different tones of grey with no real blacks and whites, it will not produce a graphic effect on *hard* photographic paper, although it might on *extra hard* paper.

The first step in the production of graphic effect by printing on hard paper is the choice of subject. Black and white contrasts inherent in the subject — black hair against white skin or light clothing against a dark background — are suitable for this purpose. Lighting which produces strong contrasts — backlighting, side-lighting, oblique lighting, lighting from above and below — heightens a graphic effect. As a basic rule, it is generally preferable to photograph a subject with strong contrasts rather than too flat a subject (pages 99, 185).

If it is known from the beginning that the black and white contrast needs to be stronger than that really afforded by the subject, then the negative itself can be given more contrast by reducing the exposure time or narrowing the aperture by one or two stops. Printing on hard paper is the simplest graphic method and it often produces a striking result on account of its bold, poster-like effect (pages 155, 186).

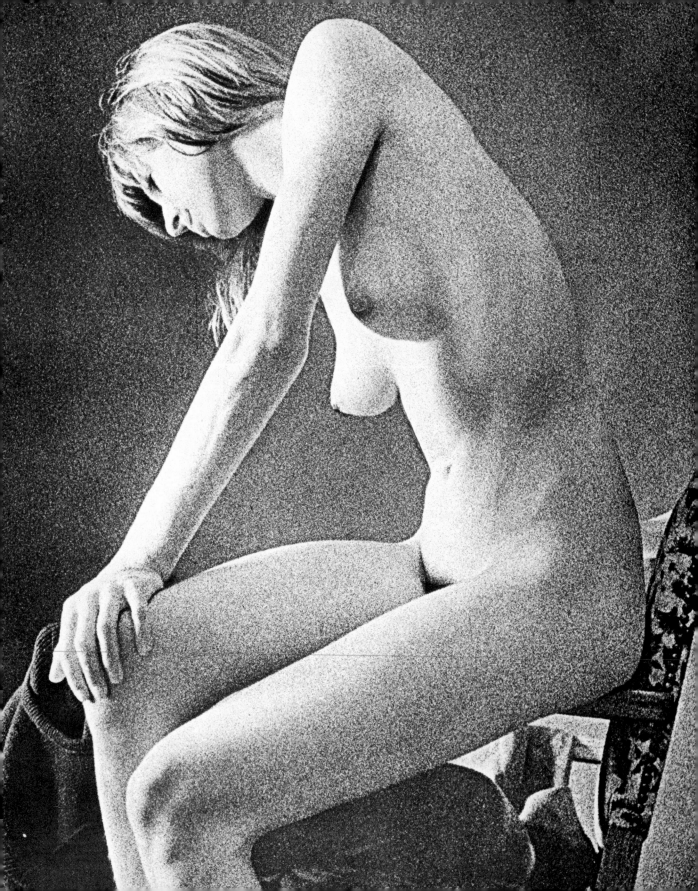

Coarse grain

In most areas of photography, visible graininess is undesirable. However, a coarse grain may be required at times to give a graphic effect. It is included as a photo-*graphic* method because it represents an abstraction of what we see as being true to life. In extreme cases the natural impressions made by the subject lose their familiar representational character and dissolve into strange, impressionistic dots.

How is *coarse* grain produced? It is generally known that fast and high-speed films have a coarser grain than slow emulsions or fine-grained films, as they are called (pages 16, 164). This property can therefore be used to good effect. Moreover, when details are greatly enlarged, the negative structure is resolved to such an extent that it is broken up completely and the individual grains of silver look like dots. This method naturally reduces the impression of sharpness. The photograph needs to be grainy but not blurred so it is better to develop the film in such a way that grain formation is intensified. This is achieved by processing the film in contrast of lith developer. If this *assault* on the emulsion is not enough, the film grain can be made coarser by under-exposure and over-exposure by one to two stops and by development for a longer time at a higher temperature. A further means of coarsening the grain is to recopy the negative onto hight-contrast lith film. A new negative, again on lith film, is made from this copy. Finally, the film grain is brought out more strongly on hard or extra hard enlarging papers than on soft and normal grades.

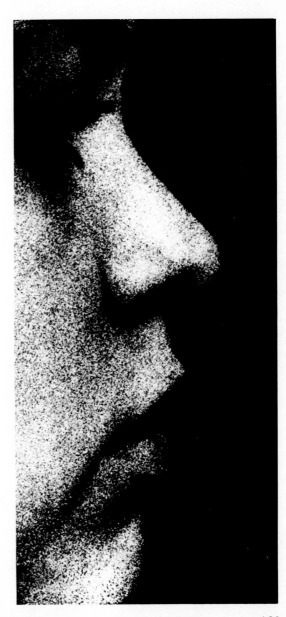

Left: 24×36 mm
50 mm lens on 35 mm 800 ASA film: 1/60th at f/5.6: 1000 w photographic lamp as side-lighting
Aperture: f/5.6 at 1/60.

150 mm lens plus 21 mm extension ring on 6×6 cm: 400 ASA film: 1/60th at f/4.
(Detail enlargement)
Both photographs developed for longer than usual and at approximately 27°C. (80°F)

Tone separations

In the photo-*graphic* method known as tone separation the range of tones in a photograph is limited to a few shades, usually three, to give a poster effect.

A strong half-tone negative is copied on to hard photographic paper by varying the exposure time in such a way that the first stage allows only the shaded areas to show and the last only the light areas (first row of photographs). By repeatedly re-copying the image on to extra hard paper, transparencies of a pure tone character are obtained, depending on the number of tones (second and third rows of photographs). In the fourth process the transparencies are developed on lith film to give *soft* negatives of roughly uniform intensity; when superimposed, they give the final tone separation negative (fourth row of photographs). The positive result is on page 191.

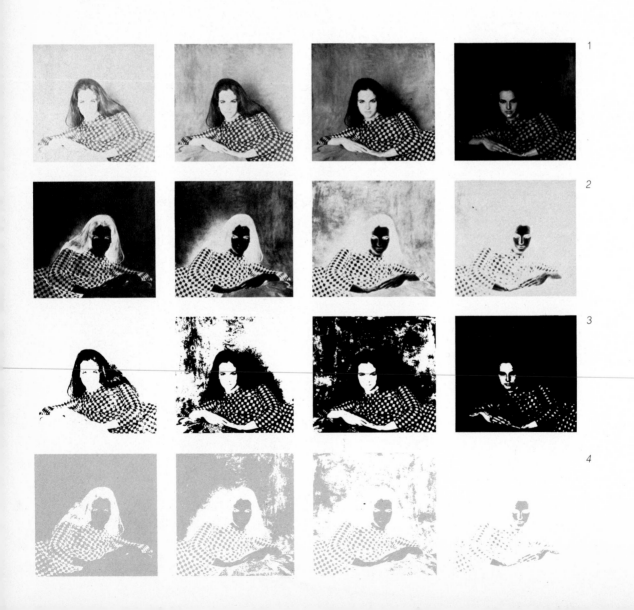

1

2

3

4

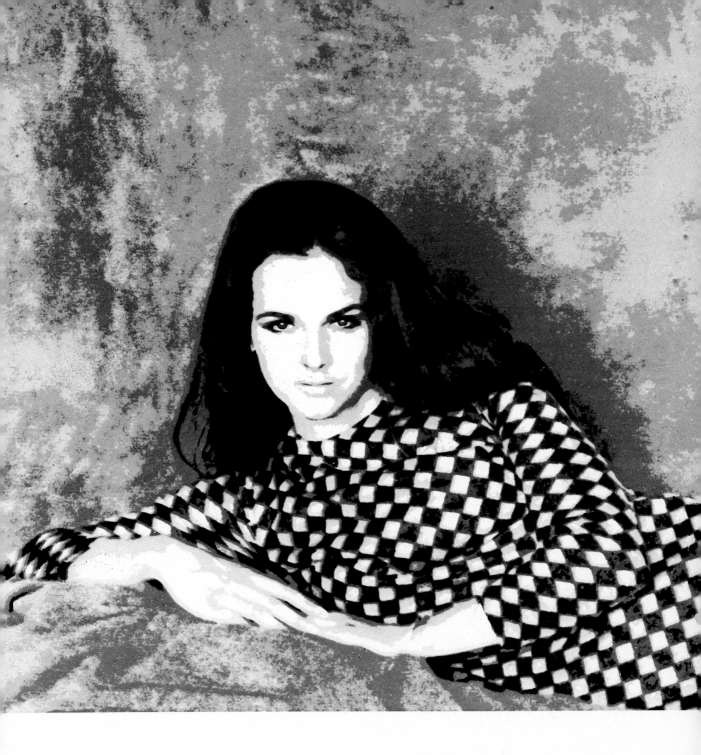

Final print
Details of the original: 80 mm lens on 6×6 cm: 40
ASA film: 1/60th at f/5.6: Frontal north light.

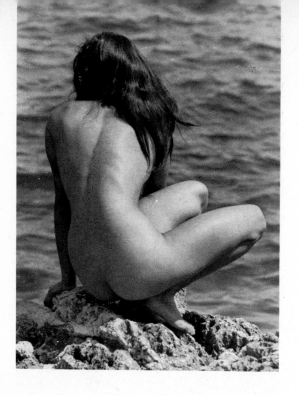

Texture screens

The illustration on the opposite page (page 193) looks as if it has been produced by a more advanced version of the coarse grain method. However, it is obvious from the other two illustrations on this page (page 192) that the *texture screen* method was used.

The original was a strong black and white negative (print, top left). It was contact-copied on to lith film through a texture screen. The screen transparency thus obtained was used to produce a negative on lith film and this was then used to produce the final print. The result shows a visual half-tone effect of pure black texture, which is very sharp in the light areas and which sometimes merges in the dark areas. Lighter or darker prints can be produced from the screen negative by reducing or increasing the exposure time (below left and right). Texture screens are obtainable at most photo dealers.

Texture screens can also be made by photographing a grey or coloured surface on high-speed film, making several exposure and varying the exposure time. The film is then developed at a higher temperature and for longer than usual to increase graininess. The grainy negative is enlarged on lith film. Another method is to photograph a suitable substance — canvas, roughcast, linen or expanded metal — with side lighting to bring out the texture. Use lith film and develop for maximum contrast.

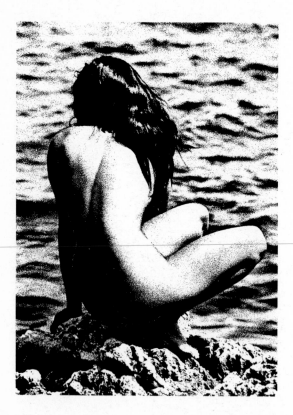

Top: Normal enlargement from the original negative.

Bottom: Longer exposure with the screen negative.

Right: Shorter exposure with the same screen negative.

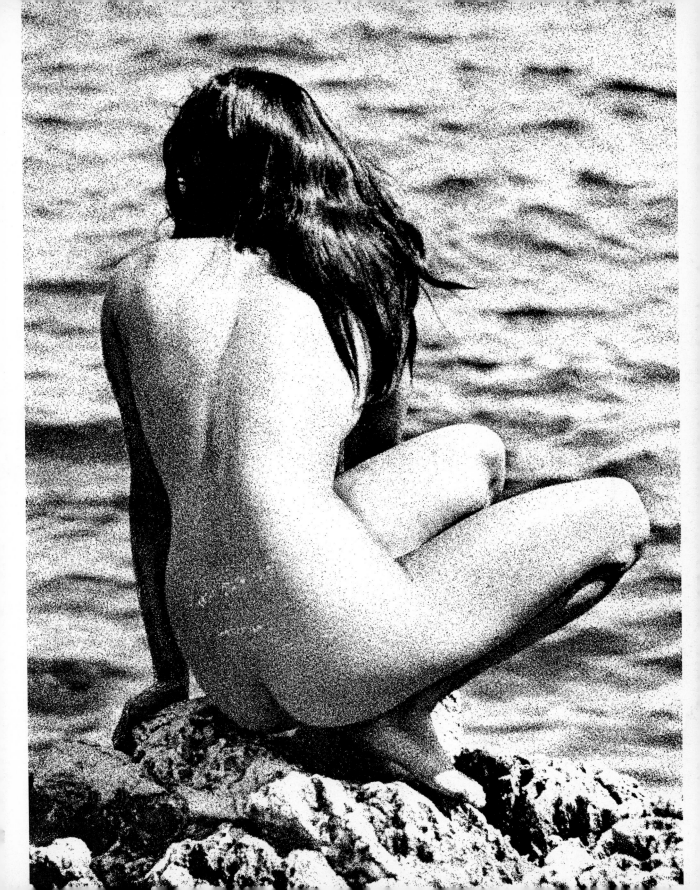

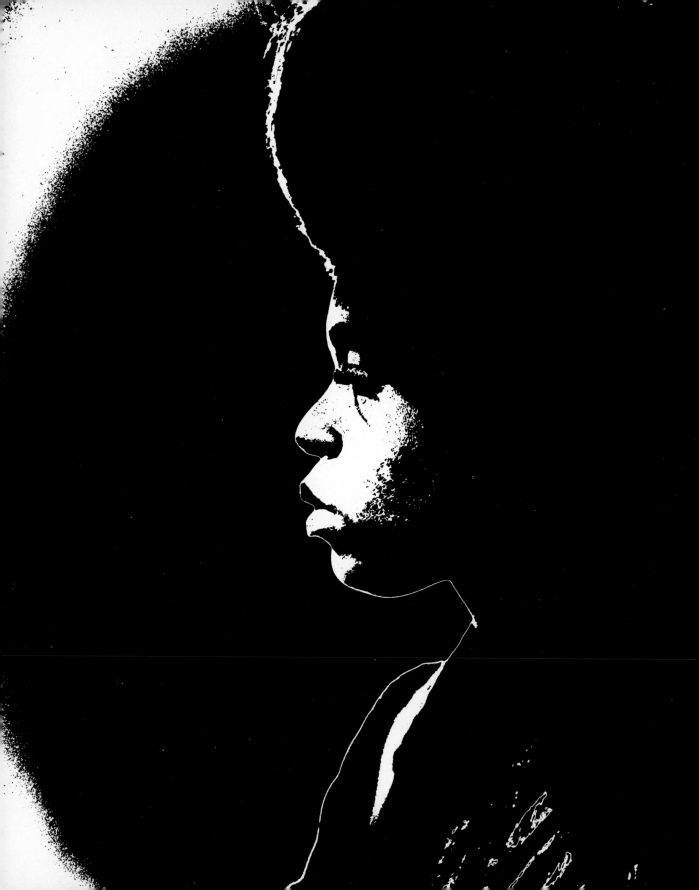

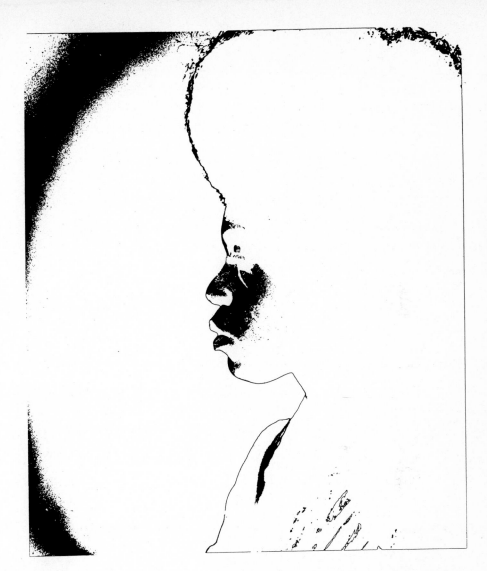

Solarization

A colour transparency is exposed by contact on blue sensitive line film and developed in normal print developer (further diluted with four parts water). The first traces of image appearing on the negative can be seen in a bright red light. Without removing it from the developer, the film is then exposed a second time for roughly two to six seconds to the light of an incandescent lamp at a distance of one metre (3.3 ft). Light areas should not yet be visible. This intermediate exposure produces a partly reversed image and delicate light lines form in the black areas. The solarization (the Sabbatier effect) is not visible until the film is developed after the second exposure. The film is finally fixed and washed as usual. The result is determined largely by the development time *before* the second exposure and by the *duration* of the second exposure. It will be necessary to experiment with different times in order to achieve satisfactory results.

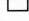

For a French
photographic
journal

Paris 1970

I am writing these lines sitting at a desk in a small hotel below the steps of the Sacré-Coeur. It is therefore from the heart of France rather than from my native Germany that I am composing this brief autobiography for the editor of a photographic journal, who asked me to provide it for his readers.

I have been aware for the last ten years that Montmartre and Paris itself are not altogether France. On leaving school I left Germany with all its responsibilities and travelled straight to the South of France. There was no question of deciding whether I should satisfy my desire for travel by going to Italy, England, Spain or France. France drew me like a magnet. In France I spent three months travelling like a gypsy from one beautiful place to another. I rushed headlong into wonderful adventures with complete impartiality. It was in the South of France that I had my first love affair. It will be obvious from this alone that my gratitude to this fine country runs deep.

I stayed until my money began to run out. But this does not mean that the little money I had, which sufficed for minimum existence, had cut short my fabulous adventures. Adventures came free.

With what little money I had, I was able to spend the nights in a sleeping bag and tent and to dine off camembert, white bread, milk and bananas. That was when I was alone. There were quite often entertaining parties, at which gloriously rich tit-bits, excellent drinks and sumptuous beds satisfied the needs of body and soul.

On the Côte d'Azur and in Provence I led a truly delightful existence, particularly in the country, away from the towns. But this was not often. At a time when I was experiencing the fullness of life

Owing to the unusual angle of view, the relaxed and natural position of the arms makes an original picture in which the side-lighting creates interesting effects of light and shade.
150 mm lens on 6×6 cm: 200 ASA film: 1/60th at f/4: 1000 w halogen lamp.

196

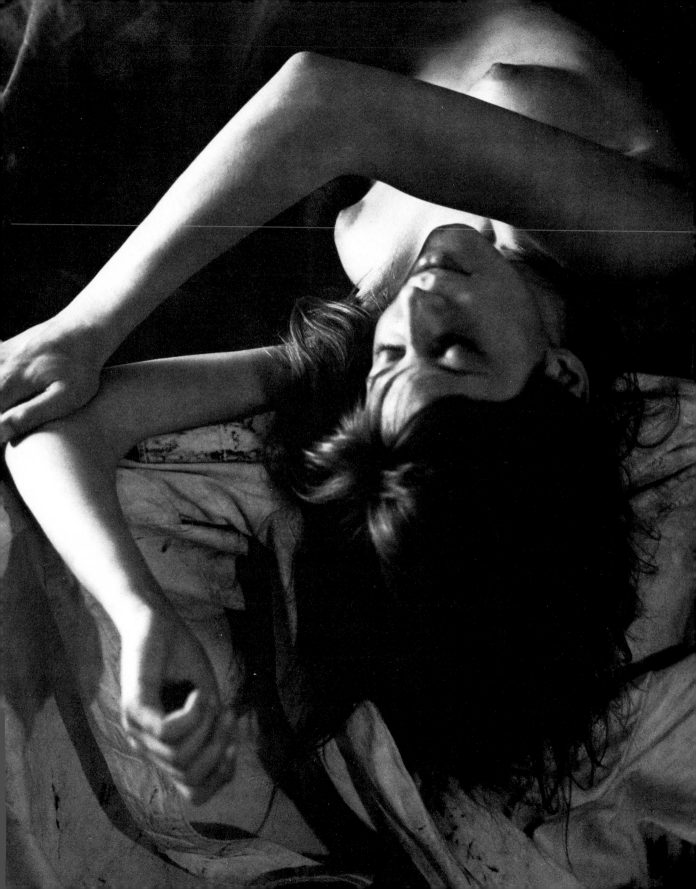

I felt a longing for other ways of life, of which I had as yet formed no clear idea. Nevertheless they found expression in my spending many an evening crouched on the rocks of the Riviera until the sun went down, gazing towards the south-east. I knew of Greece and Egypt from hearsay. I was quite convinced that it must be more interesting to walk with head held high between ancient stone columns than to sit idle and inactive on natural stone. But they were dreams. Meanwhile everyday reality changed and I sauntered round the pleasure resorts of Antibes, Jean-les-Pins and St. Tropez. My days were spent in comfortable hotel swimming pools in which Brigitte Bardot used to bathe and my evenings, late into the night, at jazz festivals

Left and right: Street scenes in France. Sometimes things "click" as you are passing by or walking beside, behind or in front of someone. When everything is right — lighting, background, etc — the photograph is taken.

150 mm lens (man), 250 mm lens (girl): 1/500th at f/4 for both photographs.
160 ASA colour transparency (left)
50 ASA colour transparency (right)

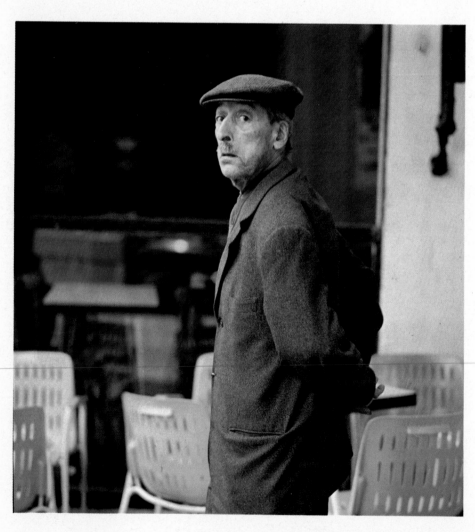

where Louis Armstrong played his trumpet. Strolls along beaches of international fame — Cannes and Nice in particular — were what attracted me now. I was even a beach photographer for three days. I can no longer recall how that came about but I well remember how it ended - I took more photographs than the customers wished to buy! And the little money I had was now almost completely gone, just when I was tasting the sweet life at its best - and so I never indulged in it to excess.

Years of study followed in Germany. Painting and sculpture at art schools in Düsseldorf and Stuttgart together with the graphic arts, including basic photography, at technical college. In the vacations I went on those longed for visits to Greece and Egypt. I was not until I had come to terms with the fine arts and after seeing the photographic exhibition "The Family of Man" that I turned to photography. From then on, however, I came to think more highly of it each year.

I bought books on photography as well as a camera. At one time I also spent three months at the National School of Photography in Cologne. But the best teacher was practice.

Early practice makes perfect.
Snapshot on the entrance steps of the College of Graphic Arts in Düsseldorf.

50 mm lens: 200 ASA film: 1/250th at f/5.6: Sky overcast.

■

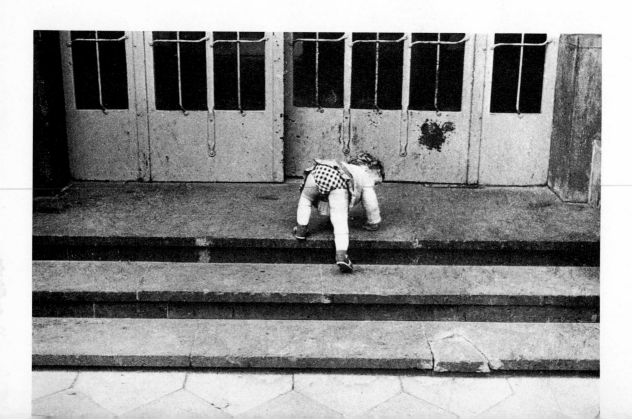